Contemporary Crafts

Contemporary Crafts

Imogen Racz

BERG

Oxford • New York

English edition
First published in 2009 by
Berg
Editorial offices:
First Floor, Angel Court, 81 St Clements Street, Oxford OX4 1AW, UK
175 Fifth Avenue, New York, NY 10010, USA

Berg is the imprint of Oxford International Publishers Ltd.

Library of Congress Cataloging-in-Publication Data

Racz, Imogen.
 Contemporary crafts / Imogen Racz.
 p. cm.
 Includes bibliographical references and index.
 ISBN-13: 978-1-84520-308-5 (cloth)
 ISBN-10: 1-84520-308-9 (cloth)
 ISBN-13: 978-1-84520-309-2 (pbk.)
 ISBN-10: 1-84520-309-7 (pbk.)
 1. Decorative arts—United States—History—20th century. 2. Decorative
arts—England—History—20th century. I. Title.
 NK808.R25 2009
 745.09730'0904—dc22

 2008037176

British Library Cataloguing-in-Publication Data

A catalogue record for this book is available from the British Library.

ISBN 978 1 84520 308 5 (Cloth)
 978 1 84520 309 2 (Paper)

Typeset by JS Typesetting Ltd, Porthcawl, Mid Glamorgan
Printed in the United Kingdom by Biddles Ltd, King's Lynn

www.bergpublishers.com

CONTENTS

ILLUSTRATIONS

ACKNOWLEDGEMENTS

There have been so many people who have helped me in writing this book. My first thanks must go to the incredible generosity and interest of the many practitioners with whom I have spoken in relation to this book. I have listed those at the back who I interviewed and have been included in the text. However, there have been others who also gave their time and expertise. I am grateful to them all.

I would like to thank the staff at Berg, in particular Kathryn Earle, who was my first editor, and Hannah Shakespeare, who took over. This has been a long project, and both have been unfailingly positive but also sure-footed in their constructive criticism.

My next thanks must go to the wonderful libraries that I have used and the staff who have built their collections. Again, I have been met with an enormous amount of patience and help. In particular I would like to thank the library staff at Coventry University library, and especially our subject head, Ann-Marie Hayes. She has built the collection to the excellent resource it is today and has been unfailingly helpful. I would also like to thank the staff at Birmingham City University Library, Birmingham Central Library, British Library, National Art Library, Smithsonian Institute, New York Public Library, Cooper-Hewitt National Design Museum Library, the New York Public Library, Free Library of Philadelphia, the Archives of the Historical Society of Pennsylvania and the University of Pennsylvania Library.

I would like to thank my colleagues at Coventry University who have been supportive of this project. In particular, I would like to thank Professor Steven Dutton who gave me some remission from teaching in order to finish the book. I would have missed my deadline without it. I would also like to thank the geography reading group and especially Dr Philip Dunham, also in the geography department, who has given valuable insights into the subject.

A special vote of thanks needs to go to Claire King, who helped edit the footnotes and bibliography of my first submission and for the final text organized everything to do with the images. This was a huge task and it was wonderful to have it in the hands of someone so capable.

Finally, I would like to thank my friends and family. Anne Tyson and Betty Haglund both took chapters early on and gave constructive criticism at a time when I needed it. My American relatives, Richard and Elsie Racz, and Karen Racz and

Terry Estes, have been wonderfully supportive, contacting their artist and artisan friends in Massachusetts, setting up interviews and helping with the permissions. However, the biggest thanks have to go to my husband Mark, who has helped in numerous ways, both practical – from crashing computers to meals – and direct. He has read the whole text and given helpful advice! I am really grateful.

INTRODUCTION

Craft is a vibrant area of practice that covers a broad range of styles, materials and purposes. Arguably it is more important now than at any time since the industrial revolution. People eat off craft objects, sit on them, wear them and enjoy them. As such, much contemporary craft fulfils its traditional roles related to society and the everyday. However, beyond these functions cutting-edge craft uses these roots in order to consider issues about our contemporary world.

I have structured the text to enable a thematic approach to the discussion of contemporary crafts that are related to the city and the country in the United States and England. I will be considering craft that is the outcome of particular ideologies and lifestyles, that represents a personal or symbolic relationship with place or where the objects are related to the environment in ways that open up issues beyond the immediate. Through mapping a range of practice, I will explore how craft today remains true to its roots in its different manifestations, and yet is also a vibrant part of the contemporary arts.

What I am also interested in are the different manifestations of these ideas on either side of the Atlantic. Historically there have been waves of influence from Northern Europe, including England, into the United States. Some of these remain important, with threads of ideas in both England and America that can be traced back to a Romantic sensibility of the late eighteenth century, to the Arts and Crafts movement, or to inter-war modernism from continental Europe. In both countries, most craft practice is true to its material discipline and is fundamentally hand-made. However, on to this platform of uniting factors there have also been individual developments that are related to social and political differences, the acculturation of the land and the recent absorption of different influences into mainstream crafts.

At various times in the decades since the Second World War, craft practice on both sides of the Atlantic has been encouraged by government-subsidized crafts councils to align itself either to industry or to art and individuality. During this time the very nature of craft has been debated and its parameters enlarged. Today's practitioners make one-off conceptual pieces, design works for batch production, are designer-makers and accept commissions for site-specific work. They frequently have a portfolio of work that includes utilitarian and conceptual objects of different scales and for different purposes.[1] As a result, there is not a stable identity of craft.

In the anniversary issue of *Crafts* in 2003, the chairman of the Arts Council, Sir Christopher Frayling, wrote that the fluid idea of craft was on the move again.[2] In spite of public subsidy, he felt that the crafts had not managed to occupy the space left by conceptual art. Crafts have their own galleries, magazines, critical vocabularies, social networks and criteria of quality.[3] In the same issue, David Revere McFadden, the chief curator of what had been known as the American Craft Museum in New York, wrote that the permeability of the boundaries between crafts and its related disciplines combined with the fluidity of conceptual underpinnings have meant that they had been forced to change the name of the museum to the Museum of Arts and Design.[4] Craft, he wrote, was now linked to craftsmanship, but 'art, craft and design exist in a circular arrangement with each field supporting, nourishing, informing and challenging the others'.[5]

It is this fluidity in the parameters of craft that has also underpinned the breadth of this book. Craft is at the intersection of a great diversity of practices within the visual arts, as well as making material some ideas connected to cultural geography. Exemplars of work and ideas that sit on the permeable boundary between craft and art or design will be discussed, as well as those that happily fit within the usual definition. In his thoughtful essay to the recent catalogue of the Renwick Gallery in Washington, DC – which operates under the auspices of the Smithsonian Institution and contains the major collection of contemporary American craft – Howard Risatti argued that the fundamental characteristic of craft is its traditional link to the human body through function. From this point of view, rather than dividing the crafts by discipline, the objects can be considered under the loose terms of containers, shelters and supports.[6] This has implications for the themes discussed.

Traditionally, not only were crafts integral with the functioning and rituals of individual and collective life, but were also connected to place through materials and their possibilities. Because of the original utilitarian function, making, material and form were inextricably bound together. On both sides of the Atlantic these links have been mythologized. In America there remains a collective cultural memory of the relationship between craft, land and the early settlers. In England there is a collective myth at the intersection of the Arts and Crafts movement, the Back-to-the-Land movement of the late nineteenth century and village wares. Cutting-edge practitioners have changed the emphasis. Material and technique go far beyond the functional necessity, but none the less makers remain fascinated with materials and their possibilities, and through these means reveal ideologies connected with the acculturation of the environment.[7] Beyond this is the realization that the traditional integration with society, which for so long kept craft separate from the 'fine' arts, gives the genre a unique voice to question society, the environment and everyday life.

The definition of the term 'craft' varies on both sides of the Atlantic and between different makers. There are, however, unifying factors. The American jeweller

and critic Bruce Metcalf has discussed the characteristics of crafts, saying that the object should be substantially made by hand. It should also have a number of other factors including the use of craft media and associated technologies, the suggestion of traditional craft functions and a reference to the relevant discipline histories.[8] The British craft scholar and museum director Paul Greenhalgh also started his definition of the genre with its traditional roots, material and touch. He owns a jug by Michael Casson and likes to hold it and think about its formal qualities.[9] These aspects underlie craft, whatever the style. Although Greenhalgh has also argued that craft does not have any cohesion other than that provided by artistic, institutional and economic reasons,[10] none the less, what he and many other writers have agreed with is the fact that the material is always part of the point, that touch is frequently implicated in communication, and that the debates that are considered are interpreted in a way that reference the roots of the material disciplines.

My book, whilst broad in scope, only discusses particular issues and types of practice. Although I shall be considering domestic, gallery and site-specific work, I will not be discussing virtual craft. When discussing traditional, utilitarian craft, the underlying philosophies that link craft and making to place and society are considered. In cutting-edge craft, the work discussed is object-based, uses discipline roots to consider ideas about the environment, and its roots in society to comment *about* society.

Craft is flourishing and is becoming increasingly visible. A recent survey conducted by the Crafts Council in Britain showed that there were 32,000 people engaged with craft on a professional level in England and Wales, which generated a turnover of £826 million in 2003. This was more than forestry, fishing or the manufacture of sportswear.[11] The makers contributed to tourism, the creative industries, were focuses of entrepreneurial activity and models of portfolio employment. The survey also gave the personal attributes of the practitioners as entrepreneurial, passionate, skilful and individualistic.[12]

Craft is also becoming increasingly visible both at institutional level and in the commercial sector. The Renwick Gallery, as well as many other prestigious museums in America, continues to collect contemporary crafts and curate temporary exhibitions in addition to displaying the permanent collection. The Corning Museum of Glass owns more than 45,000 objects that span thirty-five centuries.[13] The internationally renowned Helen Williams Drutt collection of jewellery is now at the Museum of Fine Arts, Houston. Commercial craft galleries are also expanding with the *Craft Galleries Guide,* which advertises a selection of British galleries having more than 130 entries. *SOFA Chicago,* the international exhibition of 'Sculpture Objects and Functional Art', started in the 1990s and now has more than 100 international galleries and dealers who exhibit.[14] *Collect,* the international fair of contemporary objects that is held annually at the Victoria and Albert Museum in London, was launched in 2004 and now has more than forty galleries that exhibit there.[15] *Origin: The London Craft Fair* was launched by the British Crafts Council in October 2006

and is now an annual event. It brings together the work of more than 300 cutting-edge designer-makers and is the craft equivalent to the Frieze Art Fair.[16]

Most of these developments are recent and, as a result, the critical literature has not grown in the same way as that about the 'fine' arts. Much writing about craft has been linked to discipline, history or maker and some of these are clearly important texts. Tanya Harrod's *The Crafts in Britain in the Twentieth Century* which was published in the late 1990s remains an important and encyclopaedic contribution to mapping and analysing trends in British crafts until the 1990s.[17] In addition there have been some useful anthologies about issues surrounding crafts and their histories from both America and England. Some of these have included essays by crafts practitioners themselves, like Pamela Johnson's *Ideas in the Making*.[18] Paul Greenhalgh's *The Persistence of Craft: The Applied Arts Today,* is a series of essays that concentrate on particular issues within certain disciplines.[19] Within these texts, most of which have been published within the last ten years, there is an increased engagement with critical and theoretical ideas.

There have also been exhibitions and accompanying catalogues that have considered themes in craft that cross the boundaries of the disciplines. The Crafts Council has curated many exhibitions over the last ten years addressing particular issues. *No Picnic* from 1998, for instance, focused on designer-makers and their attitudes towards products and production in the post-industrial age.[20] Lloyd Harman and Matthew Kangas's *Tales and Traditions: Storytelling in Twentieth Century American Crafts* (1993) included thoughtful essays that sought to consider the American propensity for storytelling, linking it back to the previous centuries.[21] The catalogue to *Explorations. The Aesthetic of Excess* (1990) again attempted to plot a path through American craft of the 1980s that bordered on the decadent through its decorative qualities.[22] All of these texts have made the links between the origins of craft and contemporary practice.

Of most interest for the purposes of this book have been the recent exhibitions that have considered the role of the urban and rural environments on the practice of craft. Like this book, the accompanying catalogues have included elements of cultural geography as theoretical underpinning. *Urban Field*, an exhibition held in three craft centres in 2007, sought to open up debates about the urban/rural theme in English craft. In the accompanying texts, ideas about the fluidity of that traditional duality were unpicked in a country that is both post-industrial and urbanized. The exhibition included makers who worked across the material disciplines in both the city and country.[23] *Get Real* was another cross-disciplinary exhibition, and its catalogue included an excellent essay that discussed the relationship between contemporary craft, land, landscape and the English romantic vision.[24] Again, past and present were intertwined.

What I intend to do is to develop some of the ideas initiated in these exhibitions. I will not be discussing work from Scotland or Wales, as these countries have different cultural understandings of the land and also different national and international

affiliations. This book is not attempting to be encyclopaedic and I am aware that I have neglected some important makers and types of practice. However, by selecting exemplars of my chosen trends and discussing them in some detail, I have been able to show different ways of interpreting issues, contextualize relevant ideas and consider the relationship of maker, process, material and audience in America and England. My overarching quest is to raise questions about our relationship with the environment, to the cultural myths that surround those areas and how these have been revealed in the objects.

The first chapter gives an overview of trends in the last century and discusses the acculturation of the landscape. The following chapters are paired so that similar issues are discussed in relation to American and English practitioners. Chapters 2 and 3 look at functional craft that has been influenced by particular ideologies and histories and remains rooted in the rural environment. Chapters 4 and 5 consider the ways that cutting-edge craft practitioners have explored personal responses to their geographical surrounding, critiqued some of the myths about space and place or made work that resonates with more global ecological concerns. In these objects, the ways that the materials have been manipulated and the relationship with the material discipline is crucial. Chapters 6 and 7 consider work that is made in response to the lived or material urban environment. Having considered the manifestation of particular ideas related to the city and the country, the final two chapters discuss work that is made in the environment and consider whether the underlying ideas remain constant when the practice is commissioned for public spaces.

1 CONTEMPORARY CRAFTS AND CULTURAL MYTHS

This chapter will give an overview of the development of the many diverse factors underpinning craft practice in England and America from the mid-twentieth century to the present day and consider the varying definitions of that practice. It will also discuss the acculturation of the land and cities in the two countries as this is central for the understanding of the themes of the book.

AMERICAN CRAFT

Craft has played a significant role in the development and perception of America as a nation. For the pioneers, the ability to make quilts, furniture and other necessities of life was crucial for survival. In addition, for those settlers who had come for religious reasons, these crafts were considered more important than painting or sculpture, as they were part of the everyday experience of everyone.[1] This importance in American social history was acknowledged in the centennial festivities in Philadelphia in 1876, when a reconstructed log cabin was filled with handmade objects, and twenty costumed guides showed the visitors around.[2] In addition, the crafts practised by Native Americans were fundamental to their culture, and their influence can be seen in much contemporary practice.

Craft again became important during the depression of the 1930s, when there was not only a concerted effort to define common cultural roots, but also to find ways of alleviating rural poverty. The encouragement of the practice of craft coincided with a redefinition of America that was essentially rural through looking back to the common pioneer past.[3] Among the many who devoted energy and resources to encouraging crafts as a means of alleviating poverty were Lucy Morgan, Aileen Webb and Allen Eaton. Aileen Webb founded America House in New York as a gallery to show and sell these works. This led to the establishment in 1941 of the magazine *Craft Horizons,* which was to become the major craft journal in America. From these roots the American Craft Council was formed in 1943.[4]

This redefinition of America, stressing its roots in pioneer times, led to a general revival of interest in folk arts, and an institutional interest in preserving the past.

Alan Lomax travelled throughout the States, collecting and recording songs and other folk music for the Library of Congress's *Archive of American Folk Song* during the 1930s and 1940s.[5] Substantial collections of quilts, furniture and other items from the precolonial and colonial periods were acquired by major art museums, including those in Philadelphia and Baltimore. In 1924 the Metropolitan Museum of Art in New York opened its American Wing, which provided a major space for the display of decorative art.[6] There were also large craft exhibitions, like the ones at the Newark Museum in 1931 and the Museum of Modern Art, New York, in 1932. The catalogues to these discussed the works made by anonymous craftsmen and amateurs, the carvers, carpenters and cabinetmakers who were described as being an authentic expression of the spirit of the American people and their experiences.[7] These practices and designs were further embedded within American culture through the *Index of American Design* which was started in 1935 as part of the Federal Arts Project. This pictorial record was disseminated throughout America through slide lectures, exhibitions and in publications, and became influential in the post-war collecting policies of museums and art galleries.[8]

The influx from Europe of architects, designers and makers beginning in the 1920s was another important influence on American craft and design. These immigrants brought with them established traditions, energy and expertise, as well as the social and conceptual ideas of European modernism. These gave craft a role within industry, promoted craft and design that would exist harmoniously within urban architecture through the use of geometry and rationalization, and denied narrative devices and the hand of the maker.[9] The School of Design in Chicago, founded by László Moholy-Nagy, and Black Mountain College in North Carolina became major centres for Central European ideas, and attracted some of the most distinguished designers, makers and architects.[10] The weavers Anni Albers and Trude Guermonprez, as well as the painter and theoretician Joseph Albers, taught at Black Mountain College. Franz and Marguerite Wildenhain established Pond Farm Pottery in Guerneville, California.[11] The Finnish architect Eliel Saarinen met George Booth in the 1920s, after which they founded the Cranbrook Academy of Art in Bloomfield Hills, Michigan. The teaching encouraged the rigorous European philosophy of good design linked to industry.[12] This rich input of expertise, combined with the fact that there were now groups of students and staff exchanging ideas, meant that the cities with the strongest craft movements tended to be those that had a university campus.[13]

Enmeshed within the utopian ideas that underpinned modernism, Colonial Revival and the work of those who had been influenced by the Arts and Crafts movement was a nationalist stance that overlooked the work of Native Americans, African Americans and other minority groups.[14] However, there was a growing interest in Native American craft, and their culture became influential within the American Arts and Crafts movement. For example, Gustav Stickley, who published a magazine called *The Craftsman* between 1901 and 1916, frequently included articles on their basketry, myths, music and architecture.[15] Between 1920 and 1945 there

was a change in accepted ideology from the apparently 'natural' course of Native American civilization being overlaid by that of white people, to a greater interest in its different manifestations.[16] There was also a greater interest in local craft traditions, so that Hispanic and African American crafts also became increasingly visible.

From the inception of the American Craft Council in 1943 there was a steady increase in institutions that collected crafts, as well as an increase in the number of conferences and symposia.[17] From the mid-1950s, national conferences that debated the role of craft in America were organized, which, in line with the desires of the American Craft Council and their journal *Craft Horizons,* tended to promote crafts working for industry. The Fourth National Conference of American Craftsmen of 1961, for instance, had forty speakers and panellists who spoke to the theme of 'Creative Research in the Crafts'.[18] The questions discussed included, 'Are the crafts more valid when designed as unique, individual objects or as prototypes for mass production?' Also in 1961 there was an exhibition called *Fabrics International* which sought to promote the usefulness of the hand-maker of textiles in industry.[19] The director of the Museum of Contemporary Crafts, David Campbell, echoed the ideas of the Bauhaus and Swedish design and craftsmanship by saying that the American Craft Council wanted to promote good design through a fruitful relationship between craft and industry.[20] At this time, the Craft Council was attempting to distance itself from regional and ethnic variations.

The American Craft Museum opened in 1956 in New York as the Museum of Contemporary Crafts.[21] The Renwick Gallery opened in Washington, DC, in 1972, under the auspices of the Smithsonian Institution.[22] Although it originally opened as a gallery space, in 1981 the decision was made to build a serious collection of contemporary craft. This decision was simultaneous with those made at the Cooper-Hewitt National Design Museum in New York and the National Museum of American History in Washington, which also decided to collect contemporary craft.[23] The Corning Museum in New York State opened in 1951 and aimed to acquire a comprehensive collection of glass objects from all cultures and, from the 1970s, was particularly active in accumulating contemporary work.[24] Many other regional museums began collecting craft seriously during this time. In 1965 the National Endowment for the Arts was founded and in 1973 the first full-time representative for crafts in the United States was appointed. The following year the first major grants were given, but perhaps most importantly a survey of American crafts was published which, along with lavishly illustrated books like *Object: USA,* helped to create a framework and a national canon of craft.[25]

THE DEVELOPMENT OF CRAFT INSTITUTIONS IN ENGLAND

It was not until the 1970s that crafts began to gain an important voice in England. The Industrial Revolution had severed the natural link with rural crafts and regional

styles through economic pressures and a growing taste for perceived luxury that could only be satisfied through mechanically produced wares. The industrial aesthetic of modernism further undermined the values inherent in handmade objects. Indeed, in the opening paragraph to David Pye's *The Nature and Art of Workmanship*, published in 1968, he compared the great interest in design with the lack of interest in workmanship.[26] His was a passionate plea for the understanding that good workmanship gives to the lived environment.

One of the vital components in creating the vibrant craft practice of today were the changes in education. Since the late 1960s, craft students have been graduating from art colleges. Although the Coldstream Reports of 1961 and 1962 by the painter William Coldstream for the National Advisory Council on Art Education seemed to marginalize craft, the result was that craft subjects were taught alongside the 'fine' arts, and also particular institutions were granted the right to award DipADs in certain disciplines.[27] Although this sidelined traditional discipline-specific workshop training, those who attended art colleges became aware of the debates from across the artistic spectrum and became interested in developing personal practices.

Another crucial factor in the craft renaissance was the formation of the Crafts Advisory Committee in 1971.[28] This was to be an important voice for crafts – a body that administered government grants, held and supported exhibitions, underpinned the British Crafts Centre, created an index of crafts practitioners and started a magazine entitled *Crafts* in 1973. With the emergence of graduates from art colleges who were working in craft materials but not aligning themselves to traditional practice, the continuation of an arts and crafts aesthetic and the remnants of a rural craft tradition, it was difficult to define both what craft was and what the CAC would support. The first issue of *Crafts* in March 1973 included an article on the Royal College of Art graduate and silversmith Michael Rowe, as well as other articles on bookbinding, thatching and a craft community. The article about Rowe emphasized his practice, conceptual affiliations and links with industry.[29] In direct contrast to this, the article about thatching emphasized techniques, continuity with tradition and apprenticeship training, and was accompanied by suitably rural and picturesque images.[30]

Although networks of galleries that show contemporary craft have been developed in England, the visibility of contemporary crafts within the major museums is not as prevalent as in the United States. As Paul Greenhalgh has articulated, permanent spaces with objects that one can return to again and again are influential in formulating cultural identity.[31] However, unlike America, craft in England has not been seen as a uniting social or historical factor and so the collections of furniture and other crafts have tended to focus on objects of status. The museums that were founded in the nineteenth century were considered a practical way of promoting good design for industry through exhibiting exemplars of contemporary design and art.[32] The Victoria and Albert Museum was itself born out of a belief in progress and the importance of industry. However, since then, it has not consistently collected

exemplars of craft practice. The original concept of collecting contemporary work was brought back into focus in the 1970s and 1980s under the directorship of Sir Roy Strong, who devoted a substantial part of the acquisitions budget for this purpose.[33] However, even prior to his directorship, there was a realization that there were few major platforms for craft to be exhibited. A crucial turning point was in 1973, when Sir John Pope-Hennessy offered Gallery 45 at the Victoria and Albert Museum in which to hold the exhibition *The Craftsman's Art*. This exposure of the range and energy in the burgeoning craft movement within the major design museum of the UK ensured that it was taken seriously by the press and public.[34]

Some important regional collections of design and contemporary craft have also been developed during the last few decades, including the silver and metal collection at the Birmingham Museum and Art Gallery. Through funding from the Contemporary Art Society's Special Collection Scheme, sixty new acquisitions of contemporary work have been added to the existing historic collection since 1998.[35] The Shipley Art Gallery in Gateshead has built up a substantial collection of contemporary craft since the 1970s and recently received extra funding from the Designated Challenge Fund to enhance this collection.[36] However, these are recent developments. Even within these galleries, the fine and applied arts are kept separate. In the major art museums, unlike many in America or on the Continent, contemporary craft is still marginalized.

GROWTH IN MARKET

Although there were craft shops and galleries in London and New York before the Second World War, the increase in disposable income available to the generation growing up in the 1950s and 1960s created a boom for emerging young designer-makers. Wendy Ramshaw and David Watkins took advantage of this new market and designed bright, inexpensive jewellery in paper and screen-printed perspex, which complemented youth fashion and referenced Op Art. No longer was jewellery about status and inherited taste, but became part of the trend where the consumption of contemporary goods and their customization by the user were seen as part of identity formation.[37]

To cater for this burgeoning trade in fashionable items during the 1960s and 1970s, many small shops opened in large cities. One of these was Detail in London's Covent Garden, which later opened a partner shop in Spring Street, New York. This stocked work by well-known jewellers such as Susanna Heron who, like Ramshaw and Watkins, enjoyed making inexpensive jewellery alongside her studio work. All of the pieces were made from synthetic materials like plexiglas and injection-moulded resin that lacked the cultural baggage of more established materials and could be bright and bold.[38]

As well as ventures that appealed to youth fashions, there was also an increase in galleries devoted to cutting-edge studio craft. In England, before the war, there

had been a few selling exhibitions held by specialist societies, such as the Guild of Weavers, Spinners and Dyers; there were also a few outlets in London. However, the possibilities were both diverse and limited, which, as Tanya Harrod has written, illustrates the cultural ambivalence towards handmade objects at that time.[39] In America there was a more established range of galleries before the war, as well as some, like the jewellery shops owned by Sam Kramer and Art Smith in New York, that were started in the 1940s.[40] However, during the 1970s and 1980s the frameworks for buying and exhibiting crafts expanded rapidly on both sides of the Atlantic. The Electrum Gallery, which opened in London in 1971, was an outlet for avant-garde jewellery for both sexes. Andrew Grima and John Donald opened shops in London in 1973 for the sale of contemporary work,[41] and in the following year Atmosphere opened in Regent's Park Road.[42] These galleries not only promoted work by English makers, but were international in scope, which led to a greater dialogue with trends in Northern Europe. Since then interest in contemporary crafts in England has grown enormously. In 1993 the first edition of a directory of English craft galleries was published and listed only twenty-one outlets, while the sixth edition of 2002 boasted more than 130 galleries and almost 600 practitioners.[43]

In America there was also an expansion of galleries from the 1970s devoted to cutting-edge crafts. For example, Helen Drutt opened her prestigious gallery in Philadelphia in 1974 to show twentieth-century crafts in clay, glass, metal and fibre. She saw it as the duty of an art dealer to complete the creative cycle through encouraging critical analysis, holding exhibitions and lectures, and she always made sure that she wore contemporary jewellery wherever she went.[44] Not only did she acquire American craft objects but she also exhibited the work of European makers, which helped to make visible the international patterns of ideas and to establish the developments within the oeuvres of individual artists.[45] This type of collecting, promoting and exhibiting links back to the work of art dealers such as Daniel Kahnweiller and Léonce Rosenberg in France at the beginning of the twentieth century. These dealers were just as necessary to the survival of avant-garde artists of that period as are contemporary ones today.

DEFINITIONS OF CRAFT

Complementing these galleries were the magazines that were published by the crafts councils in America and England, which helped to promote their ideals. During the 1960s, *Craft Horizons* – which was to become *American Craft* – encouraged the idea that crafts should be aligned with industry. This changed, and from the 1970s the journal promoted an interest in artistic crafts as well as publishing regular articles about galleries and collectors. The featured galleries tended to promote fashionable objects that could be sold as 'art' to culturally aware urbanites. An advertisement for Convergence in New York in 1983, for instance, showed quirky post-modern

furniture similar to designs by Memphis.[46] The standard of display, holding of exhibitions and growing international interest aligned these galleries to those that supported the fine arts.

Craft also caught the eye of certain politicians. With the political move to the right in the Thatcher and Reagan eras of the 1980s, craft skills linked to traditional forms were seen to promote conservative social values. Margaret Thatcher was photographed in her Top Office in 1987 with a teaset by David Leach and a gilt mirror frame by Christine Palmer setting the tone.[47] Skill, discipline and tradition were also espoused through architectural lettering, such as the prestigious commission for the new Sainsbury Wing at the National Gallery in London (1990–1991).[48] The general shift from public to private funding during Margaret Thatcher's government was mirrored by the concept that craft, which in the 1970s had moved towards individual expression, should be more market-aware during the 1980s.[49] The Conservative Government's desire to persuade crafts practitioners to move closer to industry coincided with their backing for design and a general increased awareness of designer products and of the designers themselves. This commodification of design fed into higher education, with the fashion store Next promoting the Royal College of Art degree shows between 1986 and 1990. More commercial craft galleries opened, and the scheme that became known as *Contemporary Applied Arts: Art Means Business* was initiated in 1987. This venture aimed to persuade businesses that well-designed craft would add to their corporate identity and be a sound, long-term investment.[50] However, these commissions were inevitably required to conform to the promotional ideas of directors and, in keeping with prevalent values, tended to be conservative.

In America, the political establishment was also keen to promote crafts. The bicentennial in 1976 led to a surge of interest in American craft traditions.[51] This was given official endorsement by the White House in 1977 when Mrs Carter gave her annual lunch for senators' wives.[52] Instead of using the usual white crockery, she invited many different practitioners from across the disciplines to make table settings, including glasses, plates, cutlery, napkin rings and all the paraphernalia that a formal lunch required.[53] This was a major success, and the White House has continued to commission craft items. Like Margaret Thatcher, Mrs Carter and successive incumbents felt that the discipline of making objects could be equated with national values. However, also like the works chosen by Margaret Thatcher (or her advisers), this was an edited version of the crafts movement that tended to be based on particular traditional forms and ideas.

In spite of these ideological pressures, the definition of craft has never been stable or unified. In 1976, the Crafts Advisory Committee published an index of 'craftsmen of quality' that was essentially an advertisement for craft in England. Included were photographs of objects by more than 300 crafts practitioners from across the disciplines set against a paragraph about the practitioner, where he or she had trained

and how to buy the objects.[54] The types of craft represented ranged from hand-knitted sweaters and patchwork quilts to cutting-edge metalwork and sculptural ceramics. The works were catalogued according to discipline and function. Although many of the makers were graduates from the new art schools, in order to be included they had had to submit their work to a panel of master craftsmen for an assessment of their quality.[55] This overlap of rigorous discipline skills and the definition of crafts according to technique and function were part of an emerging internal debate about whether crafts should be an almost para-art activity that expressed individuality or remain true to its roots.

This came to the fore in 1982 when Michael Brennand-Wood both exhibited in and curated a Crafts Council touring exhibition entitled *Fabric and Form: New Textile Art from Britain.* The exhibition was reviewed in the November/December issue of *Crafts*, with Peter Fuller arguing that the exhibition was an example of 'the decadence of Council-subsidized fashions', which he considered had already played havoc with the nation's painting and sculpture.[56] He felt that this sort of work represented the breakdown of textile practice and the special skills and knowledge associated with it. Michael Brennand-Wood's reply was that skill and tradition had not been forgotten, but now textiles had a broader function. This was a rapidly developing discipline which no longer had to be represented by works that were tasteful, soft and flexible.[57] Like Audrey Walker, who also entered the debate, he felt that art schools taught the relevant techniques, as well as aesthetics, that acknowledged the material disciplines. Walker, who was head of the Embroidery and Textile department at Goldsmiths College, said that she frequently took the students to the Victoria and Albert Museum so that they could study pattern-making and the traditions of textiles, but that context and content were also crucial for makers of the era.[58]

Clearly the arguments that were articulated in *Crafts* over the next few issues underline the fact that there was a wide diversity of craft practice. It was by no means all urban centred with only around 12 per cent working in London, and over the next decade there was a significant shift of professionals away from the South East to the North West.[59] Also suggesting the diversity of practice are the statistics that, of full-time women crafts practitioners working in 1992, only 53 per cent of glassmakers, 64 per cent of ceramicists, 67 per cent of metal workers and 46 per cent of textile workers had a diploma or degree. A significant percentage of makers were entirely self-taught. The figures were similar for men.[60] The other tendency was that those who had not been through higher education were more focused on traditional skills and forms and less interested in the type of craft promoted by the Crafts Council. While 12 per cent of practitioners in 1992 thought that there was no difference between fine art and craft, more than 15 per cent strongly felt that craft should be rooted in its discipline traditions.[61]

There have been and continue to be substantial changes to the profile of those working in crafts in England. By the time of the report of 2002 more than 64 per cent

of makers had received degrees, with many more seeking formal training to develop their professional practice.[62] There were 32,000 professional makers practising in England and Wales. More than 50 per cent of makers regularly visited galleries and exhibitions and, although about a third lived in the South East, with 20 per cent in London, there were also significant pockets of rural makers, especially in the South West and near Bristol.[63] Although the crafts were again categorized by discipline in this report, toys and musical instruments were no longer included, whereas fashion accessories were added. These findings show not only that craft practice remained diverse in intention, but also that higher education was increasingly becoming the norm.

In America, there has also been a wide range of ideals underpinning craft practice. As well as the distinction between urban and rural practice, there have also been strong regional identities that have grown up and been supported by the regional groups of the American Craft Council. These reflect both the different profiles of the social groups of the makers, as well as the materials and climate of the areas. Some of those traditions can be traced back to the depression, when regional crafts were fostered as a means of alleviating poverty. However, the Arts and Crafts movement also celebrated differences in regional styles brought about by available materials and climate. Since the important exhibition *The Arts and Crafts Movement in America* at Princeton University in 1972, there has been an exponential rise in books and exhibitions on the subject. This has also been aided by the growth in regional museums. For example, in 1992 the Indianapolis Museum of Art opened new displays, one of which explored the previously overlooked contribution of the Arts and Crafts movement in the region.[64] This movement had also dominated a number of conferences in the previous year, including *Virtue in Design* in Wilmington, Delaware, and *Celebrating American Arts and Crafts* in Los Angeles. [65]

Collect, the international annual craft fair held in the Victoria and Albert Museum, is dedicated to promoting world class craft by encouraging individuals to collect objects. It includes examples of both innovative cutting edge practice and work that acknowledges tradition. What is recognized as a growing development is the willingness to work across the traditional discipline borders, while still retaining the interest in skill.[66] This is clearly also an important concern amongst American practitioners. While acknowledging that today's crafts have strong regional tendencies, Lloyd Herman has indicated that the freedom to cross material and technical boundaries is an important characteristic of contemporary craft.[67] In America, as in England, the boundaries between craft and art and craft and design have become permeable. There is also increased recognition that one of the functions of craft has always been display: with the incursions into the traditional territory of the 'fine' arts, content has become more apparent, but as with crafts in Northern Europe, the material and the way that it is manipulated and shaped has remained a crucial factor in the creation of meaning.[68]

AMERICAN AND ENGLISH CULTURAL IDENTITIES: GEOGRAPHY

One of the defining characteristics of craft is that it has always been part of the everyday. Even today's practitioners acknowledge its social, ritual or material roots, even if the works are not intended to be utilitarian. Traditionally, craft objects were made using the materials to hand, which determined the ways that they were formed. Contemporary crafts still frequently reference the environment, and this forms the basis of this book. What I want to do here is to consider how the roots of the cultural identities of America and England have been linked to the acculturation of the land.

In England, the countryside and cities have developed over millennia, with many ancient features still visible in the landscape today, including prehistoric and medieval field systems and Roman roads. These accretions of past histories that are so evident in the countryside are integral to the idea of Englishness. Most towns and cities have also developed from early settlements and have the remains of old centres, with shops and monumental civic and religious buildings. Many industrial cities in the Midlands and North grew enormously during the nineteenth century, and incorporated surrounding villages into their urban sprawl.[69] However, above this physical environment is the important psychological relationship with English landscapes, cities and country towns, which has been influenced by tourism, the arts and literature.

Although America developed its cultural ideas from those of the Old World, from 1776, when America declared its independence, there was a strong desire to forge an independent national identity and to reveal this in the arts.[70] There were large towns and farmed land in America prior to European settlement, but because the settlers perceived that they had a legitimate claim that superseded those who were already there, and because many, especially the Puritans in New England, arrived in enough numbers to be able to form self-contained societies, whole tracts of land and towns were developed from scratch in a manner that served their needs.[71]

There are two main forms of towns that have developed from settler times: those founded by the Puritans in New England and those developed out of the Quaker settlement of Philadelphia. Large New England towns developed early as the land was so poor, so that Manchester and Lowell, for instance, became manufacturing centres for textiles, guns, locks and machine tools.[72] Boston is one of the few towns in Massachusetts to have retained brick row houses. Further inland, individual wooden houses were built, set within large plots of land, and it is this individual, single-family, free-standing house that has set the pattern for the dream home throughout America.[73] William Penn laid out the plan of Philadelphia as a grid in 1682, which was both a flexible and apparently democratic system, and which therefore suited his Quaker ideals. This grid pattern became a model that was copied throughout America.[74] Unlike the open aspect of towns in New England, Philadelphia became

densely populated, and row houses were more frequently used both in this city and in outlying towns.

American cities and industrialization grew late in comparison to their European counterparts. It was not until the turn of the twentieth century that there were real and profound changes, with railroads connecting different parts of the country, automobiles crowding the cities, and an acceleration of life and a new social order created by industrial work patterns.[75] These cities came to represent America, with mechanization, speed and progress being symbols of the new and dynamic economy that was setting America apart from Europe. In 1914 Alfred Stieglitz likened New York to a giant soulless machine, and during the 1920s and 1930s many artists, such as Lynd Ward and Charles Sheeler, devoted their energies to depicting man-made structures like bridges, railways and new buildings.[76] Others showed images of city experiences, from the scenes of people enjoying popular culture by Reginald Marsh to the huge murals of men working in factories by Diego Rivera from the 1930s.

With an average of 378 people per square kilometre squashed into England's land mass of 130,410 square kilometres, as opposed to America's 33 people per kilometre with a land mass two and a half times the size of the European Union, the two countries have very different perceptions of space.[77] Most people in England inhabit a small, carefully demarcated segment of property, ideally with a small outside garden. Most people live in towns and cities, and many of those living in villages are people who have escaped city life and want to experience the 'authenticity' of living in the country.[78] Consequently, public spaces, parks and the network of public footpaths that cross fields, go along coast lines and follow ridges and valleys are treasured. This public access to the countryside and the idea that farmers not only produce food but are stewards of the land is deeply embedded. One of the immediate results of this is that the English expect the landscape to be manipulated and shaped. As well as the obvious crafts of dry stone walling, hedge laying and tree management, there is a long history of furnishing the parks of stately homes with art and architectural features. The English Land Artists of today place their work into parks and reflect these aspects of husbandry and constructed landscape.

There is less of a palimpsest evident in rural America, and although there are parks devoted to historical figures, with heritage architecture preserved, the diversity and richness of stately homes and gardens with sculpture and follies is not as concentrated or as embedded as in England.[79] In the more democratic area of husbandry, again the newness of settler habits means that although some changes are visible, much remains of the initial European plans. In some cases nature has reclaimed the land. The Berkshire Mountains in New England, for instance, which in pioneer times were quite heavily populated, have the remains of dry stone walls, early farmhouses and small graveyards that have been largely obliterated by secondary forestation. Because there is not the network of ancient rights of way and because of the distinctive, non-European qualities of American scenery, the various walking trails and national parks in America celebrate their apparently natural state.

ACCULTURATION OF THE LAND

Viewing the land as a place of pleasure has been part of English consciousness since the Romantic sensibility was awakened in the eighteenth century. This was not only fostered by artists like Turner and Constable, who painted awe-inspiring stormy images of the countryside or harmonious scenes that included picturesque rural characters, but also in travel guides like those by William Gilpin who wrote for the new middle-class tourists. In these guides, he discussed the countryside not as a place of work but as a place to be viewed artistically, with rural cottages, worn-out horses or twisted trees as picturesque embellishments.[80] However, the greatest pleasure was to be found when a scene took one beyond words so that it was felt more than surveyed.[81] From about 1750, the valorization of the countryside was promoted by magazines such as *The Gentleman's Magazine,* which encouraged readers to write in with their experiences of visiting different areas of England.[82]

An affinity with nature was also promoted in the writings of William Wordsworth, William Hazlitt, John Ruskin and William Lethaby, among others. In Wordsworth's *Guide to the Lakes*, his stated wish was to 'furnish a Guide or Companion for the Minds of Persons of Taste and Feeling for the landscape'.[83] Showing an obvious love and knowledge of the area, he suggested walks, explained how to seek out views and provided commentaries about nature, landscape and gardening. Although he fought hard against roads and railways encroaching upon the wildness and solitude of the area, none the less the nature he discussed was one that had been shaped by man and was experienced through walking. Hazlitt also chose the solitary walk as his vehicle to deepen his love of nature. For him, nature was company enough, with every object presenting itself as an old friend.[84] However, this increased importance of feeling for the land was not just about leisure activity, but was also an essential element in the forging of a unified national identity.[85]

Ralph Waldo Emerson realized that his generation represented a defining age in America, which needed to break free of its religious burden. In 1827 he declared that this new age was one of introspection, of transcendentalism and metaphysics.[86] By 1828, he had read Hazlitt's *The Spirit of the Age,* had become acquainted with the writings of Wordsworth and Coleridge and, like the writer Henry David Thoreau, thought that these writers were pure emanations of the modern spirit.[87] They both responded with enthusiasm to the English Romantics' concern with spiritual growth, and their idea that nature was a mirror to the soul.[88] In *Nature* of 1836, Emerson discussed the importance of solitude, and how the lover of nature adjusts his inward and outward senses to gain an almost childlike understanding of it.[89] However, Emerson's small volume was also overlaid with the idea that this self-cultivation would also lead to a greater understanding of the nature of God.[90] Just as Ruskin was later to write, nature itself is a guide to an ethical life and is the fundamental context of our lives. 'Nature is a discipline of the understanding in intellectual truths'.[91] Like Emerson, Thoreau's inspiration came from his walks

around Boston and Concord. In *Walden* of 1854, Thoreau chronicled his simple life at Walden Pond outside Concord, Massachusetts. Although within walking distance of Concord and not far from Boston, he considered it a place of purity where the beholder could measure the depth of his own nature.[92] It was the direct experience of nature that was important, and by living close to nature he could, like Emerson, critique society and materialism.

The real appreciation of American landscape as being culturally significant did not develop until the 1820s and 1830s when tourism began to become established. With the development of a new wealthy middle class, reliable transportation, independence and stability, visiting and admiring the natural wonders became a way of uniting the disparate groups in America.[93] Among these diverse groups were many different religious sects who had found a place where they could live out their beliefs. Whereas the land had initially only been viewed as somewhere that could be utilized, it now began to be interpreted within all of these groups as uniting God with nature.[94] Not only was it God's gift to a chosen people, but it was part of a group destiny, 'one nation under God'.[95] It is these uplifting and moral aspects that became translated into so much landscape painting of the nineteenth century, as in works by Frederic Church or Albert Bierstadt.

Unlike the Romantic paintings by Turner, where light dissolves the solid earth into a wash of atmospheric haze, the landscape paintings by nineteenth-century American artists, who wanted to portray not only the landscape but also the spiritual awe that the scene produced, were filled with detail. In small-scale Luminist paintings, like those by Fitz Hugh Lane and Martin Johnson Heade, which were quiet evocations of emptiness and wonder, as well as in the fully sublime, large-scale and dramatic works like those of Thomas Cole or Frederic Church, the images drew the audience in through simultaneously suggesting intimacy and distance.[96] Although these paintings drew on European romantic traditions, the imagery set the continent apart. Not only did Europe have nothing like the Grand Canyon or Niagara Falls but, for artists like Bierstadt who travelled to the Midwest and beyond, there was the spectacle of hoards of bison stretching across the plains, wolves and bears hunting in the open and also Native Americans living as they had for millennia. When European-Americans discovered the Yosemite Valley in the 1850s they extolled it as a natural cathedral, so, although America did not have the man-made religious monuments of Europe, it could boast of natural, dramatic phenomena that inspired awe and religious feelings.[97]

Other scenic areas, such as Niagara Falls and the rugged Connecticut and Hudson River valleys, also became popular destinations for tourists.[98] Thomas Cole, who painted many scenes of these areas, declared in 1835 that 'the most distinctive, and perhaps the most impressive, characteristic of American scenery is its wilderness'.[99] This is echoed today on the home page of the National Park Service which, alongside images of forest foliage and vast dramatic mountains has a caption that states, 'Experience your America'. Clearly the advertised vast, empty and open spaces still

resonate as an important factor for Americans: in 2006, 272,623,980 leisure tourists visited the parks.[100]

I have spent some time discussing the cultural roots as embedded in their physical environments in order to lay the basis for many ideas that are relevant today. Emerson's natural aesthetic can be traced to the present in America through the diverse cultural works of Horatio Greenough, Frederic Church, Frank Lloyd Wright, Edward Weston and John Cage.[101] In today's work they have become intermingled with the regional practices of Native Americans and other ethnic groups. In England, there is also an important lineage that comes from the Romantics like Turner and Wordsworth, through to Samuel Palmer, Barbara Hepworth, the Neo-Romantics and up to contemporary land artists like Andy Goldsworthy and Richard Long. Between the wars, for instance, Paul Nash, John Piper and Graham Sutherland felt, like Wordsworth, that nature and the affinity to certain places was revealed in art through having been filtered through their sensibilities. They felt that nature provided a touchstone for the validity of their work.[102] Contemporary Land Artists like Goldsworthy, Long and David Nash and crafts makers like Jim Partridge also have this strongly intuitive sensitivity to place and material that becomes embodied in their works. However, what is also important is that, like the ideas underpinning the Arts and Crafts movement, the way that the land is viewed is fundamentally urban. The diversity of populations within the cities has made a large difference to the perceptions of the urban and rural environments.

2 CONTEMPORARY ARTS AND CRAFTS MAKERS IN RURAL ENGLAND

This chapter will discuss crafts made in the countryside that express a continuation of ideas and styles that link back to the Arts and Crafts movement. Many of these ideas emerged from William Morris's desire to change the capitalist system which he felt was destroying the humanity in working people. His was a romantic vision that integrated life and art, and he had an urban viewpoint of the countryside. However, these ideals continue and it is their relevance today that will be considered.

H.V. Morton's famous book *In Search of England*, written in 1927 and still in print, describes a car journey around England through which the author hoped to discover the 'soul' of England. This idea was prompted while abroad where, feeling homesick, he conjured up an image of the country. It was a 'village street at dusk with a smell of wood smoke lying in the still air and, here and there, little red blinds shining in the dusk under the thatch'.[1] During his travels, and within a few pages of the beginning of his book, Morton was visiting 'the last bowl turner in England', who had 'craftsman's hands', and was happy in the work that he had learned from his father, who in turn had learned the trade from *his* father. Using tools that could be dated back to the dawn of man, this craftsman was described as being the last vestige of a once common way of life.[2] Morton's trip took him around England, but it was in the countryside, with the accretion of knowledge of the land and related crafts, where Morton expected to discover the 'authentic' England that dated back through the millennia.

Of course, Morton was writing within a context. His romantic idyll has its roots in the eighteenth century when the perception of the countryside, by the middle and upper classes, moved from being an area of crops and potential profit to somewhere that could excite feeling. As England became increasingly urbanized in the nineteenth century the countryside became an area in which city dwellers spent leisure time, and that the rural poor left in search of a better life in the city. The demographic shift of retirees and commuters going to live in the country that has

occurred over the last century continues to belie the myth of eternal values that Morton and many writers of the twentieth century have explored.[3]

This idyll and the faith in the values of country people that Morton discussed were also part of a broader dialogue that emerged from the Arts and Crafts movement. William Morris's works of fiction like *News from Nowhere* supported his utopian, socialist dream, and described a life where people used simple utensils, wore simple attire, had a purpose and were happy and healthy pursuing a life in the country. One of the essential ingredients was the socialist ideal of a working fellowship, initiated by Ruskin and developed by Morris, where people could move away from the 'every-man-for-himself' principle of labour, towards small self-supporting communities.[4] Morris believed that there were only two courses of action available to contemporary England: to accept the pretence of the prevalent art that he linked to commercialization and advertising, or to struggle to create an art that would 'pervade our lives and make them happier'.[5] As part of his desire to change the capitalist system, he felt that all men should be masters of their machines, should be free in their work and produce wares that were suitable for themselves and their neighbours.[6] Just as 'nature makes pleasant the exercise of the necessary functions of sentient beings', so creating functional wares that are beautiful is part of the 'serious business of life'.[7] An essential aspect of Morris's socialist vision was the harmony between life and art.

William Lethaby, one of Morris's friends and a central promoter of Arts and Crafts ideals, integrated this growth of the complete human being with closeness to nature. He decried the educational system that had divorced man from customs, traditions, crafts and making.[8] Indeed, he praised the architect Philip Webb, who he saw as really understanding and promoting the practical aspects of building – 'architecture with all the whims which we usually call "design" left out'.[9] What he meant by this was that builders who understood the materials that they were working with, and made their decisions according to need and local traditions, were more fulfilled as human beings, and made their buildings appear to grow harmoniously from the soil. Webb and Morris had founded the Society for the Protection of Ancient Buildings in the early 1880s and Gimson, Lethaby, Morris and many other of this close knit architectural circle met in London and exchanged ideas.[10] While advocating respect for the countryside and the traditions of making, it should be remembered that these were essentially educated urban dwellers looking at those ideas from the outside.

Morton's description of the last bowl turner in England was simplistic, for although many traditional artisans had given up their trades, from the late nineteenth century this new generation of idealists was becoming interested in traditional crafts. Ernest Gimson, for instance, found an elderly chair-maker called Philip Clissett, who taught him the trade of making tall-backed, rush-seated chairs.[11] He joined forces with the brothers Sidney and Ernest Barnsley and all three left London and Birmingham for the Cotswolds in order to pursue a simpler life making furniture and other domestic items. At the time this was subversive. Not only did these incomers turn

their back on the capitalist ideals that underpinned industrial production, but they were middle-class, professional people who were pursuing trades that traditionally belonged to the artisan classes. In addition, the objects themselves were frequently simple and unadorned, and so were without the associations of contemporary commercial value.

The migrants to the countryside, including Gimson and the Barnsleys, Alfred Powell, Eric Gill and C.R. Ashbee (who brought a colony of London craftsmen to live and work at Chipping Campden in the Cotswolds), had a curious social status that was neither the same as artisan craftsmen nor did they have the outlook of the traditional middle classes.[12] Their desire was to see a sound revival in good handicrafts and building in the English country, and to pass it down to the next generation. Architecture and building, which were Gimson's central passions were, he felt, the sane dealing with the beauty of the earth, and were best understood through traditions that had been established over the millennia.[13]

Morris, and later Eric Gill, believed that if people bought less but were willing to pay the real cost of honest labour, then all could live in conditions that were decent and fair and could work in harmony with nature.[14] In Gill's many essays he espoused anti-industrial ideals, paraphrasing Lethaby when he wrote that 'art is the well-making of what is needed' and that a maker of a teapot contributes to a good life.[15] Part of being human, he wrote, was making a mark, not in pursuit of riches but for the enrichment of the soul.[16] Like Morris and Lethaby, he linked this impulse to 'nature' which he felt interpenetrated everything.[17] It was through the evidence of making work with care and using good quality materials that it was felt that simple and apparently rustic forms would gain cultural value.

CHANGES OF THE 1970S AND THE MOVE TO THE COUNTRY

The ideals of uniting life and art, and living a simple life in the country continued to be a significant inspiration for makers throughout the twentieth century. However, with the formation of the Crafts Advisory Committee in 1971, which gave grants to individuals, held and supported exhibitions and, in 1973, started a magazine entitled *Crafts*, there was a marked increase in crafts being made in the regions.[18] The grants that were bestowed by the CAC were popular. Some were large bursaries of £2,000, which were awarded to established practitioners to enable them to reassess what they were doing and where they wanted to go.[19] The smaller grants were more widespread, and a glance through issues of *Crafts* from the 1970s reveals how many people were able to leave what they had been doing in town and move to the country to set up their own small businesses. These had a real impact on the local economies as well as the burgeoning crafts communities. In 1980 for instance, the Guild of Yorkshire Craftsmen saw its membership grow from 20 to 200 in the space of

eighteen months.[20] Other regional centres were also being formed or strengthened. The Guild of Northumbrian Craftsmen started in 1976, and in Gateshead the Shipley Art Gallery was building up a permanent collection of contemporary crafts that they wanted to be the best in Britain.[21]

Crafts continued the myths established by Arts and Crafts intellectuals through depicting those who had moved to the country as having a desirable way of life.[22] The articles tended to be about lifestyle and the economics of craft, and included deeply shadowed and evocative photographs of the craftsmen at their work. Paul Caton, a bowl-maker, was shown in his workshop surrounded by his traditional tools and materials, with his dog in the background. Another showed him outside with a wooden bowl and partially sawn trees, representing the beginning and end of the process.[23] Another maker shown in *Crafts*, Anthony Horrocks, articulated the common theme that people were tired of the uniformity of machine-made objects, and felt swamped by the flood of objects. Echoing the ideas of William Morris, he thought that a return to cottage industries would solve many of the country's problems.[24] Both were articulating the appeal of an uncomplicated life through making objects well using traditional techniques.

In 1984 Peter Dormer reaffirmed these ideas with his belief that crafts were essentially conservative, were related to a way of life and provided solace.[25] He was concerned that the new styles of 'craft' being practised by those emerging from art schools placed too much emphasis on ideas, rather than retaining the traditional values of discipline skills and the commitment required in the processes of making objects.[26] Reflecting the ideas of Caton and Horrocks, he wrote that makers of traditional crafts were frequently people who were disaffected by the low standards of industrial ware, and wanted to live in a manner that allowed them independence, time for their family and friends, and dignity in work. These values were different from those being advocated in contemporary art movements at the time which, although confronting issues of consumption and the everyday, were urban in outlook and did not attempt to unite making and life in a continuum.[27]

As well as giving a voice to those who had made the choice to live and make in the country, *Crafts* magazine also published articles that were critical of the underlying ethos. Christopher Frayling and Helen Sowden wrote that the craft revival of the 1970s was based on a particular reading of the English countryside, citing the partiality and nostalgia evinced by Raymond Williams in his seminal book, *The City and the Country*, for a bygone age in the country.[28] They also felt that the media was adding to this nostalgia through, for example, Hovis advertisements, which suggested the trustworthy artisan working in an organic community.[29]

However, this interpretation of the situation, while right in itself, now appears a little simplistic. The move to the country to make crafts in the 1970s had more complex social underpinnings than the similar movement earlier in the century.[30] One of the reasons for the growth was the Feminist movement. Art schools and the art market tended to be male dominated, whereas the crafts had always been more

inclusive. The Green movement also had an influence, often being expressed as anti-industrial and therefore anti-product design.[31] Jonathan Porritt saw some of this as a fashion. Whereas in the 1960s everything had been about the space age and plastic, in the 1970s everyone wanted to live like Italian peasants as 'peasants were close to "real" things'.[32] Habitat, among other shops, catered for this trend by selling Italian peasant floor tiles, crocks, and goods made from earthenware or pine.[33]

Another social pressure was an increased emphasis on self-development and fulfilment by the middle classes. Traditionally the middle classes have been what has been termed 'outer-directeds', or those looking for financial success and social standing.[34] During the 1970s there was a great increase in 'inner-directeds', or those believing in personal development and autonomy, who also opted for a low consumption lifestyle.[35] Those who became craft makers for these reasons did not necessarily go through art school, but gained the requisite knowledge gradually through learning the craft as they worked or being apprenticed to other makers.

What the practitioners of traditional rural crafts still place an emphasis on is the combination of discipline skills, traditional forms and a particular lifestyle. Indeed, many makers today continue with the living tradition of ideas and forms based on those of followers of the Arts and Crafts Movement. Morris's ideas are still being debated as relevant, or indeed imperative, as a model for survival today.[36]

ARTS AND CRAFTS SURVIVAL – WINCHCOMBE POTTERY

Winchcombe Pottery, situated on the edge of the Cotswolds, is one of many small potteries, like John Leach's Muchelney Pottery in Somerset, that continue with the Arts and Crafts principles of truth and beauty, simplicity of life and work, and a link back to indigenous village wares. The original Winchcombe Pottery survived Victorian industrialization, closed during the First World War, but after reopening in 1926 retained something of its previous existence under the leadership of Michael Cardew and later Ray Finch. The opening of these enterprises ran counter to the trend of closure of small artisan potteries. Whereas in 1900 around 100 small pre-industrial potteries existed, by the end of the depression there were only about a dozen, and by the 1970s there were just a handful remaining.[37] Some, including Winchcombe Pottery, had survived the competition from industrially produced domestic ware in the nineteenth century through changing what they made to cater for prevailing fashions, or to suit new agricultural or gardening needs.[38] These potters would have seen themselves as low-grade craftsmen, who were making pots out of necessity.[39] However, Michael Cardew, who took over the pottery in 1926, was well educated and had spent a few years learning the craft from Bernard Leach, had made a choice to continue with a lifestyle that was being played out in different country locations by followers of the Arts and Crafts movement.

The ethos of the pottery still reveals the influences of the East and West that were promoted through the writings of Bernard Leach. At the beginning of *The Potters Book*, Leach articulated the problem, as he saw it, for pottery in England. Industrialization had eradicated traditional folk art, so that those forms and the material understanding that had arisen out of making had been lost. Although mass production did not in itself create bad forms, Leach argued that 'machine crafts, even at their best, are activated at one remove – by the intellect'.[40] This removal from direct human involvement and the impulse of competitive commerce had lowered the general standards of taste. As examples of the world's best pottery, he discussed those from the T'ang and Sung periods of China or the early Japanese tea-master wares, which were special because they were the result of a completely unified human expression.[41] He urged studio potters to look at Sung ware, as it combined the best quality natural materials with forms that strove for unity, spontaneity and simplicity.[42]

These ideas from the East overlap with those of Morris, who promoted the aesthetic of honest, well-made crafts. He felt that the user of a vessel would gain pleasure through the recognition of the hand of the maker that had been guided by a happy and healthy brain.[43] This notion of making using intelligent hands was an important feature of Arts and Crafts philosophy, with the nuances of individual work appealing to the emotions and intellect through the senses. 'All the greater arts appeal directly to that intricate combination of intuitive perceptions, feelings, experience and memory which is called imagination'.[44]

This way of expressing the human was felt by all of those connected with the Arts and Crafts movement to be found in village wares rather than the then popular, industrially produced products. Cardew was later to write that all of his pots were very rustic and country, which he associated with materials as well as with particular styles.[45] The hand-thrown wares from Winchcombe still use the traditional techniques, and their very simplicity ensures that the potter has complete control over every step, from rude clay to finished cup (Figure 2.1).

The main decorative feature is the contrast of the brown or biscuit glaze against the stoneware body. Small niceties linked to use have been incorporated: the glaze at the top of the handle of a cup or mug at just the point where the thumb appreciates the smoothness, the gentle outward turn of the lip that fits the drinking mouth, and the scale and outward shape of the mug that allows for the vessel to fit comfortably in the hand.

Until the change to stoneware after the war, the clay was dug from a neighbouring field, and the brushwood for the kiln fires was collected from the nearby hills, as it had been for centuries. It is this material link with place that was always quintessential to village pottery. However, rather than directly linking to local stylistic traditions, the standard ware that Cardew designed, and which is still made today, was based on the North Devon forms that he remembered from his childhood.[46] What he aimed to produce were pots for everyday use by middle-class people like himself, at a price

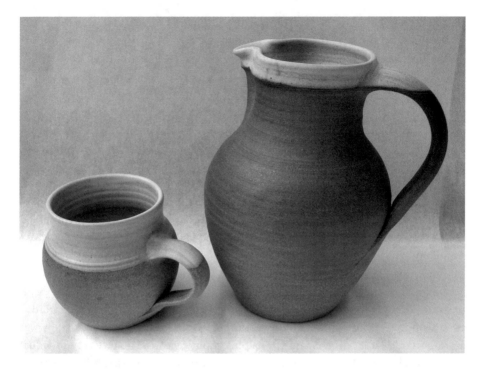

2.1 Winchcombe Pottery: Mike Finch, *Mug and jug*, wood fired stoneware, glazed inside only. Photograph by Mike Finch.

which meant that they would not be too worried if they got broken.[47] So, while the forms suggested an 'authentic' voice of everyday wares that would have been consumed by local populations, actually the objects were born from a more general understanding of tradition, and were designed to appeal to an outsiders' myth.

Ray Finch, when he joined the team in 1936, was apprenticed and learned all the stages of potting through doing and becoming integrated into the local community.[48] Like Cardew, he chose this lifestyle, in his case having read Eric Gill and G.K. Chesterton, who both advocated living and working in harmony with nature. Finch shared their loathing of industrialization and believed in the humanity of small workshops.[49]

The workshop continues to operate as it was run then. Theoretically, every member of the team still makes all the wares and has a hand in all of the procedures. In reality, some make more than others, while others are in charge of the kilns.[50] Although all make the standard ware, and each piece is made using a set weight of clay, height and form, there are variations that distinguish one maker from another. It is here that the individuality important to expression, discussed by Morris and more recently Dormer and Pye, is realized. Ray Finch is a dry maker. David Wilson makes the lid shelf in a different manner to the rest of the team. Different members of the workshop tend to make slightly different shapes. Ray Finch's cups, for in-

stance, are more elegantly upright than Eddie Hopkins's Devon-inspired plump forms. Each maker attaches handles in a slightly different way.[51] As Peter Dormer has commented, thinking resides not so much in the language used, but in the physical processes involved in handling the material.[52]

Cardew wrote that repetition throwing is a great means of self-expression. The physical aspect of repeating movements and concentrating for a long time means that conscious effort becomes effortless and creativity gets a chance to begin.[53] Many others have also commented on this shift towards a free flow between mind and body. Mick Casson, an eminent potter from this same tradition, wrote that potting changes the person through the quiet involvement in a particular but narrow range of skills.[54] Another potter, Daniel Rhodes wrote how the meditative quality of making meant that anxieties are forgotten and that the work becomes a natural expression of the self, 'an unforced, unselfconscious, genuine flow of person to pot'.[55]

These ideas link with those of Maurice Merleau-Ponty, who has argued that the body is the focus of understanding the world. Repeated touch and the habits of particular movements are understood by the brain as patterns performed in relation to particular tasks.[56] For familiar tasks, like sewing, we do not need to look at our hands as they are part of the internal threads that link the sewer and the object. It is the phenomenal body rather than the objective body that we move, and it is in those repeated movements, as in throwing pots, that the body and mind can flow together.[57] As Lethaby wrote, 'art is the humanity put into workmanship'.[58] However, rather than just being an instinctive practice, as Dormer and many makers have commented, this tacit knowledge has a severe morality, where every action shows that we are what we know, and also how much we care. Linking this back to the Arts and Crafts Movement, Dormer wrote that 'fundamental precepts such as honesty and integrity in work as well as 'truth to materials' are expressions of the morality of practice'.[59]

It is also through the rhythm of the week at Winchcombe that the Arts and Crafts ideals of art and life coming together are performed. Every day is different. Monday is the beginning of the working week which, depending on what is required and whether one chooses to throw larger or smaller vessels, will set the pattern for the next few days. On a throwing day the first task will be the weighing and wedging of the clay, after which a few dozen pots will be thrown and the handles will be attached on Tuesday. Wednesday and Thursday will again be for making, and on Friday all the pieces will be left to harden. Glazes will be mixed and applied and the main kiln fired up about once a month, after which the process will start again. On the day that I visited, everyone stopped for lunch and ate outside.

HART GOLD AND SILVERSMITHS

Hart Gold and Silversmiths of Chipping Camden also have their roots in the Arts and Crafts movement. They still work in the same building that was used by

C.R. Ashbee when he transferred his London-based Guild of Handicrafts to the town in 1902. The original workers included jewellers, silversmiths, enamellers, printers, modellers, blacksmiths, cabinetmakers, polishers and gilders, who were following the socialist dream of pursuing a rural idyll that interwove good crafts-manship and husbandry in their lives.[60] The original generation included George Hart who ran the workshop from 1908, and, although the guild closed as a limited company in that year, he was one of a number who decided to remain in the region and continue to make their crafts.[61] Today, the Old Silk Mill still houses a busy co-operative of craft makers working across different material disciplines and styles.

Many of the objects made today are to the same designs that Ashbee's craftsmen made at the beginning of the century. Hart has a full order book with commis-sions from all over the world, but this international interest has been there since the workshop started. Virtually every page of the visitor's book has someone who has come from abroad, like Frank Lloyd Wright who visited in 1910.[62] People commission objects from cutlery to decanters and sauce boats, and sometimes specify slight changes in the designs. Since 1988, the centenary of Ashbee's birth, there has been a growth in interest in his tableware, which was the largest area of production early in the century (Figure 2.2).[63] Like the original tableware, these objects have ornament concentrated in particular areas with other parts left plain. Unlike machined wares, which have a highly polished, smooth finish, the objects made today, as originally, keep the soft sheen of the planishing hammer which, like the pots from Winchcombe Pottery, make evident the Ruskinian emphasis on the hand of the maker.[64] The forms also vary slightly from object to object, which again suggests Ruskin's and Morris's ideas about individuality. Using similar tools and techniques to those that have been used for hundreds of years, the skills have been handed down from father to son, and currently there are three members of the family working there with the fourth member having served his apprenticeship under David Hart.

However, there are differences between Winchcombe and Hart owing to the differing materials and more complex processes involved in creating works in metal. Unlike clay, silver and gold are expensive, and some of the parts would take many hours to make. Consequently, rather than one maker being in complete control of the object from sheet to finished decanter, there is a network of other small manufact-urers who supply particular components, such as the spoon handles and decanter tops which are cast in Sheffield. The glass for the decanters is blown at a small studio called LoCo Glass in the Brewery Arts Centre in Cirencester.[65] However, this is how the original practice would have been when James Powell and Sons of Whitefriars made the glass for the decanters, and some of the designs in the catalogue of 1905 showed items that had been stamped.[66] The market, then as now, is important and, like the wares produced at Winchcombe, the ideal is not to provide items just for a wealthy elite.

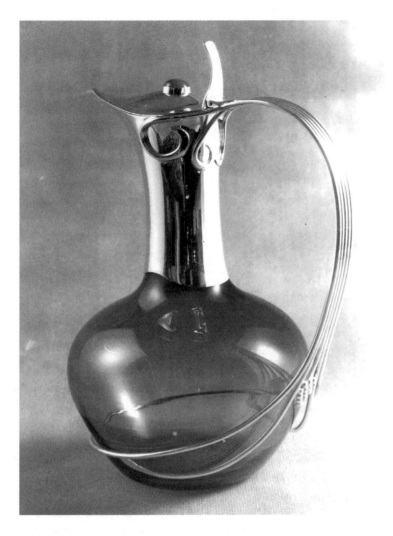

2.2 Hart, *Silver Decanter*. Photograph: www.hartsilversmiths.co.uk.

Some of the other metal components are made by the local blacksmith Jeff Humpage, who learned his trade from the master blacksmith Alan Knight, and works in a small workshop in a nearby village. All of his wrought-iron objects are made by hand in the traditional manner. Like most craft makers, his is a pragmatic vision, where he has some items that are his 'bread and butter', such as his domestic fowl hut movers and curtain rails with attractive endings, as well as other items that are more involved and costly.[67] These latter works, like his trivets or lighting pieces, reveal a link to Ashbee's style and methods. Although hammering hot metal involves less direct contact of hand to material, the individual marks and nuances still ensure that even simple designs are different from what which would be available from a

shop. Like the makers at Hart and Winchcombe, Humpage is in control of all of the factors involved. However, because he does not have a standard ware that sells readily, each commissioned item has different technical problems, which he enjoys solving.

In spite of the material differences, all three groups have retained the Arts and Crafts link with the land. Ashbee had a farm, David Hart's father had a smallholding and his brother has a farm that David helps with, as well as having a vegetable plot and bee hives.[68] Jeff Humpage has been affiliated with the Worcestershire Wildlife Trust and makes objects for the Domestic Fowl Trust. So, although their actual craft materials are not directly linked with nature, their lives, work and rural environment are interconnected.

FURNITURE

Lawrence Neal, a chair-maker in Warwickshire has retained the material link with his surrounding environment in his rush seats. His chairs are made to, or are inspired by, the original designs of Ernest Gimson, in a tradition that has been passed down from Gimson, to his apprentice Edward Gardiner, to Lawrence Neal's father Neville Neal, and to the present working studio (Figure 2.3).[69]

Neal is in control of all the factors, from the gathering and preparation of the reeds from local rivers, to the acquisition of traditional timbers from managed resources, and through all the processes of making and finishing the chair. Not only is the rhythm of life and making intimately linked with the natural life cycles of nature, but the skills and styles are evolving slowly.

Gimson's ideal was of well-made and designed items that were simple, and used wood in a logical and sympathetic manner. He learned to make the rush-seated chairs from a traditional village artisan. However, for the larger pieces of furniture, the basics of the Cotswold style of plain surfaces, clean lines and chamfered edges were inspired by agricultural implements rather than traditional furniture and were developed by Sidney Barnsley during the 1890s.[70] Many of the more elaborate designs were based on seventeenth- and eighteenth-century English and Dutch furniture that they saw in houses and museums. However, some were also developed from designs from further afield. One of their recurrent works was a cabinet on a stand with many pigeon-holes, drawers and cupboards, which was derived from Spanish and Portuguese prototypes of the sixteenth and seventeenth centuries.[71] So, although there was a relation to place in the use of local materials and the link with country styles, not all of the furniture produced had English roots. Like Morris, who studied diverse designs in the South Kensington Museum, or Bernard Leach, who looked to the Far East for inspiration, what has become known as English design is culturally very complex.

Sidney Barnsley's son, Edward Barnsley, continued with their styles and ideas, as well as those of William Morris, until his death in 1987.[72] He made a broad

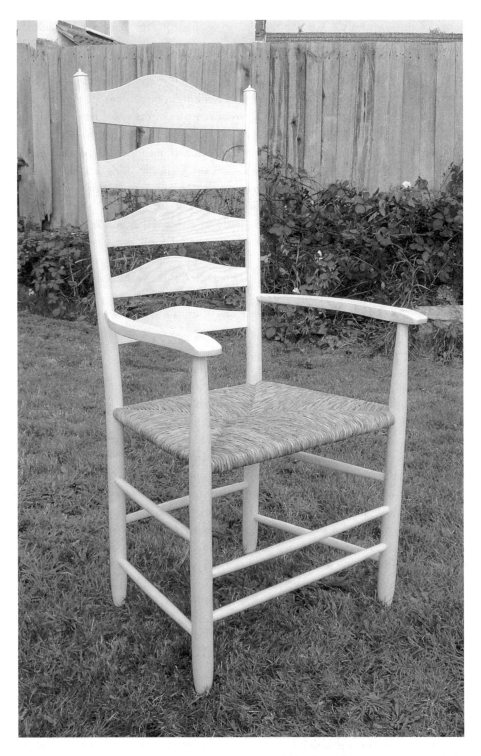

2.3 Lawrence Neal, *Gimson no. 3*, Ash, 46 in. × 21 in., 2004. Photograph by Lawrence Neal.

range of furniture in the Cotswold style, using high quality woods and detailing. Originally Barnsley made every element by hand, but the costs of the materials and processes forced him to do more and more by machine.[73] The furniture-maker William Hall, who has a workshop adjoining the Winchcombe Pottery, continues the tradition of Cotswold furniture alongside fulfilling commissions for film sets. He grew up in the area and this style has always been part of his visual landscape.[74] In his range, he includes ladder-backed chairs, simple tables and a chamfered chest, all of which reveal the joints with the construction adhering to the grain of the wood. Like Edward Barnsley, he also makes much of the furniture using machinery as it is simply uneconomic and 'self indulgent' to do the preparatory work by hand.[75] However, some furniture-makers still make every element by hand. Nigel Griffiths in Derbyshire, for instance, learned his trade from his father and makes fine oak furniture using quartered oak for the expressive grain. Every aspect of his country style, traditional tables and chairs, from the dovetails to the finishing, are made using hand tools.[76] However, what this also means is that there is the same conundrum that Morris faced. While clearly making furniture that will last for generations, the initial cost takes this furniture out of the reach of most people.

BASKET-MAKING

Clearly some crafts are expensive to produce in terms of cost of raw materials, time and machinery. Baskets are not, however, and there has been a general revival in both cutting-edge and traditional work for domestic and garden use.[77] Some makers produce handmade baskets for companies like P.H. Coate and Son, who have been making functional wares and growing willow in Somerset since the nineteenth century.[78] However, many are individual makers who grow willow and make baskets and outdoor sculptures, buoyed up by increased interest and the grants, exhibitions, courses and network provided by the Basketmakers Association.[79]

David Drew has been living on the Somerset levels, which has a strong willow tradition, since 1974, when he changed his occupation from engineering to basket-making. Like many, he learned the basics from an established maker, bought in the willow and then practised by himself until he felt confident in his skills.[80] He then moved into a derelict farmhouse with some land attached, which allowed him to grow his own willow, as well as vegetables. For his baskets he also collects other natural and local materials, including hazel, chestnut, oak, ash, buckthorn, straw and bramble.[81] His link to place through materials and tradition is important. Like the followers of Arts and Crafts ideas, he combines a simple lifestyle with his work.[82] As argued by Morris, because he is control of all of the factors of his craft, the necessities of making and growing create a rhythm to life. Short cuttings are planted in spring. The year's growth is cut in late autumn after which, depending on how the material is to be used, it is dried or stood in running water for a few months, then stripped.[83] Like the materials of wood and clay, coppiced willow is of the earth. In

all three, the handling of the material provides that direct link with the eternal values of the natural. However, whereas Winchcombe now buys in their materials, and fine furniture nearly always requires wood to be sourced from elsewhere, the speed of the growth of willow means that Drew and other basket-makers manage to maintain that direct link to the soil and seasonal rhythms through growing what they use.

Drew, like many craft makers has had apprentices who have been vital in enlarging the circle of those wanting to make in the traditional manner. Jenny Crisp, for instance, learned basket-making and willow growing from him in the 1980s.[84] Like Drew, she is involved in the process of making baskets from the first act of planting to the finished product. However, in keeping with the reality of many contemporary craft practitioners, she has also enlarged the range of her work. As well as making traditional baskets, cooling and picnic trays, she also creates live willow projects like fences, barriers and ornaments (Figure 2.4).

Crisp grows rare types of willow both for her own use and for others. In addition, she takes on commissions, holds courses and conducts demonstrations. However, unlike many practitioners who are discussed elsewhere in the book, she is not concerned with expanding her business. The important element for her, as with many others discussed in this chapter, is the lack of division between art and life. Echoing the ideas of Morris, Gill and Dormer, she wants to make objects with care that will then be used and appreciated by the purchaser.[85]

Clearly the Internet is vital. Potential customers can go online, see the objects within their context, read the details and understand how and where they are made.

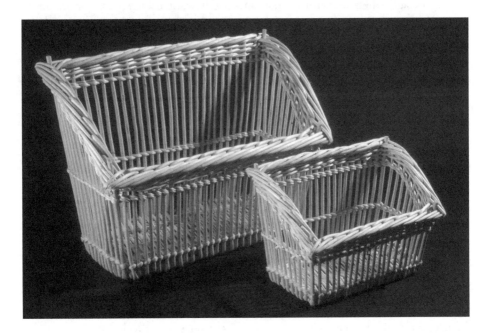

2.4 Jenny Crisp, *Fitched magazine and letter racks*, stripped willow. Photograph by John Cols.

Although other baskets can be purchased for less money, there is an authenticity that underpins these works. Like the photographs in *Crafts* from the 1970s, which were discussed earlier in the chapter, the lifestyle, process and materials are evident on the website, and it is the potent framing of the works within this context that links back to the ancient triumvirate of author/object/meaning.[86]

In spite of the fact that so many of the objects discussed in this chapter could be made cheaper by machine, there is a market for handmade and simple objects. In our post-industrial age, the advances in the Internet, the mobility of society and the growth in the heritage industry have all contributed to enlarging the available market. No longer can living in the country and making functional items be considered subversive, but a manifestation of the plurality of society aided by the ease of communication. City dwellers can instantly access images of willow shopping baskets, and at the click of a button can order handmade linen tea towels, or commission a rush chair from a pattern by Ernest Gimson, all made in traditional ways by practitioners living in deepest Herefordshire or Warwickshire. They can go out for the day, visit a workshop or a National Trust property, buy a hand-woven blanket or a domestic fowl hut mover and then return home. The growth in these possibilities has made these buying choices an extension of leisure pursuits, and the vicarious consumption of time and the authentic experience.

MARKET

So, in an age when everything that one could want or need can be made by machine, why is there this increased interest today in functional objects made by hand? Sometimes it is because people are willing to pay to have something unique, which they may well not use, but which will be special to them.[87] There is also the increased interest in the Green movement with its concern for making things that will last, do not use diminishing resources, are a pleasure to use and fit within a social fabric of maker/consumer.[88] Beyond this is the rapidly changing world of the post-industrial society, where identity is fractured and consequently roots and stability are cherished.

However, functional work does not have to be linked stylistically or ideologically to the Arts and Crafts movement. Garth Clark, while enjoying pottery by descendants of the Bernard Leach tradition – or Bernard's orphans – as he calls them, has questioned the relevance of that vision today.[89] Clark acknowledges that Leach was helpful at a time when the practice of pottery was in a shambles. He offered ceramics a 'comforting brand of fundamentalism: purity of form, acknowledgement of function as the root of all beauty', and the idea that the aesthetic worth of a pot was determined through the choices made at each step of the way.[90] However, the 'performance' of making these pots is only linked to the past and, in order to be relevant to the present, Clark argues that ceramics needs to build a market and develop a new way of approaching function.[91] He also believes that makers should

not be afraid of functional objects that are unique and up to date.

Jean Baudrillard has argued that the public consumes mass-produced objects through the associated meanings and lifestyles suggested by advertising. The objects themselves are meaningless.[92] The ceramic tradition that Clark was arguing against has created a collective style. The slight variations within each hand-crafted piece, that Leach thought of as intrinsic to spontaneous making, return one to the idea of how the individual becomes implicated within the object. Whereas Leach was making his works at a time when the handmade was considered reactive, since the crafts revolution of the 1970s (as Pye was one of the first to note) the perception of the value of human involvement in objects has changed.[93] On the website for John Leach's Muchelney Pottery, the mugs, plates and tea pots are sold as part of a continuum of a rounded life of making, selling and nature. The pots are the focus of an image entitled 'tea with friends', making the various different components of their standard ware the extension of the potters themselves.[94]

However, more than just the making and consumption of handmade objects is the perceived relevance of an apparently vernacular tradition. For the original Arts and Crafts practitioners in the late nineteenth century, the connection between craft and vernacular styles had already been broken.[95] What we see today as an English tradition is complex. Indeed, many traditional potteries kept themselves going by fulfilling the dreams of Victorian collectors of an imaginary pre-industrial life through regressing to previous styles.[96] It is some of these functional wares that Leach saw at Michael Cardew's parental home in the early 1920s, when he was trying to find what remained of an English pottery tradition.[97] For collectors today, even if the objects are following the patterns of Cardew, Ashbee or Gimson, they are buying a recreated vernacular tradition. The dream of eternal values and vernacular tradition are, like the myths associated with the rural idyll today, just that – a myth.

Eric Hobsbawm has discussed how traditions can be invented.[98] While the objects made today are a continuation of an invented tradition, the original reinvention was a result of the rapid transformation in society that had weakened the traditional social patterns for which the old traditions had been designed.[99] Hobsbawm states that there are three types of invented traditions, those that establish or symbolize social cohesion, those that establish or legitimize institutions, status or relations of authority, and those that inculcate beliefs, value systems and conventions of behaviour.[100] If we draw these arguments towards craft, the idea of a living tradition of forms that correspond with particular value systems and lifestyles does create one shared vision of an English tradition. The notion of solace that Dormer discussed is only there when there is social cohesion around particular ideas and values. From the 1980s it has been argued that nations are not geographical spaces, but are imagined images of a shared identity.[101] Crafts that draw upon the ideas of the Arts and Crafts movement are a window onto a past, but can also be viewed as expressing an authentic contemporary reality.

3 THE ARTISAN TRADITION IN RURAL AMERICA: WESTERN MASSACHUSETTS CASE STUDY

In this chapter I will be discussing the work of artisan craft makers who work in Western Massachusetts, in particular the area around Shelburne Falls. I have chosen this region as it has a high number of practitioners who have worked there for many decades, and there are overlaps, as well as distinct differences, between their work and ideas and those that I discussed in the previous chapter. The practices on both sides of the Atlantic have developed from the romantic ideal fostered by educated people of moving to the country and making functional crafts. However, in Massachusetts there are American overtones in the links back to pioneer times and the philosophies developed by American writers which overlaid the original European ideas. Both have developed their styles through looking to those of the past. However, because this happened later in America and was less rooted in a particular social movement, there is not the concept of a standard ware, but an almost post-modern, pragmatic drawing from many different sources within each body of work.

The Berkshire Hills and Western Massachusetts have a strong cultural history that is still evident in the types and styles of objects made. There were three historical strands of craft practised in the region: the Shakers, the early settlers and the work of practitioners influenced by the Arts and Crafts movement. Both the Shakers and the followers of the Arts and Crafts movement were concerned with integrating well-made crafts with a simple lifestyle. The Shakers immigrated from Manchester, England, in 1774, and established communities throughout New England and as far west as Kentucky. As part of their everyday lives, they created objects that combined utility with spiritual embodiment. This was revealed through simplicity, the best use of natural materials and care in making.[1] The Arts and Crafts movement was influential throughout America, and there were lively societies formed in Massachusetts after N. Willis Bumstead opened his shop in Boston in 1871.[2] These societies promoted the use of local materials in the most suitable way as a means of creating social cohesion and linking the artist and object to the user.[3] The early

settlers came with their own inherited styles, but pragmatically adapted these to the materials that were available in order to meet their needs. The result was that the styles of all three strands of craft practice were linked although the underlying philosophies differed.

Their characteristics – simplicity and the making of utilitarian objects well in suitable materials – have remained important in the region and do set it apart from other areas of America. In its different current manifestations – those of the traditional artisan and of those who have moved into the area – simplicity and functionality can be seen as part of a living tradition. In 1966, for instance, in the regional selection of the exhibition *Craftsmen USA '66'*, the work exhibited by those from the northeast were thought to be stylistically and philosophically different to those from the rest of the country. The work from this area was characterized as being simple, utilitarian, unpretentious, well-made and conservative.[4] Contemporary makers in Massachusetts have continued with this aesthetic.

REGION

Unlike the myth of the cosy English countryside described by H.V. Morton and outlined in the previous chapter, rural America does not have a particular and defining archetype. As discussed in other chapters, the social and ethnic populations that inhabit the different regions, together with climactic and geographical characteristics, give each region its craft identity. Western Massachusetts is mountainous, rocky and forested. In the Berkshire Hills, the houses are set back from the country roads in loose-knit and isolated communities, with encroaching forest, where bears, mountain cats and coyote hunt. Shelburne Falls is a small, pretty town in the north, which is set around a fast flowing river that once supported a cutlery industry. The winters are cold and long and the soil poor, so that many of the original settlers either moved to the towns or to better conditions.

The reinvention of America during the depression of the 1930s as essentially rural and based on pioneering individuals was a way of creating a market for crafts as well as unifying the nation through common roots.[5] Whereas the myths in England were developed by an educated elite, those in America have grown from the socially more egalitarian basis of the family farm and an economy sustained through those units.[6] Rugged individualism and survival in the face of adversity has underpinned many subsequent arguments about what it is to be American. Although these myths have been made more complex through other imported influences, the contemporary ease of communication as well as better education, none the less, the concept of the pioneer remains potent. Partly, this is manifested in the resurgence of interest in heritage that has grown exponentially since the bicentennial in 1976, when museums and historical buildings were opened and a proliferation of articles and books were published on the subject.[7] As later commentators have observed, all Americans realize the central role that useful craft had in transforming the wilderness into the

civilization that they recognize. The original settlers had to be carpenters, coopers, dyers and weavers in order to survive.[8]

Deerfield in Western Massachusetts has an historic centre, a number of houses brought in from other sites, as well as a vast and growing collection of furniture, textiles and objects dating back to the pioneer times. Like the Hancock Shaker Village in Pittsfield, Massachusetts, it attracts many visitors and in both artisans are employed to make baskets and furniture in relevant styles. They provide a link between the detached 'tourist gaze' and a more bodily understanding of previous lives. Because so many artisans working at these historic sites also create similar, simple, well-made work as part of their studio output, there is a continuity of 'authenticity' that has resonance in conjunction with the larger rural environment.[9]

ARTISAN CRAFTS

Like England, there are the remnants of an artisan culture with roots that go back many generations. Early immigrants had brought their own traditions of making objects, but when they settled in different regions of the United States, the climactic conditions, and therefore the materials that were available, forced changes to be made so that different regions developed their own styles. The remaining artisan culture has retained these links with the environment, and the forms are the result of using these materials in the most efficient and appropriate manner.

Ash grows well in Western Massachusetts and is still considered the indigenous basket-making material. Although white oak, which is used further south, does grow in the region, the harsh climate of the north-east means that the trees grow slowly and the growth rings are consequently too close together for use.[10] The basket-making family of Higgins and Lafond have been working in the area for generations and still make woven ash baskets in the same way, with the same tools and to the same patterns they have used for decades (Figure 3.1).[11] Kenny is the son of Melton Lafond, who in turn learned traditional ash basket making from his well-known father-in-law Ben Higgins of Chesterfield. Once the tree is felled, it is quartered and the wedges of the trunk are pounded, which forces the growth rings to separate, and these become the weaving material. The growth rings are then divided into splints and woven in and out over the more robust uprights. The Shakers at Hancock Village also made ash baskets with very similar results, the major difference being the solution of the top, where the Shakers finished their baskets with binding as opposed to Higgins's use of ash rings and nails. As William Daley has discussed, form is an idea that is tempered by the possibilities and limitations of material, structure and maker.[12]

Although these baskets are still being made, the need for them to service local requirements has gone. Higgins baskets were used by farmers for harvesting potatoes and picking fruit, but many of the local farms have now been abandoned. Smith College in nearby Northampton was also a regular customer, but that outlet has also

3.1 Kenny Lafond/Melton Lafond, *Baskets* (finished and unfinished), ash. Photograph by Imogen Racz.

stopped. In addition, the global market has brought in cheap alternatives. Although ash baskets last indefinitely and can be mended, large baskets from China cost only a few dollars and there are also plastic alternatives. The labour cost of the eight hours it takes to make a traditional basket has therefore taken these outside the realm of everyday usage. [13] However, the referencing of a particular regional tradition is important for many and the baskets are sent all over America for use as magazine, knitting and log holders.

Tradition is suggested on the Internet, where a tourist site for the region discusses Higgins and Lafond baskets as being part of a past way of life. Like the reference to 'the last bowl-maker in England' that was discussed in the previous chapter, Ben Higgins was described as 'the last basket-maker, whose ash baskets were hand made – from Tree to Basket'. [14] The baskets are photographed, beautifully grouped on the steps of the old New England workshop, and the text discusses the works in terms of the material link to the environment, the longevity of the baskets and the process of making. The Internet site for the nearby Williamsburg Blacksmiths, who have been operating since 1840, promotes their wares for those who 'appreciate the traditions of early American wrought iron'. [15] Although it says that the comforts of modern life are important, none the less, their hand-crafted, traditional style objects for the home operate smoothly and don't creak as they have been made according to traditional methods and with care by individuals. Just as with the Internet sites for those practising traditional crafts in England, there is a relationship between the

objects shown and the makers. However, above these elements is the suggestion of important regional traditions that have their roots in early America.

THE MYTH OF CRAFT AND RURAL AMERICA

Jack Earl has been making porcelain scenes of American rural life since the 1960s. They are not of a particular place, but they depict people he knows – 'real', regular, hard-working, small town people set in country scenes, frequently with dogs, trees and small patches of ground.[16] As such, they affirm the myths of the common everyday existence of small town America, which is rural, slow and has tight-knit communities. Like the work of many inter-war Regionalist painters, such as Grant Wood, these objects give the illusion of stability and social cohesion.

Earl's depictions are an affirmation of an ideal that was suggested between the wars and was aided by the Servicemen's Readjustment Act of 1944, commonly known as the GI Bill of Rights. This act was part of a whole package of measures designed to mitigate a possible economic slump brought about by the sudden repatriation of ex-servicemen through providing money for them to gain further education or training, or to set themselves up in business or farming.[17] As a result, an unparalleled number of people went to university where crafts, which were taught alongside fine art, became a popular subject. Many of these graduates relocated to rural areas that were outside zoning restrictions and where the overheads were low. Clearly this was as much about lifestyle as practicalities, as many fine artists working in a range of materials were happy to be in cities where there was a support network of galleries and dealers. Like the move to the country in England, which was discussed in the previous chapter, these makers took over the skills of the traditional artisans, who had frequently been making for their own and local needs. As a result, there was no established support network, no unified American style and no ready market, so that these incomers were free to draw on crafts from many sources.[18]

This post-war move into the country was further advanced with the urban crisis of the 1960s, which resulted in many cities becoming areas of mass poverty, social deprivation and abandonment. Middle-class whites relocated to the suburbs and further out into the countryside.[19] There was also a dramatic shift in social climate as, part of a 'back to the earth' movement, many moved into the countryside and made crafts that explored different, and frequently non-Western, traditions.[20] As in England, the demographic shift had a huge impact on agricultural areas that had previously been poor and remote, as well as on the small towns that were no longer viable as industrial or agricultural centres.

During the 1970s, as now, Middle America was turning to crafts at many different levels, from the amateur who makes one patchwork quilt in his/her life to those who are making craft objects for a living. As Jack Lenor Larsen discussed in 1973, crafts are 'a people's art'. Echoing the ideas of William Morris, he saw the new-found interest in craft as being a human reaction to the depersonalization of

mass production, and when so much money was being spent on negative things, craftsmen were retainers of what was valid, real, creative and sensitive.[21]

Rose Slivka was more emphatic. In an extraordinary and powerful article of 1971, she made the argument for craft being a means of controlling one's destiny, a way of leading a productive and responsible life close to one's feelings, and as a way of living humanely and being involved with the nature of work.[22] Her argument was not only about the positive aspects of working with one's hands but, echoing a theme that ran through many articles of the time, that of not wanting to be part of a corporate culture where one is judged by efficiency and measurable outcomes. She felt that solutions to issues in work and culture were being determined by what was quick, easy and accessible, and were more concerned with appearance than with inner subjective conscience.[23] In this article, her insistence on individuality as fundamental to freedom resonated with a previous article that linked the individuality of craft objects to pioneer individuals, who had formed the character of the country.[24]

This tradition of independence being linked to the pioneers has been potent throughout the twentieth century. For example, the architect William Gray Purcell published an article 'Back to the Woods' in the magazine *Inland Architect* in 1959, where he promoted the self-sufficient life. He wrote that through living in the forest one would understand nature in its fullest extent, and through valuing hand skills and using materials from the locality one would be independent of others and understand true wealth.[25]

Although few people can live in a remote area and be self-sufficient, making objects by hand is valued. One of the driving forces behind this interest has been Taunton Press, which still publishes a range of magazines for home and craft making, including *Fine Woodworking* and *Fine Homebuilding*. This press, which is located in a rural community in Connecticut, advertises itself as valuing integrity and excellence and hoping that the creative skills of the readers will be enhanced through independent thinking.[26] Although catering for an amateur audience, many professionals also find the magazines invaluable, with tips on new machinery, ways of making things and articles being written by highly skilled amateurs.[27] However, it is the rhetoric that is interesting for the purposes of this chapter. Not only are the magazines catering for 'independent thinkers', but are also intended for those who have a 'passion for creative activities that enrich your life'.[28]

Among the members of an educated class who migrated into rural America in the 1970s and 1980s were craft makers who helped to create a framework for craft skills to be revived. Many, like Tom Kuklinski, Peggy Hart and Jim Picardi, came to Western Massachusetts during the 1980s, when it was poor and the practice of crafts was almost non-existent. The abandoned buildings that had housed small industries, like those at Easthampton and Florence, were converted into studios and lofts. Land in the 1970s and 1980s was cheap, so that many artists were also able to buy small farms.[29] Although there are now many craft makers in Shelburne Falls, there are also many others who run small workshops in the surrounding district. The business

directory for the town lists nineteen craft workshops, many of which also double as galleries, as well as a number of craft and art galleries that exhibit work made further afield in the area.[30] What helped to make the practice of crafts viable in the area are the pockets of wealth around the university towns of Northampton, Amherst and Williamstown. These draw more than 35,000 students to the area and create a dense concentration of well-respected academic communities.[31] As well as the obvious educational benefits, these colleges attract wealthy parents, academics and graduates. Each college has its own art gallery, and the surrounding towns have well-established commercial galleries.

RE-ESTABLISHMENT OF CRAFT IN THE AREA

Initially, there was not much information available for craft practitioners who were starting their own businesses. However, *Craft Horizons* had advertisements for summer schools, craft suppliers and articles that offered advice. One from 1973 gave feedback from a questionnaire that had been sent to all the crafts centres that could be found in the United States, which had asked about their experiences and reasons for setting up the centres.[32] Out of more than one hundred of the centres located, sixty replied. Some were run by the state or other official bodies, some had developed from being a shop, and some started as an idealistic enterprise. Only 15 per cent were located in rural areas, and most of those were aiming their objects at the tourist market. However, these rural ventures seemed to be the least centred on profit, with most makers following a dream of finding out about oneself through the experience of making and living in beautiful surroundings.[33] This was also confirmed by those working in Western Massachusetts today. The glassmaker Jonathan Winfisky, for instance, said that he initially came to the area in pursuit of a dream[34] – the views from his windows stretch across the mountains, he has a large plot of land, and he can make a living from blowing glass. All of those interviewed said that they loved working in a beautiful place, being part of a strong crafts community, and finding the means that allowed them to lead independent and decent lives.

Like many makers in the early years, Winfisky spent time on the road with his van full of glass objects, travelling around the state from shop to shop in order to sell his wares. As the market for crafts grew and well-organized craft fairs developed, selling and networking with other makers became much easier. Begun in 1966, the major retail and wholesale craft fairs run by the American Craft Council have become important arenas both for networking and selling craft. In these, the selected practitioners meet the public and become a focus for craft made in the region.[35] Since the first fair at Stowe in Vermont, there are now more than ten annual shows run by the ACC, and in 1999 the winter fair in Baltimore grossed $30 million in five days.[36] In addition, there are local guilds, like the Hilltown Artisans Guild, that bring together makers from the hill towns of Western Massachusetts to consider

selling strategies, put on juried exhibitions, annual fairs and demonstrations.[37] Clearly these organizations have become a focus of attention both for makers and buyers, and are supplementary ways of reaching a public beyond the traditional studio shop and the Internet.

USE OF MATERIALS

As in England, handmade objects are becoming increasingly valued in the post-industrial age. As many have suggested, the immateriality of digital imagery that often appears to work along invisible and elusive channels has given a greater appeal to things that can be touched and held.[38] Writing about pottery, Garth Clark has discussed the Western trend towards sensory deprivation in our everyday lives. Until recently, vessels were made to be held and were integral with rituals and ceremonies, so that surface and shape were important multisensory aspects that contributed to those social imperatives.[39]

As well as display pieces, the potter Mark Shapiro of Worthington, Massachusetts, makes simple and functional wares which, like the work discussed in relation to the Winchcombe pottery, the Ruskinian authenticity of the touch of the maker is evident in the finished piece, and the texture of the material is important. His works are at the opposite end of the spectrum to the fine porcelain vessels that are discussed in Chapter 6. He mixes clays from the south-eastern United States to get a body that reacts well under the hand and has some intermediate components, and he also likes to include a brick clay from Georgia that still has organic material remaining.[40] The vessels are then salt-glazed and fired in a wood-burning kiln, which again gives uneven surfaces and colours. One of Shapiro's previous apprentices, Maya Machin, has remained in the area and, like him, uses a wood-burning kiln, produces functional ware that is wheel thrown and has minimal decoration. For her, like other potters who have been associated with Stonepool Pottery such as Ellen Huie and Michael McCarthy, tableware is important as it is both pleasurable to make and, for the user, adds pleasure to daily tasks and rituals.[41]

This direct link between maker, material and user is also evident in the fine furniture made by Tom Kuklinski. He prefers to use local trees, like large maples which have fallen and died. It is not difficult to find 200-year-old trees fallen by the road that were originally used for their sugar, and have now had their limbs removed for firewood so that only the heart wood remains. This is a beautiful material with individual characteristics (Figure 3.2). By using large pieces rather than veneers, not covering the surface with stains or thick varnishes, and by hand-sawing, chiselling, plaining and scraping, the furniture becomes individual and the natural qualities of the wood are enhanced. Indeed, he likes to collaborate with the blacksmith Robert Compton and incorporate some forged metal elements as they both feel that the metal against the wood enhances the intrinsic qualities of each material.[42]

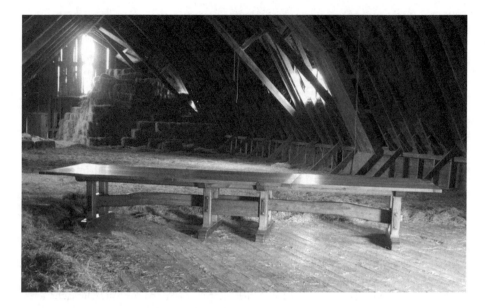

3.2 Tom Kuklinski, *Boardroom Table*, pine, reclaimed chestnut with custom-forged hardware by Bob Compton. Photograph by Tom Kuklinski.

Crafts through the ages have relied on haptic qualities to contribute to everyday rituals. However, in the exhibition of *Objects for Use* held in 2001 at the American Craft Museum, which mapped the range of contemporary American functional craft, it was unusual for works in any craft medium to be unadorned and for hand or tool marks to be evident in the surface.[43] Most tended to emphasize obvious skill through elaborate forms and decorative details, through juxtaposing contrasting materials and through shiny surfaces. The tendency towards technical virtuosity in functional wares developed during the 1980s, when the creation of luxurious effects through exotic materials, eye-catching details and special finishes was considered a way of justifying high prices and appealing to the juried fairs.[44] The simplicity, types of glazes, texture of material and obvious hand marks on the objects made by those from the Stonepool Pottery resonate with the similar qualities of the work made by English potters from the Leach tradition.[45] In their work, and in that of Kuklinski, virtuosic show is not the point. The authenticity resides in the quality of craftsmanship, the interaction with the materials, the maker's mark, the fact that each piece is individual, together with the knowledge of who has made it. As Paul Smith has articulated, what attracts buyers to these objects is the humanity and pride that has gone into making them, which is communicated to the owner through use.[46]

However, although the original settlers and Arts and Crafts makers used local materials, today's objects may be made from materials from further afield. Furniture is expensive so that it is frequently made to commission. Patrons not only want something that reveals skill and quality, but they also have particular desires to be

met. The furniture-maker Jim Picardi does make furniture using local maple and cherry, but also uses imported materials such as bamboo ply in some of his kitchens.[47] Tom Kuklinski uses local trees where possible, but in order to fulfil a particular commission, he asked a buyer to search for a suitable oak tree, which was shipped over from Woburn Abbey in England. Mark Shapiro was advised against using New Jersey clays, where potters would originally have sourced the material, as they were too contaminated. The potter Andrew Quient, who creates both functional and art pottery, uses industrial clays that are already made up.[48] The textile-maker Peggy Hart also uses materials from outside the region and sells the products out of state. She buys all the wool shorn from the sheep of a particular farm in Pennsylvania, which then buys back the finished blankets to sell at their shop to the tourists who come to see a real working farm.[49]

INFLUENCES

The rich history of the area provides both inspiration and ways of making a living. Many basket-makers are employed by both Deerfield and Hancock Village to demonstrate basket-making. Winfisky has made a reproduction glass vessel of a colonial period piece in the Sterling and Francine Clark Museum, which was commissioned by the museum.[50] Alongside his work for private clients, Tom Kuklinksi has repaired antiques for Deerfield, and made other works in that style.[51]

However, as well as these direct instances, the past resonates in today's practices in subtler ways. The potter Mark Shapiro has a deep interest in the local pottery made between 1790 and 1830. Situated on what would have been one of the main east–west routes, the area is rich in archaeological finds. There is a potency present in shards of previously used wares that retain a fingermark of the maker, and which speak of clay's ability to be moulded literally to the needs of humans and be an enduring trace of past lives.[52] While we might look at these from a historicist point of view, in the late eighteenth century makers like Jonathan Senton and Fred Carpenter were making high tech wares of the day.[53] Some of Shapiro's works directly reference these. However, in other pieces there are other influences, including Chinese and Japanese forms (Figure 3.3).

Like Bernard Leach, who has been an important influence in American ceramics as well as Shapiro's, there is recognition of the high quality of historic Asian pottery that combined the best materials with spontaneity. Also like Leach, Shapiro acknowledges the importance of the vernacular. While Leach and Hamada influenced Voulkos and Autio towards a more spontaneous engagement with the material of clay, Shapiro has been especially influenced by Leach's writings, and those of Michael Cardew, towards the production of well-made everyday utensils.[54]

Shapiro also makes sculptural vessels that reveal combinations of influences. They may be grouped together, like those of Hans Coper or the wood turner Christian Burchard, into families of objects, where relationships between each individual piece

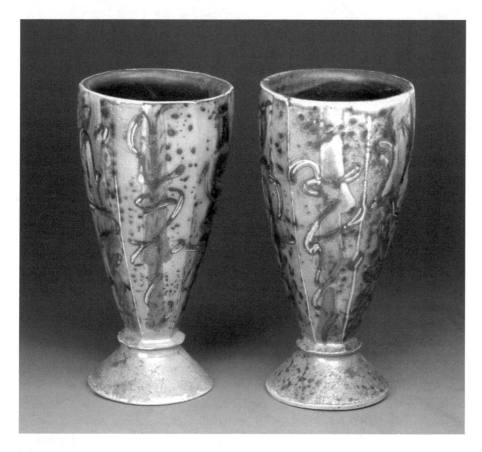

3.3 Mark Shapiro, *Two Faceted Cups*, wood-fired salt-glazed stoneware, 15 × 7.5 × 7.5 cm. Photograph by Mark Shapiro.

are created. The diversity of his practice is unlike potters in England whose practice has developed from the ideals of Morris or Leach, in that Shapiro does not make a standard ware, although he is interested in the notion of tacit knowledge. Having repeatedly read about traditional potters discussing making a dozen of any one thing, he has thrown vessels in quantities. Like the repeat-throwers discussed in the previous chapter, he has found that the body takes over and understands the forms that are being made.[55]

Tom Kuklinski has also been influenced by a variety of styles from the past. In some works there is the simplicity of plain surfaces, chamfered edges and robust construction that suggest the Cotswold style. In others there are overtones of older styles. He loves historical oak English furniture which is neither too formal nor clumsy. He also admires Arts and Crafts furniture, but again only where it is not too formal. Rather than directly referencing previous styles, he will often have a germ of an idea and will look through books for inspiration.[56] Echoing the ideas of Christian Burchard, he likes to respond to the individual materials and create

something that brings those characteristics together within a piece that works. An example of this is a conference table that he has made for a client. Its stretchers have been reclaimed from the floor of a barn and he has used their shape as part of the design. The chestnut retains some of the character from its previous usage and is also a good material for joinery that will last. The pine top comes from a tree growing on Kuklinski's farm and provides a contrast of colour, grain and texture.[57]

These two examples highlight the fact that the makers working in the area are not trying to follow a particular style or given ideology. Unlike the original artisans who specialized in one form, these makers take inspiration from different sources and also treat the material as an emotional starting point. Many of those interviewed also mentioned that the breadth of their practice was comparable to local farmers who make maple syrup, have some dairy cattle, do bed and breakfast and might also have other part-time jobs. Rather than being purists, they also need to make a living.

PRAGMATIC CONSIDERATIONS

This approach is also linked to the processes used, and again is connected to the way that early settlers interpreted influences. Although William Morris had made use of Jacquard looms in his workshop at Merton, this was not continued by many of his followers in England who reverted to hand looms. The Arts and Crafts movement in America was always more pragmatic about the use of machinery, and Jacquard looms became the accepted way of making cloth that was in between handmade and industrial. The weaver Peggy Hart was attracted to the Shelburne Falls area because of the large empty barns in which she could house her old Jacquard looms. She designs the patterns, which are sometimes inspired by the weave, sometimes from memories or images, and then transfers them onto the machines (Figure 3.4).

Unlike hand weaving, when making cloth on a Jacquard loom, everything needs to be planned in advance on squared paper. This design is then transferred onto the chains, after which the machine takes over.[58]

Like the furniture-maker Jim Picardi, Peggy Hart is a realist about machinery and outsourcing. The huge growth in independent makers has encouraged machine makers to cater for this market, but in addition many small support businesses have developed to undertake some of the processes. Picardi has a small workshop, and says that the good quality, specialist electric tools that have been designed over the last few decades have made it possible for him to survive economically. He loves to make individually commissioned pieces of furniture, but some of his work is also for kitchens and interiors. For this work he can outsource the making of drawers, which are all machine dovetailed to a very high standard; this saves time and keeps the jobs flowing through the workshop.[59] Although Peggy Hart does the weaving in Shelburne Falls, the washing, spinning and dying of the wool, prior to the design and weaving are all outsourced within New England.[60] It is this network of skills and small entrepreneurial ventures that allow the different crafts to prosper. As

3.4 Peggy Hart, *Wool Blocks Throw*. Photograph by Peggy Hart.

Jack Lenor Larsen written, 'these small businesses may be, after all, the American Dream'.[61]

The fact that there is so much craft activity in the area means that many of the local population are tuned into crafts. There are local classes for basketry, for quilt making and other hand crafts. They become an educational resource for schools.[62] As well as this local boost to activities and the economy, the attractiveness of Shelburne Falls combined with its local craft skills, has also attracted people from around the country to come for holidays. Becky Ashenden has started a weaving school, where students stay for a week to learn the different processes connected with the hand loom. Weaving is always a slow art and, because the objects are not large and impressive like furniture, it is difficult to make a living from production-weaving.[63] This venture, however, allows the unusual craft of hand-weaving to be

learned. Beverley Bowman, who works nearby, took classes with Ashenden, and now makes traditional style works in natural materials. Ashenden had learned her skills from training in Sweden, and Bowman has written that these skills and the types of products remind her of her own Swedish roots.[64]

IDENTITY

Although there are the uniting factors of simple, well-made, functional crafts in the area, as has been discussed, there are also varieties of practice that relate to those of the past, but not as individual styles. They are more eclectic, even within particular works. This can be related to American society, which is mobile and fluid. Paralleling the broader profile of American society, there are few makers in Western Massachusetts that can trace their roots to the area in which they are living, and indeed even the original pioneers would have moved around as necessary. The use of heritage as a uniting factor for Americans has also meant that there is a broad sweep of understanding of cultural identity. Whereas in traditional societies identity is rooted through a framework of stable relationships, in most Western cultures, especially America, this has been fractured through migration and the breakdown of social groups and roles.[65]

Peoples' identities are socially constructed, but if one accepts the narrativist concept proposed by Martin Heidegger, Alasdair McIntyre and Harry Frankfurt, then we also choose certain distinctive features that define us, and develop those.[66] In this way, we shape the story of our lives and the way that others see us.[67] If we take this active viewpoint on identity, then deciding to move to the country to make crafts when this is paralleled by many others becomes a rational lifestyle choice. Most of those interviewed commented on the strong crafts community in the area, where they felt part of something broader. Making artisan crafts, where the forms and ideas link back through history also adds to this sense of being rooted in a place. Added to this, utilitarian objects have a ritual aspect that connect people from different times. The simplicity of the wares harks back to the roots of the nation – the egalitarian farm and rural communities. Here again, the social construction of self and the choice of what is important, underpins the way of life. As Mark Shapiro has written, 'as a potter, I have been able to control most aspects of creative production – the concept, making, finishing, marketing, and selling of the work – in a process and within a scale that preserves and enhances the humanity of creative experience'.[68]

Through choosing a case study based on a geographical area, I have been able to show how the crafts of one part of the state are interrelated. The influences have meant that simple and functional work that is well made is characteristic of the area, although in our post-modern, post-industrial society there are many variations. Because there is such a strong community, other support businesses have also grown up. These small businesses, that allow the makers to work independently in rural communities, add another layer to the palimpsest of the cultural idea of being American.

4 CRITIQUE AND EMBODIMENT IN RURAL ENGLAND

In Chapter 2, I discussed crafts in England that were made in the rural environment and rooted in the Arts and Crafts tradition. Many of those who continue with these ideals today are the descendants of the original makers who moved to the country during the early twentieth century. They create functional objects, respect traditional discipline specific skills and live in a manner that unites art and life. In this chapter, I will also be discussing craft that has links to the rural environment, but here it is through conceptual frameworks that have been developed recently through the increased fluidity and transference of ideas across the visual arts. Although many of the myths and practices surrounding rural crafts have their roots in the late eighteenth and nineteenth centuries, the works discussed in this chapter are *about* the countryside and are meant to be viewed in gallery spaces or collected as works for contemplation.

The conceptual ideas that resonate in the objects discussed in this chapter overlap with those that underpin some fine art practice. However, the roots of the material disciplines form the basis of the means of expression, so that these works offer a different dimension to those made by fine artists. There are two main concepts underpinning the work discussed in this chapter: a critique of particular myths about the rural environment and the materialization of a personal link with place. These ideas have developed in recent decades and reflect the changes in education. While the Camberwell School of Arts and Crafts had produced many eminent studio potters at the beginning of the twentieth century, it was the in the work of the generation that emerged after the Coldstream Reports of the early 1960s that real change occurred.[1] The Royal College of Art opened its doors to 'aspiring artists, designers, studio potters and sculptors using ceramic materials' in the 1960s, and when there was increased disenchantment with design during the 1970s, many of these students opted for what has been called 'para-art activity'.[2] They were taught alongside fine artists, had the same history lectures and became involved with the same issues that interested all the students, so that it became impossible in an art school environment to maintain the idea of 'good honest potting'.[3] This was equally true for all the material disciplines.

The fragmentation of contemporary art in the post-modern era allowed artists to explore ideas that were outside the commercial, city-based and hermetic parameters of modernism. With the development of the ecological movement, one area of art developed in relationship with the rural environment and was influential across the visual arts. Carol McNicoll, for instance, responded with irony to the preciousness of land and landscape in works such as *Portable Lawn*, where a small patch of turf was preserved in a block of resin that could be wheeled around on casters. Other artists and craft practitioners who create work in the landscape, like David Nash, Andy Goldsworthy, Richard Long, Jim Partridge and Jony Easterby have continued the English tradition of developing a relationship with particular places and making work that is an outcome of those sites. Many crafts practitioners who produce gallery work have also been connected with these groups. The ceramicist Jenny Beavan, for instance, went on an artistic walk along Hadrian's Wall with Hamish Fulton, Richard Long and Tony Cragg in the 1970s.[4] Polly Binns quoted the writings of Richard Long extensively in her PhD and worked with David Nash while at Kingston Polytechnic.[5] The work of both Beavan and Binns is the outcome of an ongoing relationship with particular places, which is, as Lethaby has written, particularly English.[6]

Another important concept developed during the 1980s and is concerned with critiquing the myths of rural stability and order that were historically promoted in the visual arts. Like the romantic feeling for place, this is an outsider's vision. However, this is the reality of England, where increasing numbers of people commute to work in the city or live in the city and spend leisure time in the countryside. Indeed, the colonization of rural England by commuters has created a crisis of rural life, in that the agricultural workers can no longer be thought of as being the authentic voice of rural ideals.[7]

URBAN CRITIQUE OF NATURE AND THE COUNTRYSIDE

There are many urban-based artists, designer-makers and crafts practitioners today who use elements from nature or who critique the myths surrounding the rural idyll. Some draw on nature in a decorative or surreal fashion, like the design duo Timorous Beasties, who created an installation for the Wellcome Trust consisting of forty-eight screen-printed lampshades decorated with biological motifs, such as tsetse flies and the flu virus, and which were arranged in a double helix that suggested DNA.[8] These motifs were drawn from nature and were clearly related to the interests of the commissioning body, but they were treated in a decorative fashion that is at the root of many craft disciplines. Neither these works nor the decorative traditions suggest empathy with the objects or nature, but rather human control, an intellectual process of mediation and stylization.

Patterns in textiles have traditionally been the outcome as much of the different processes involved in their making as of the broader decorative influences present at any one time. Trading and colonial nations like England and Holland have incorporated influences from overseas for many centuries, so that patterns form a visual language that provides clues to cultural roots and interactions. Since the 1980s, Michael Brennand-Wood has explored this synthesis of the artificial and natural in his textiles, drawing on traditions of pattern making from different parts of the world, which form the heart of textile production. Islamic patterns, with their complex repetitions of geometric figures and the apparently informal suzunni covered with flower heads, have inspired a recent body of work – the *Stars Underfoot* series.[9] However, rather than being woven into or printed onto the fabric, this series used real flower heads made into repetitious patterns. As with all decoration, the elements have been removed from their original world and reconstructed into a new cultural realm. The apparently natural, individual garden flowers are no longer value-free or collectively a site of cultural focus. Like a garden, they have been organized into an artificial display and, like pattern design, one can see the different dimensions, each of which plays its part in the composition. His *Consequence of Proximities* series from 2003 explores this idea further (see Figure 4.1).

In this work Brennand-Wood did not use real flowers, but computer-sewn flower heads arranged at different heights from the backing, each with its own slight variations. Although not depicting actual varieties of flowers, the bright and uniform colours with their regular patterns mean that again they suggest cultivated and exotic types. Like the flowers represented in seventeenth-century Dutch flower paintings, these are not pastoral depictions that suggest the plenty of nature, but are a refusal of natural time. As in those paintings, like Ambrosius Boschaert's *Bouquet in a Niche*, the bringing together of individual elements shown in their perfection breaks the bond between man and nature, and places these works outside the limitations of the natural world.[10]

It is the resurgence of the use of decorative elements in both the fine and decorative arts, as well as the fact that utility is no longer the primary objective of crafts, that has helped to create a fluidity in the boundaries between the two areas of practice. The intellectuals who had promoted a modernist aesthetic had decried decoration as hiding the construction and material of the object. Indeed, Loos and Le Corbusier considered that the machine aesthetic was not only intrinsic to the spirit of the age, but that it also had a moral value. Whereas standardization and prefabrication were the natural aesthetic of the machine, producing less expensive goods that could therefore be made for the masses, decoration took time to design and apply, created a spatial illusion and appealed to the emotions rather than the intellect. These ideas had pushed the various arts apart, with craft appearing both reactionary and superfluous.

The recent trend of divorcing decoration and pattern from being something added to an already complete object to being something that has meaning in its own

4.1 Michael Brennand-Wood, *Consequence of Proximities – All Night Flight*, embroidered flowers, acrylic, wire, graphite, fabric on wood panel, 75 × 75 × 12 cm, 2003. Photograph by James Austin.

right has been an important development across the visual arts. Whereas modernism had the utopian ideal of improving society at its heart, this concept of progress is no longer valued. Rather than each object existing within an integrated symbolic system, our post-industrial society has spawned a complexity of individual and cultural identities that are revealed in objects that reflect this fragmentation through a superimposition of signs. Craft and design no longer use rational form and order as a means to achieve a better future, but are now concerned with expressing and critiquing the world.[11] Many contemporary English makers have embraced this complexity and used it in order to subvert decorative intent, to critique long-established myths about the idyll of the country and to synthesize and thereby critique, the apparently innate categories of natural and artificial. One discipline that has considered these aspects is ceramics, which has again used the roots of its discipline to explore ideas and vocabularies.

The major ceramic factories of the eighteenth and nineteenth centuries, like Meissen and Worcester, made floral designs and rustic scenes depicting shepherds and shepherdesses, simple country dwellings and picturesque landscape from the late eighteenth century. Influenced by continental philosophers – such as Jean Jacques Rousseau, who espoused the idea of the nobility of the peasant, or Goethe, who advocated a simple and rustic experience of nature – these scenes were popular. In addition, the new urban, middle-class market, which had severed its ties with the countryside, looked upon the rural environment in a sentimental manner. Staffordshire figurines of simple country folk, who were apparently well-fed and content, were made in abundance as ornaments during the nineteenth century. There was also a ready market for sentimental paintings of happy peasants working in rural idylls that was at odds with the reality of hardship and strife. It is these popular myths that were propagated in many of the industrialized crafts that some contemporary makers have chosen to critique.

Richard Slee, for instance, has subverted the idea of natural and harmonious nature through embracing the 'kitsch' that was decried by Clement Greenberg. His *Blanket Bay (up the wooden hill)* of 1999, for instance is a patchwork of small shapes of glossy, brightly coloured turf, some of which have small figurines made by Far Eastern factories for the English market.[12] These cheap figurines set on the bright and decorative turf are exactly what modernists like Greenberg or Fry would have thought of as lacking true aesthetic value. Greenberg thought that the mechanical and formulaic way that mass culture had translated the stratagems of 'mature culture' created 'vicarious experience and faked sensations'.[13] However, through creating an installation of these elements and reinforcing their artificiality, Slee subverts their sentimentality.

His *Flower* of 1989 also critiques the 'olde worlde' English pottery tradition, supplanting the illusion of natural nature with a three-dimensional 'ornament' that is close to the formulaic simplicity of the Disney cartoons that he enjoys.[14] Like them, there is a careful gradation of colour, a slick editing of form that reduces the image to a representation that also hints at sentimentality. Also evident is the in-fluence of the rationalization and perfection of form and colour distribution from the American ceramicists Ken Price and Ron Nagle, and Slee's vocabularies suggest a similar Warhol-like mechanization of nature.

Linked to this vision of the country idyll that ignores the history of hardship and toil, is Yinka Shonibare's *Mr and Mrs Andrews Without Their Heads* of 1998 (Figure 4.2). However, unlike the work of Slee, Shonibare has chosen to critique the apparently natural codes and narratives within high culture. *Mr and Mrs Andrews Without Their Heads* was based on the famous double portrait by Gainsborough that places the couple under a tree next to well-tended fields. Not only was this a portrait of the couple, but a representation of their wealth through the depiction of their land, attire and poses. Gainsborough's painting, in being part of a continuum of similar depictions, reinforced the arenas of power though the creation of a seamless

4.2 Yinka Shonibare, MBE, *Mr and Mrs Andrews Without Their Heads*, wax-print cotton costumes on armatures, dog, mannequin, bench, gun, 165 × 570 × 254 cm, 1998, SHO 33, © Yinka Shonibare, MBE, courtesy of the artist and Stephen Friedman Gallery, London. Collection of the National Gallery of Canada, Ottawa.

narrative that collaborated with accepted assumptions of the elite and made those on the margins invisible. Like so many portraits of the time, the source of their wealth, the slave trade, was hidden from view.[15] In addition, the maintenance of the land in England required the service of many poor agricultural workers, who were again removed from the depiction. Shonibare countered this by removing the emblem of status that had underpinned their lives: their lands. He also removed their heads and substituted 'African' fabric for their contemporary clothing. This brightly patterned 'Dutch wax print', which today is read as stereotypical African cloth, also creates a narrative myth in that it is not African but is found in English markets and is made in Indonesia to appeal to particular groups of people. The textiles that he has used, both in this work and others, subvert notions of ethnicity, power and authenticity.[16] In the work of both Slee and Shonibare the scale and codifications of the originals have been used in order to force the viewer to reconsider overlooked ideas. Unlike the work of Slee that is almost domestic in scale, *Mr and Mrs Andrews Without Their Heads* is large and is intended to be viewed in a museum. Through critiquing a painting that has an iconic status within English culture and institutions, and placing that critique back into the museum space, Shonibare has also debunked the strategies of power and exclusion of those spaces.[17]

In order to create a dialogue with the narratives that are presented to the public in museums, Grayson Perry worked with the collections in the museums of Lincolnshire, which culminated in his *Charms of Lincolnshire* of 2006. In this work he brought together a range of objects in the collection that reflected the social history of the county. The themes that he put together from these objects were emotive: death, childhood, religion, folk art, hunting and the feminine. Intervening in this map of the past he placed his own ceramics, woodcuts and photographs, which depicted the fictive life of an unknown artist: a farmer's wife, who had been driven insane by the death of her children.[18] His installation of real and fictional evocations highlighted the hardship of rural life in previous centuries and our contemporary insulation from death and the realities of physical labour. As city dwellers, we have become divorced from the reality of husbandry, choosing to see the picturesque surface. Indeed, visiting a village art show where the paintings were rural scenes of villages, barns and landscape, he found that none of them depicted contemporary life, but were concerned with the charms of the picturesque ideal.[19] In a country where farming is an industrial process and so much wildlife has been lost, the prevailing innocent vision is a façade. On one of his pots made for *The Charms of Lincolnshire,* Grayson Perry quotes Carl Jung: 'Sentimentality is a superstructure covering brutality'.[20]

PLACE AND MEANING

As well as critiquing myths that have developed over the centuries, many practitioners have developed positive relationships with particular places which they express within their works. This direct experience, that might be forged through walking, sitting or contemplation, is different from the experience of someone who is attached to the land through agriculture and husbandry. As has been discussed in the first chapter, this understanding of place and its acculturation into the psyche of the English was promoted and embedded by artists and writers from the late eighteenth century. However, although these roots were also absorbed by Arts and Crafts practitioners, what will be discussed here are works that are abstract and conceptual.

Studio pottery between the wars was the first discipline to engage with constructing vessels that were sculptural in form. Not only did these practitioners engage with the material of clay as a means of expression but they were also influenced by the ideas and work of fine artists. Since the 1950s Gordon Baldwin has made abstract sculptural vessels that reveal the influence of Modernist artists like Henry Moore, Brancusi and Jean Arp.[21] Like Moore, his work suggests a dialogue with the landscape, and while the forms are invented, there are echoes of rocks and abstractions of natural forms that have been absorbed through experience, journeys, sights and sounds.[22] As John Houston commented, clay itself is of the earth, and through manipulation and metamorphosis it can represent 'nature humanized'.[23] Form, the handling of space,

the skin of the clay, how it has been manipulated – whether it has been thrown, pinched or coiled – it is these aspects that create meaning.[24] Baldwin's works give the impression of randomness, with torn edges and marks that are hard to define but that are highly controlled. His forms evade definition. He fires the pots repeatedly and works the surface until there is a dry stoniness about them with the suggestion of ancient mark-making.[25] These aspects create a tension between the apparently natural and human intervention.

This sculptural tradition in ceramics has been continued in the abstract work of James Campbell, Sandra Eastwood, Sara Radstone, and many others, where the material, form and surface have been manipulated to suggest natural features. Radstone, for instance, explores the notion of erosion in her work, both as a spiritual concept as well as the suggestion of natural forces working on rocks over a period of time.[26] The surfaces of her works are covered with differing monochrome slips, rubbed back and textured with scratches. They reference the surfaces of ceramics by Hans Coper and paintings by Ben Nicholson.

In recent years, this rich English tradition of creating works about the indigenous landscape, which runs across the visual arts, has been augmented by travel and artistic influences from overseas. Karina Thompson, for instance, travelled to New Zealand in 2003 and became interested in Maori textiles.[27] Sue Lawty has been greatly influenced by both the artefacts and landscape of many different countries, especially the mountainous regions of Nepal and Africa.[28] Cynthia Cousens became a visiting lecturer and exhibited in America in 1998. The following year she spent four months in New Zealand, where the landscape provided a starting point for a new body of work.[29] Some practitioners have also produced work in collaboration with makers from other countries, again creating a cross-fertilization of ideas. *Through the Surface* of 2003 paired makers from Japan and England, so that they could collaborate on making works for the exhibition.[30] What unites all of these practitioners is the instinctive dialogue with the rural environment that is evidenced through material manipulation. Building on personal experience, which is opposed to the Enlightenment rationalization of perception, the body itself becomes the medium of experience and the centre of understanding.[31]

Writing as long ago as the early 1970s, Philip Rawson articulated these ideas as being particularly pertinent to ceramics, but they can also be thought of in relation to the other disciplines. He wrote that

> Other arts … have come … to resemble cut flowers, separated from the living plant that produced them, in the case of ceramics we are now everywhere brought face to face with the root. This appears in the primal interweaving of matter, human action, and symbol that each pot represents. Inert clay from the earth, is made into something which is directly and intimately related to active craft… This then becomes what one may call a 'transformation image', which contains so much projected into it from man's daily life and experience … that it can seem to him almost like a projection of his own bodily identity.[32]

I have quoted this at length as it articulates what many of these practitioners are attempting. It is the combination of materials, processes and the inner reality of the maker's world that becomes transformed into an object. This outward expression of idea can then communicate with the spectator's own range of understanding.[33]

Hands Across the Border, a cross-disciplinary touring exhibition from 2004, showed work of practitioners who were based near the border between England and Wales, and who created work that was linked in a tangible way to their local landscape. In spite of the diversity of materials and styles used by the exhibitors, all shared certain philosophical values, as well as having a desire to draw in the audience.[34] All showed individually crafted objects that used traditional processes related to their disciplines, like throwing, stitching and hand weaving. All the exhibitors also used natural materials, and yet the exhibition was not about traditional craft as each person's work was distinctive and personal.

Jim Partridge, for instance, made a material link in using local unseasoned oak that he scorched and waxed in order to enhance the natural grain. As a result, each block became a small landscape of fissures and bumps that were further enhanced by the hollows of the vessels, which were not smooth and uniform. Simon Carroll also allowed his material to speak, but in his works the malleable qualities of red clay were exploited. Like the work of Partridge, the objects do function, but this is a secondary aspect. On each of his jugs he employed diverse techniques and glazes to render the patterns of dirt tracks, hedges, brooks and other elements of the worked landscape in which he lives.[35] As Rawson wrote, we accumulate memories and traces of experience that are charged with the vestiges of emotions that originally accompanied them.[36] This personal response to surroundings, translated into handmade objects links memory, embodiment, skill and material in seamless relationships.

Christopher Tilley has discussed perceptual space from a phenomenological standpoint. He describes this as an egocentric space that becomes important for the individual through emotional attachment and the growth of personal memories and encounters.[37] Craft makers frequently discuss the importance of making, the time, the meditative quality of repetitive movements and, above all, the fascination with the material. In both the relationship with landscape and the evolving handmade object there are openings of the mind, a meditative but active engagement with the substance of life.

The textile artist Polly Binns, for instance, has had a long relationship with particular parts of the north Norfolk coast and considers that her daily walks, where she concentrates on the shifting flux of the sands caused by the tides, are crucial to her work. Her PhD is structured so that it charts the development of working *from* the landscape to working *in* the landscape and finally working *with* the landscape.[38] She aligns herself with Richard Long, feeling that the walk, the repeated experience of observing change, is fundamental to her work and provides one more layer upon the palimpsest of human and geographic history.[39] The sands at Blakeney are tidal and so change constantly. However, upon that natural repeated washing and disturbing

are the human elements of sluices, bridges and mooring posts, all of which become pointers and stages as she walks. As well as these marks, there are the transient man-made changes of footsteps, or dramatic interventions where people have chopped up the sand looking for lug worms. However, mediating all of these physical aspects is the constantly shifting light.[40] Pamela Johnson has described Binn's approach as phenomenological.[41] Certainly her repeated walking and viewing of the unstable shoreline, knowing each permanent aspect intimately and squelching her way through the mud would correspond with Tilley's ideas of understanding the world through bodily movement.[42] Similarly the bodily link with the processes of transforming material into something with meaning is an extension of this outdoor activity. Both require time, reflection, an openness to change and repetitious movements. Drawing on Bachelard's ideas of intimacy and immensity blending in solitude, her work fuses the grandness of vision created in the imagination and the intimacy of the immediate bodily movements.[43]

Binns's textiles are subtle multi-layered surfaces. She incorporates the traditional techniques of stitching, pleating, cutting and knotting. As well as this she uses liquid paint that is absorbed into the surface, sometimes on top of the stitched surface, sometimes allowing the threads to float free. The regularity of the stitching and the subtle changes of density and colour are exemplified in *Serial Shimmers and Shades* of 1996. Here the small nuances and shadows of the surface of the beach have been translated into the grey/ochre of the loose-painted canvas and the punctuation points of the regular threads. In *Sand Surface and Shadow, Winter*, also of 1996, she incorporated both inward and outward pleats and cut diagonals, which created intense line shadows (Figure 4.3).

Binns has written that the physical activity of making, the nuances of touch and scale, and the slow changes that happen during the evolution of a work are fundamental to her practice.[44] Increasingly the work has become more deeply felt and poetic, although not autobiographic. Linking the work to post-minimalism, where the simplicity of the grid that pervaded earlier work gave way to a more human expression, Pamela Johnson has written of how Binns works in a liminal space, on the threshold of perception or an 'unthought known'.[45]

The jeweller Cynthia Cousens also uses walks, close observation and the forms of nature as the wellspring of her work.[46] Attuned to the countryside from her childhood on a farm, her work was initially a more literal translation of the growth of forms. However, after having received a South East Arts Major Award for Crafts in 1995, she spent the winter walking on the South Downs, where she drew, gathered information and objects, and looked at and responded to the landscape. She began to explore the linear aspects of the views, including the skeletons of trees as well as the paths through woods.[47] The fourteen necklaces that resulted from this were less about creating work for the body – which one would expect in jewellery – but were sculptural metaphors related to her experiences within nature (Figure 4.4).

4.3 Polly Binns, *Sand Surface and Shadows*, linen canvas, painted and stitched, 280 × 210 cm, 1996. Photograph by Simon Sandys.

Through the colour of the patination, the crispness of the line, the lightness and density of material, the sensory memories were translated into form. Although more recent work has included other materials, metal is the enduring material with which she has a dialogue. It is where she feels most at home: 'picking up a torch is like picking up a pencil'.[48] Like Binns, the act of making and manipulating material becomes the funnel for the outside experience of moving through and experiencing space.

The ceramicist Jenny Beavan lives and works in Cornwall, which has been and remains important for china clay and slate mining, as well as having a long pottery tradition.[49] The countryside is very different from either the Norfolk coast or the South Downs, as it is rugged and littered with reminders of its mining past. As artist in residence at Imerys Minerals from 2001 to 2002, she produced a body of work that is related to both the materials and landscape of the mined area, called *The Cycle of Healthy Water* (Figure 4.5).[50] As well as considering the properties of water as vital to life, she became aware of the crucial role that water plays in clay extraction, as well as in the separation of the constituent parts for use in the china clay industry.

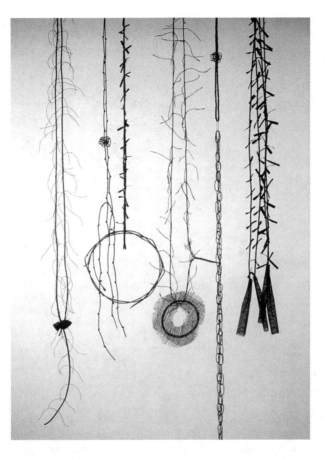

4.4 Cynthia Cousens, *Winter, Necklace Studies*, 1995. Photograph by David Cripps, collection of Birmingham Museum and Art Gallery, Birmingham, UK.

Beavan was allowed access to various pits that revealed the strata of geological layers and where grasses, rhododendrons and other plants found enough sustenance to survive. She walked around the sites, looking, listening and collecting. The resulting works were interpretations of the site, with whorls of raised china clay reflecting the movement of water, and the textures of the land being suggested through different clays and glass. The direct link with the site was through pressing the gathered plants into the clay, which were burnt out during firing creating echoes of the forms. Like Binns and Cousens, she translated the memories and impressions of the site into works with meaning through exploring the material possibilities.

Developing from the residency has been a series of works based on a trail near her home. She walks there frequently, noting the subtle changes of season and weather. Beavan has her favourite tree in a wood behind her studio, which she incorporates into her work by pressing sheets of clay onto the bark to explore the textures. The tree is dead, so she was surprised to find that the local fishermen also value

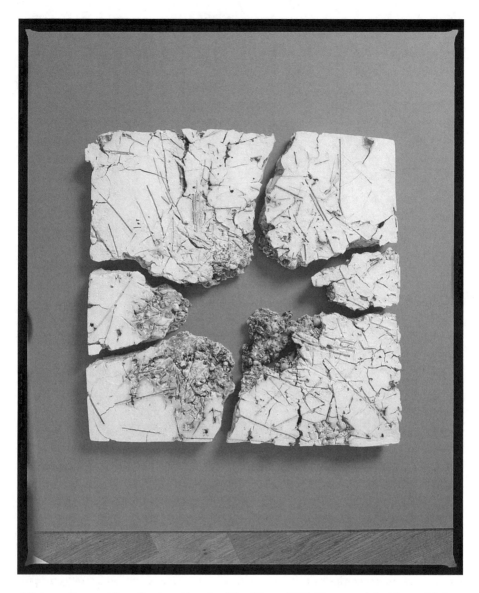

4.5 Jenny Beavan, *Water Erosion*, china clay, 57 × 57 cm, 2002. Photograph by Howard Spiers.

it.[51] Echoing the ideas of Tilley, particular landmarks that have become absorbed into common consciousness have social meaning.[52] Through incorporating plant materials or textures from these places, Beavan has added another personal layer to an understanding of a particular place.

All three practitioners have used their different disciplines and the associated processes in order to translate feelings and memories that have grown up over a period of time. Although revealed in very different ways, each has enhanced the inherent qualities of their materials as a means of communication. The scale,

absorption possibilities, stitch and slash of textiles evoke the watery but cut surfaces of the sand. The cold coloured, sharp contrasts of different metallic qualities evoke cold crisp winter landscapes. The malleability of different textured clays, and the fact that added elements can be fired out into an echo of the original, reinforces the earth-ness of the material. The materials are the touchstone of communication.

However, another link with a particular place is through collecting materials and incorporating them into objects so that they are physically visible. Whereas Beavan's gathered plants were burned out during the firing process leaving a shadow of their forms, David Binns has used 'souvenirs' of memories in the form of stones that he has found, which he has then ground into a material that can be used and fired.[53] The use of aggregates in order to accentuate the original clay-ness of the material is an important strand in contemporary ceramics. One of the pioneers of this – Ewan Henderson – created vessels that suggested geological strata through the incorporation of different materials that either remained visible or became burned away during the firing process. However in the work of Binns, the aggregate is incorporated into a body that is not rendered uneven during firing. Although not revealed as more than grains, these added elements that have been worked on, mixed into the clay and fired are small accretions of experience – personal memories of place and activities. During the long processes of making, where he finds the repeated movements create a meditative quality, memory and consciousness play a vital part.[54]

Dail Behennah, who was a geographer and now makes work that reflects her passion for maps, has also included elements from particular places and times into her willow constructions. In her objects, short pieces of willow are constructed into grid-like structures that suggest the formalization of maps. However, they also cast shadows, giving them a presence of their own. In some, like *Grid Dish with Pebbles* of 2004 or *Dish with Blackthorn*, stones and slate, or small gnarled twigs collected locally have been strung within the objects, creating a formal disjuncture between the apparently natural and the constructed (Figure 4.6).[55] As well as the memories connected to the embedded objects, their presentation within a given framework suggests codification and classification. Mapping is not just taking the physical measure of the world, but can also reflect the spiritual, the remembered, the imagined and the contemplated.[56] It is these elements of resonance, memory and material that are important in the layered response to the land.

In all the works discussed, the practitioners have created metaphors of experiences and memories that have been linked to place. Like those critiquing the myths of the rural idyll, they have drawn upon their material disciplines, both for techniques and issues, and through these means have enlarged the languages of each. In the work of both groups of artists, the works resonate with accepted and apparently natural understandings of nature, place and history. The process, consideration and time taken in making the objects link the close geography concerned with the small movements of hands and arms with the larger mental and physical geographies involved in the engagement with the broader environment.

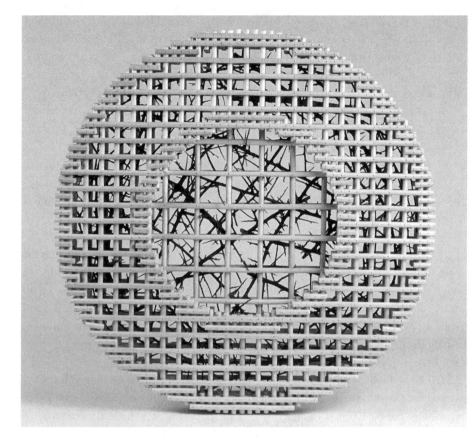

4.6 Dail Behennah, *Dish with Blackthorn*, white willow, silver-plated pins, blackthorn, 61 × 61 × 8 cm, 2004. Photograph by Jason Ingram.

5 MATERIAL, SPACE AND PLACE IN AMERICA

This chapter will discuss American cutting-edge craft that represents personal responses to the environment and nature. Like the makers discussed in Chapter 4, the majority of these practitioners have been through higher education and, although staying true to their material disciplines, consider debates from across the artistic spectrum. As well as including work by those who respond to their surrounding rural environment, I will also incorporate some who live in suburban America, where the debates and processes are more urbanized. Overarching the diverse works that will be discussed in this chapter is a desire by the makers to communicate the preciousness of the natural world and the fundamental relationship between humans and nature.

Contemporary ideas about the landscape have their roots in the eighteenth and nineteenth centuries.[1] However, while the underlying myths related to individuality, geography, indigenous and pioneering crafts are the same as discussed in Chapter 3, the works discussed here should not be mistaken for artisan crafts. They are conceptually based and *about* place and space. While there are many purely decorative depictions of the elements of nature in American crafts, these will not be discussed. What will be the focus of the debate are those works that evoke an instinctive and personal relationship with the natural world and a concern for the environment. However, the sheer scale of the land mass and the diversity of cultural groups in America means that the material cultures and the perceived importance of the countryside and nature are also varied. It is not possible to cover all the relevant ideas or regions here, so I will divide the chapter into subsections that relate to those who explore the properties of materials, those who evoke a relationship to place and space and, finally, those who depict elements of nature in a way that suggests man's efforts to order and classify the natural world.

MATERIALS AND MEANING

Janet Koplos has written that the medium in craft never becomes invisible but is always a constituent part of the message.[2] In cutting-edge craft, the importance of revealing

the qualities of materials became important from the 1950s in anti-industrial, anti-Bauhaus gestures. However, rather than just being against the mechanical taming of material, it was also a positive move towards exploring discipline possibilities through considering ideas and techniques from a broad range of practice, including contemporary art practices in America, and crafts from non-Western societies.[3] While these early objects were not meant to be about the landscape or nature, what they achieved was an enlargement in material vocabularies, which led to the development of objects being able to speak in a symbolic fashion. *Craft Horizons* also changed its emphasis from promoting craft in industry to one that was more diverse and celebratory of individual creativity. From the 1960s and 1970s it published a range of articles, from those about contemporary crafts practitioners to general ones about folk art, crafts by Native Americans and work by indigenous populations from around the world.

Fibre art initiated much of this material and technical research. During the 1950s Lenore Tawney, Alice Adams, Dorian Zachai and Sheila Hicks experimented with non-traditional processes. Tawney exhibited free-hanging weavings with exposed warp, open constructions and uneven selvages in 1955.[4] *In the Dark Forest* of 1959 was a layered, loose-weave hanging, where areas of warp were left bare and there were concentrations of density and texture. By the late 1960s, fibre was being constructed into soft sculpture, paralleling experiments in fine art. However, rather than reflecting urban popular culture, like Claes Oldenburg's cloth hamburgers, these artist craftsmen experimented with wrapping, braiding and other traditional, non-Western techniques. Sheila Hicks used wrapping in *The Principal Wife Goes On* of 1969, where clumped and long tails of skeins were thrown over a baton, in a way that paralleled works by Eva Hesse. Claire Zeisler, who collected ethnographic art, created her *Coil Series* in the late 1970s, which were free-standing works of wool and hemp. *Number III* had individually wrapped threads emerging like a fountain from a central point. As she wrote in 1968, it was the material itself that was important, in its raw, natural, unrefined state.[5]

The 1950s to the 1970s in America were also crucial for the growth of studio crafts and the exploration of material qualities in other mediums. In 1962 Harvey Littleton and Dominick Labino gave a glass demonstration at the Toledo Museum of Art, which showed the possibilities of a new glass that could be melted at a lower temperature than had been previously possible.[6] This had a profound influence in America, as hot glass could now be made in small workshops, which allowed for a direct relationship between the material and the artist to be developed.[7] It led to the liquid qualities of the material being explored in a way that has dominated American glass since then.

In ceramics, the concentration on materials was initiated by Peter Voulkos who, from the late 1950s, tore, mended and distorted his forms, revealing the malleable qualities of clay. The unlikely spark that ignited this revolution was the meeting of Bernard Leach, Shoji Hamada and Soetsu Yanagi with Rudy Autio and Peter

Voulkos in 1952 at the Archie Bray Foundation in Helena, Montana.[8] Hamada gave a demonstration of his skills, but not being used to the type of wheel available at the foundation, he asked Voulkos to work the kick mechanism while he made the pots. From this demonstration Autio gained a new understanding about the connection of man and work, and Voulkos learned about freedom of expression and attitude.[9] Following this meeting, Voulkos met avant-garde artists such as Franz Kline and Wilhelm de Kooning at Black Mountain College and the Cedar Bar in New York, where he realized that it was valid to critique material.[10]

The links between the new expressive qualities that were being explored in ceramics and Abstract Expressionism were celebrated in the exhibition *Abstract Expressionist Ceramics* of 1966.[11] Voulkos and the other Californian makers were consciously breaking away from tidy and 'well-made' crafts that were based on centuries of learned skills and functional purpose, and making work that could be considered art. While the discussions and systems that supported the exploration of material were urban, clay is of the earth and its material qualities gave these works resonance.

Abstract Expressionist painters like Jackson Pollock or Mark Rothko had intertwined the material of paint with their own expressive gestures. As Greenberg commented in his view of modernism, they used the materials and processes as a means to critique the discipline.[12] Rose Slivka discussed this tendency in ceramics, linking the eruption of sculptural fervour to the energy of the nation, which was built through the actions of ruggedly individual men who were used to improvising. As a result, the classical beauty of Western Europe was considered absurd.[13]

In woodturning, makers also moved towards more expressive approaches that either cherished the imperfections within individual blocks of wood or celebrated the gesture of the maker.[14] Again, the emphasis was on critiquing the material and allowing for gestural chance. Rude Osolnik was one of the pioneers in sculpting flawed wood and, by the late 1970s, David Ellsworth and Mark Linquist had emerged as the main leaders of the woodturning field. Both paralleled the developments in glass, ceramics and fibre in that they were creating work that was sculptural and a celebration of material. Ellsworth's work was delicate, whereas Lindquist's was bold. For some of his works, Lindquist used a chainsaw, but rather than smoothing off the cuts, they were left as expressive gestures.[15] In his *Mediating Vessel* of 1972 he kept the bark intact on the outside in a celebration of the original tree. In *Nehushatan* from a decade later, he kept the burl rim with a large crack running through, as well as the marks from the chainsaw.

More recently some woodturners have developed the idea of letting the material take over after the maker has finished, by allowing the wood to move according to its natural drying processes. Again there are parallels with soft sculpture, like those by Claes Oldenburg or Robert Morris, where gravity gradually causes the works to slump, so that the modernist concept of a 'finished' work is no longer relevant. Although the artists that Morris discussed in his essay of 1969 were using

industrial and found materials rather than natural ones, this idea of contingency that separates process from ends has become relevant in woodcraft from both sides of the Atlantic.[16]

Christian Burchard, for example, has been exploring the inherent qualities of wood for most of his life and enjoys revealing the history of individual blocks as well as the inner structure.[17] In addition to sculptural and figurative works, he has made many families of thinly turned baskets (Figure 5.1).

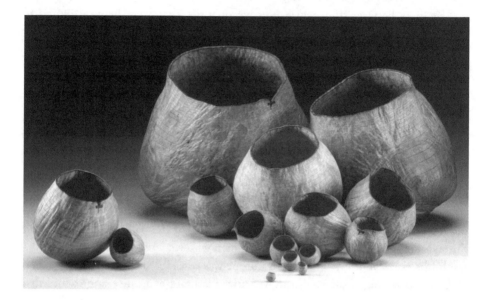

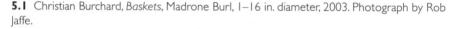

5.1 Christian Burchard, *Baskets*, Madrone Burl, 1–16 in. diameter, 2003. Photograph by Rob Jaffe.

In conjunction with the contemporary woodturning trend, he has become less concerned with imposing obvious virtuoso techniques on exotic woods, and instead uses bleaching, burning, carving and sandblasting in order to reveal the properties of the material and form.[18] He works almost exclusively in madroño root burl, which is used extensively for veneers. However, again in keeping with the ecological concerns of many turners about the use of rare and exotic woods, he uses the parts that remain after veneer cutting. As discussed in a conference of 1991, the push for exotic hardwoods in woodcraft has had implications for forests.[19]

Madroño has a high water content. As the wood dries it deforms dramatically, either causing cracks or asymmetrical shapes to evolve. In a series of baskets made in 1997, Burchard turned the walls to a thin gauge, which allowed each individual piece to deform in its own way. Some of his individual vessels and families of baskets are bleached so that the asymmetrical forms and undulations of surface that have developed during drying are the focus. Others have sandblasted surfaces that allow

the natural colours and grain to be part of the meaning.[20] Being different in size and displayed as family groups, relationships between the parts are suggested. However, just as the wood moves, every time that the clusters of vessels are displayed, the grouping will look different. What also matters is the relationship between him and the wood where, having worked with the material for so long, he instinctively understands how the wood would like to be used. It is these aspects of negotiating with the material during the making process, and then afterwards allowing the material to move in its own way, that Burchard enjoys.[21]

What unites all of these developments within the different disciplines is that rather than hiding or taming the materials, these practitioners have used their skills and involvement in order to reveal the intrinsic characteristics of each material. All of these works are the outcome of responding to the object as it evolves and using chance and improvisation as positive elements. The influential Harvard philosopher George Santayana was one of the first American thinkers to consider sensuous beauty and its relation to material. He wrote that the beauty of the material itself was the foundation of all forms of beauty, and that when combined in perception with form it raises the latter to greater poignancy and power. This importance of developing a material and a sensory understanding of the world, he wrote, were the most primitive and fundamental aspects of our aesthetic understanding and of the health of a civilization.[22]

PLACE AND THE ENVIRONMENT

Since the early 1980s (slightly later than in England), American makers in some disciplines such as basket-making have developed beyond this exploration of materials as an end in itself. They use materials as a means of conveying personal memories and a link to place, as well as to broader themes such as concern for the environment and human renewal through nature. There are three main roots to this understanding of place and the environment: the link back in time to the life and crafts of indigenous people; a dialogue with pioneer settlers; and more global concerns that are articulated through the use of local mediums. The makers discussed here do not make works in a traditional style, but suggest particular concepts through the way the materials, techniques and forms have been manipulated.

Jill Nordfors Clark, Fran Reed and Pat Hickman, for instance, have acknowledged a tradition from the Native American tribes, which is particular to the northwest coast of America, in their use of fish skin and guts to make their baskets. The indigenous Native American tribes used every element of fish and other animals left after eating the flesh, not only for their survival but as a way of honouring the animals they had killed. By using these materials today in the framework of an affluent Western society, it focuses the viewer's attention upon how elements that are generally considered waste can be used in a way that does not endanger the fragile ecosystem.[23] Interest in Native American crafts by European Americans was

initiated in the 1920s, especially in pottery and basket-making. This continued, and during the 1960s there developed a greater respect for the natural ways in which indigenous materials were used to create works of sophistication.[24] Consciousness was also raised during the 1970s, when Native Americans who had been relocated to cities started to join forces and raise awareness about their needs and traditions.[25] This coincided with the development of the ecology movement and the two have coexisted as a theme in craft since then.

As discussed in Chapter 3, local materials, place and the history of particular places is a key element in many craft practices. Nordfors Clark lives and works in a place where Native American culture has been marginalized. She has written that 'my work ... has been inspired by these native people ... their environment, and their use of a readily available material to make essential pieces of clothing and vessels'.[26] Whereas Native Americans made functional, albeit beautiful, objects from locally available materials, the objects by Nordfors Clark are for contemplation and are inevitably an outsider's vision. They can be viewed online or in gallery spaces, and while these works refer directly to the lived past of the region, they have also become interventions in the myths created by museums and books. Beyond the physical conquest of the West, the acculturation of the land through display, images, tourism and literature makes official histories appear natural. However, these works that suggest the traditions of the tribes while not being embedded in life and ritual, query the constructed history.

Besides making the cultural link back though time, Nordfors Clark also incorporates aspects of her own memories. As well as using fish parts in her baskets, she combines these materials with objects found on the beach such as shells and agates, and other natural materials like hog casings and quills, as well as domestic items like lace and buttons. The things found on the beach relate to her walks where she goes to restore herself. Sometimes objects will have added significance, such as the forsythia branches that were incorporated into her basket called *Remembering*, which were gathered at the time of her father's death.[27]

The retention of the echo of a functional form is important. Whereas the techniques used in making glass, ceramics and wood tend to create hollow shapes, in making baskets the shape of a container is the outcome of a conscious decision. The materials used in basket-making have always tended to be humble and found in the locality. The mental expansion into the environment and back through time is important to many cutting-edge makers. In an exhibition from 1990, many of the basket-makers cited Gaston Bachelard as a spiritual mentor. His book, *The Poetics of Space*, explores the emotional and imaginative power of enclosed spaces.[28] Bachelard discussed nests and shells as being primal and bringing out the things that are most animal in us. Drawing on the journals of Thoreau, he considered the added excitement humans feel about a tree when it includes an inhabited nest with the birds pursuing their simple but busy lives. From these musings, he drew the reader into dreams of security and inner contemplation with the suggestion that the forms

themselves can be springboards for thoughts.[29] It is the interaction of materials, form and process that creates the layers of resonance.

Writing in the early 1980s, the basket-maker John McQueen also presented the idea that containers were both physical objects and mental states. For him at that time – he has since created installations – a basket had to be a vessel with both an inside and outside. Echoing a common understanding in craft on both sides of the Atlantic, he thought of these as universal forms; we contain thoughts, we are contained on the earth and in the atmosphere.[30] However, although acknowledging basket-making traditions and respecting a lifestyle that relates to that of the early pioneers, he has always created work that is *about* nature and relevant to today's practice. McQueen's understanding of nature has been constructed over the years through living and working in a rural environment, and the process of collecting basket-making materials acknowledges the seasons and the rhythms of life. As in the work of English makers Polly Binns, Cynthia Cousens and Jenny Beavan, this understanding of the natural world and depth of knowledge of particular places based on landmarks and seasonal variations has resonance with the phenomenological ideas of Christopher Tilley. Through having an intimate working relationship with the environment, an understanding based on all of the human faculties is developed.[31] For McQueen, the rhythms of life become part of the whole process of making.[32]

This interconnection between art and life was explored in a lecture that McQueen gave in 1988, where he discussed living in the country, chopping his own wood, living without electricity and sawing blocks of ice for his ice house. These were fundamental aspects that underpinned both his life and work.[33] However, although McQueen was clearly living in a manner similar to the early settlers, the baskets that he made at the time, from the bark forms shaped around logs to the containers made of burdock burls, were not meant to be functional. They were the vehicle for translating the sensations of a particular place, often near his New York State farm, and investigating the fragile truce in the control that man attempts to exert over nature.[34] These ideas relate to both Henry Thoreau's *Walden* and the ideas of William Gray Purcell discussed in Chapter 3. They are fundamental in the cultural understanding of a particular American dream, and resonate across the different styles of craft.

Like many basket-makers in recent years, McQueen has moved away from just creating vessels and using only natural materials. He has made installations, used words, created drawings in the air with natural materials and has introduced plastics, and yet the materials themselves are still fundamental to the message. The basket-maker and sculptor Gyöngy Laky also uses a variety of approaches. Her work combines small pieces of wood that she collects from orchards, trees in parks and along streets, as well as industrial hardware. She is interested in the relationship of humans to nature and, like many of the makers discussed in this chapter, is concerned about the environment and would like the relationship to be more positive and wise.[35] However, her international upbringing has made her work less connected to

specific American myths and more linked to global questions of the world around her.[36]

The messages are both local and political, and it is the manipulation of the materials that create these tensions. To attach the small pieces of wood that make up her work she uses a variety of manufactured connectors, which serve to define the constructed nature of her work. In *Spike* of 1998, she attached pieces of apple prunings together with long vinyl-covered steel nails that protrude in a forest of sharpness. The fierce physical forms are then mirrored by the cast shadows. The knubbly contours of the plum prunings in *Valley House* of the same year have not been interrupted, as they are held together by hidden drywall bullets.

It is this tension between nature and industry that is so frequently evident and continues in her recent work like *Cradle to Cradle* of 2007 (Figure 5.2).

5.2 Gyöngy Laky, *Cradle to Cradle*, apple wood, commercial wood, screws, 15.5 in. × 30 in., 2007. Photograph by Ben Blackwell.

The title of this work was inspired by an environmental book by William McDonough and Michael Braungart.[37] Like so many of her sculptures, there is a tension between dialogues about place and more international concerns. For years she travelled along a road where the orchards were annually pruned and the branches burned, and she became interested in the environmental issues concerned with these husbandry techniques.[38] However, beyond these localized instances of waste and degradation

of the land is a more global understanding of the implications of environmental and political decisions. Apple wood prunings 'cradle' the machined commercial wood. The outer and inner layers are connected with screws and suggest the tension between human manipulation of resources and nature. *Cradle to Cradle* combines local waste with industrial products that are both uniform and international, which lay bare the relationship between the local and global, and between nature and man.

For all the makers discussed in this section, it is the emphasis given to the materials that remains the defining factor for creating meaning. Each artist expresses the importance of man's relationship to nature and how that can become less exploitative. Nordfors Clark, McQueen and Laky epitomize a number of significant trends in contemporary crafts. These include concern for the environment, a respect for traditions that were less intrusive, a link back to earlier pioneering ways of life and a more global outlook. All three have also combined these concerns with personal memories. However, it is the materials that have been used in unusual ways that act as mediator. As the founding director of the Renwick Gallery, Lloyd Herman has written, it is the freedom to cross the boundaries of material and process that exemplifies craft today.[39]

SPACE

As discussed in Chapter 1, one of the crucial and distinctive features of America is its huge scale and awe-inspiring natural phenomena. To the early settlers, not only did the landscape, especially in the west, differentiate America from Europe, but it was also seen as an escape from the oppressive and hierarchical side of civilization.[40] The sublime paintings from the nineteenth century, as well as those of the post-war Colour Field and Abstract Expressionist painters that expressed this grandeur, were so successful in their emotive gestures that they seemed to diminish the expression that craft was capable of achieving.[41] Their functionality, domesticity and interaction with social events meant that crafts in general were outside the orbit of these grand statements. However this was challenged in the controversial catalogue to the touring exhibition *American Pieced Quilts* of 1972.[42] Through taking the quilts away from the domestic environment and hanging them on the walls of galleries, pieced quilts, described as 'distinctly American', were praised for their formal qualities which were seen to echo those of contemporary art, particularly in their use of colour fields and understanding of negative space and formal abstraction.[43]

While the exhibited works were non-illustrative, image-making – which was scorned by Greenberg in his efforts to ratify the work of Abstract Expressionism – has always been most evident in craft mediums that have a suitable surface.[44] The tradition, scale and technical possibilities of quilts and woven hangings have meant that textiles have dominated this field. However ceramics, both because of the literal link with the earth as well as the opportunities of the fired surface, have also entered

into the debates, although their depictions have tended to be less about evoking awe and more concerned with geology or a personal link with place.

While traditional quilts were primarily functional, they have always been a valuable means of self-expression with social importance. Not only were there regional variations in forms but the works could be commemorative, have political messages, document local births and deaths and link to natural phenomena.[45] Between the wars there were many striking quilts made that were personal statements about the depression, political promises and industry.[46] After the war, with the craft revival and the development of the women's movement, quilts and other works made by traditionally female processes became legitimized as art. In the words of Lucy Lippard: 'the quilt [became] the prime visual metaphor for women's lives, for women's culture'.[47]

It is this everyday aspect of both its domestic and social history, as well as the softness of the cloth that has kept many makers working in the medium. Even when quilts are shown on the wall they still emit a 'touch reflex'.[48] Like all crafts, their sensuous qualities can connect the viewer not only with personal memories but also to the frequently overlooked bodily awareness of the world that runs parallel to our intellectualized, verbal and abstract society.[49] As Anne Brauer recently commented, most people have a memory of a quilt that they have lived with. As well as the remembered feel, quilts are also associated with sleep and comfort, as well as family and childhood.[50]

Many makers since the 1980s, especially women quilters, have explored the theme of a personal relationship with the natural world. Judith Tomlinson Trager, for instance, created *Lunarscape* in response to growing up on the western edge of the continent, where one might see ten thousand stars curving off into the horizon. The quilt itself is constructed in a close spectrum of blues and purples with pale dots and clusters of patterns.[51] What is important is the expression of the vast expanse of space. She has created many other pieced quilts to suggest the light on a landscape or the expanses of fields or sea. Nancy Halpern's quilts evoke both the undulating patterns of sea and land, but also the scents that she has smelt as pine or humus is crushed underfoot. Linked to the aims of other makers, she has written: 'My work crystallizes a moment of actual observation, but more often the observation is the core, surrounded by its possibilities.'[52]

What unites Trager and Halpern, in spite of their different locations within America, is the personal response to space and place, the gradual embodiment and understanding of an environment that is expressed in the work. Just as in the work of the English makers Cynthia Cousens, Polly Binns or Jenny Beavan, the objects that are made over time, using skill and tacit knowledge, express their feelings of the larger geographies around them. However, the differences in work are related to geography. The vast space in American landscape that continues to be immortalized in photographs like those of Anselm Adams, in Western films and on the web pages for the National Parks, is an important facet of American identity.

5.3 Ann Brauer, *Views of Spring*, cotton, cotton batting, 96 in. × 96 in., 2006. Photograph by David Caras.

Anne Brauer's quilts also contain these aspects and are related to both her childhood memory of the flat landscape that surrounded her in Illinois and to her present landscape in western Massachusetts. Living in a remote village in the mountains, she likes to get up early and watch the dawn, believing that we have an intuitive and personal bond with land and nature.[53] It is these feelings that are then translated into her work. Her quilts in the *Prairie Series* evoke the limitless space of flat landscape, with large skies and low horizons (Figure 5.3). These are not specific landscapes but are abstracted; the repeated small facets of cotton with their given printed textures set up rhythms within the textile. In order to suggest space she grades the tones and textures. In *Views of Spring* of 2006 for instance, the 'sky' moves from dark at the top to light on the horizon. The 'ground' is dark at the base and again works towards the light in the distance. Cutting across these are four red pieced rectangles that represent houses.

Although her quilts reference the abstract paintings of Kandinsky, Klee, Monet and O'Keefe, they are still true to the roots of the medium. She grew up sleeping under a postage stamp quilt made for her by her grandmother. Because the pieces were so small, there was always something new to see.[54] In her recent work the individual pieces are also small, and although not hand-stitched the quilts made from these connected fragments represent time and skill. These are personal works that gradually evolve from the memory of a feeling and what works at the time of making.

The ceramicist Wayne Higby has used the surface of his vessels and pieced sculptural works to suggest landscape and space. The rhythmic block patterns relate both to the influence of Oriental and Islamic art as well as to the places where he has lived. He has been inspired by the stillness and rhythmic decoration of the former, as well as the traditional Chinese disregard for the middle distance.

His work has changed according to his location. He grew up alone near Colorado Springs with the sky and broad expanse of the bluff. The light was so clear that the forms appeared to have edges, which he translated into the bold crispness of the patterns. Since moving to Alfred in New York State, he has been influenced by the softer light which he has translated into softer colours and edges.[55] However, these are not meant to be literal evocations of place. His bowls from the 1990s were a distillation of his memories of the western landscape, with the suggestion of geological strata and the imagery flowing across the inner and outer surfaces. Like the quilt format, the vessel form was just a point of departure, a way of resonating with a comfortable and familiar object and exploring imaginary landscapes.[56] Like textiles, the processes involved in making ceramics take time. These are not the immediate gestures of the Abstract Expressionists that critique the medium of paint. However, the use of textiles and ceramics are the point. As Higby has written, the artist 'strives to stand at the juncture of the spiritual and the material – to bridge the space between and create meaning where before there was none'.[57] Also like the quilts the scale is intimate, so that there is a suggestion of Bachelard's blending of two types of space, that of the inner immensity of daydreams and the imagination that gives real meaning to the intimate understanding of the outer world.[58]

ELEMENTS OF NATURE

Traditionally, elements of nature have been incorporated into crafts for decorative means, as an expression of skill and creativity, to add status and to give pleasure.[59] However, in some recent American practices, elements from nature have been used to consider ways of looking and methods of cataloguing that date back to the start of museums. Collections in museums separate natural objects from nature and place them within human-controlled systems of ordering knowledge. They interpret the world and create frameworks of cultural identity. Unlike the work of Yinka

Shonibare, who was discussed in Chapter 4, the works that I will consider here do not critique accepted myths, but acknowledge scientific systems of viewing the world and use these in order to consider broader themes. In this section I will be discussing jewellery and how particular makers have again used the roots of their discipline in order to consider the issues.

The metal smith Deb Todd Wheeler has gained much inspiration from her own suburban garden and thinking about the nature and communication of creativity. Her *Seven Variations on a Theme* of 1995 to 1996 were seven rings that were interpretations of floral forms, which combined ideas of display with nurture (Figure 5.4).

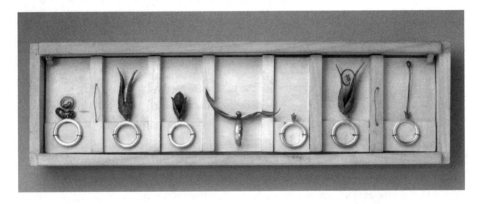

5.4 Deb Todd Wheeler, *7 Variations on a Theme*, wood, copper, silver, olive pit, gold, pearl, 1995–1996. Photograph by Dean Powell 1996.

The idea of exploring one simple form and letting it evolve in different directions was inspired by both the sculpture of Constantin Brancusi and the sonatas of Beethoven and, like their works, each element should be seen in relationship with the others.[60] As in many of her works, she has used one of the traditional themes in jewellery of encasing and preserving something special, but instead of a locket-like device she encased each ring into a specially made case that she thought of as being like a shipping crate, crude but serviceable. Having learned that termites take their wings off to feed to their young, she translated that idea of nurture into these rings, surrounding the 'growing' shoot with wing-like forms. Rather than being literal translations of natural forms, these were meant to suggest metaphors and create a tension between the possibility of touch and function – as rings – and their encased, gallery state.[61]

Wheeler's *Acorn* of 2000 continued with the theme of display. However, in this work there was a suggested narrative that entwined the life cycle with the process of making. Using a 3D rendering program called Form Z, she plotted one of the acorns that fell from the tree in her garden and then asked the program to generate forms

from this to be etched onto copper. She then manipulated the flat, etched sheet back into a three-dimensional form, which bore no resemblance to the original nut.[62] In spite of the sophistication of the machinery, it was unable to reproduce an acorn, or indeed generate anything more than an abstract form. Each compartment within the display box contained an element of the process from tree to acorn to final copper object, using diagrams, images and small sculptural forms. This apparently scientific way of presenting nature – which underpins museum display – could not however 'explain' nature. At the heart of the work is a sense of awe about the mystery of life.

In both works it was her surrounding environment that formed the basis of inspiration. The pruning, choosing and editing that are essential in the process of gardening also have parallels in designing and making, where editing and learning from failure are important in realizing dreams and understanding possibilities.[63] In forming an artwork in metal or in the garden, one is combating as well as collaborating with material possibilities, and in both evolution takes place. Wheeler has spent time in the Harvard Museum, which has an extraordinary collection of glass botanical specimens.[64] Here the material has been used in order to give an impression of natural plants that have been selected, cut and will forever be viewed in their perfect state. Unlike the work of Wheeler, or of many botanical books, they do not show the progress of life and creation.

Rather than suggesting the forms of nature, Sandra Enterline and Jennifer Trask have both incorporated natural elements into their jewellery in ways that suggest cabinets of curios and museum collections. Enterline uses snake eggs, partly concealing them with metal casings in *Ten Mile 4* and *Shell Shop* of 1995. She has also included insects into her work, usually pairing them with 18-carat gold. It is the juxtaposition that is important – a visual and mental vibration about what is precious, the concept of nature versus culture, as well as the material attributes of both.[65] Jennifer Trask has also encased natural elements, including minerals, insects and feathers, into small, locket-like cases that both suggest taxonomy and highlight the intrinsic beauty of the materials. These works also suggest the scientific cataloguing of collections through having their chemical code etched into the back of the small cases. As she has written: 'My work usually focuses on color and textural combinations or "phrases". The pieces define a subjective taxonomy of aesthetics; a catalog of texture, color and light derived from a sense of wonder and an obsessive need to collect.'[66]

Like Wheeler, she wants to create a sense of wonder about the natural world, and although both suggest cataloguing and viewing systems, and acknowledge the roots of jewellery traditions, Wheeler's work is designed to be seen in a gallery space, whereas Trask's collections of found materials are meant to be worn.

Trask's *Wunderkammer Necklace* of 2006 includes a range of both found and 'high' jewellery materials like gold and silver, carnelian and hessonite garnets, various insect wings, crushed shells, a shed snakeskin and appropriated jewellery pieces (Figure 5.5). Many of these were gathered from the rural and mountainous area of

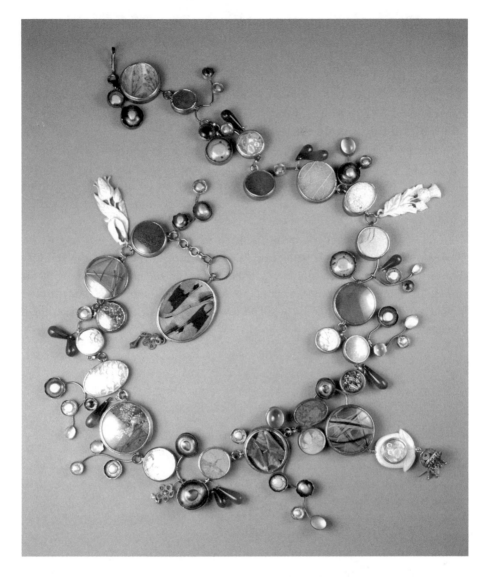

5.5 Jennifer Trask, *Wunderkammer Necklace*, silver, 18K, 22K, 24K gold, copper, shakudo, steel, mica, pigment, eyeshadow, found objects, bone, Pandora moth wings, re-appropriated found jewellery parts, glass eyes for fish and reptiles, shed snakeskin, moonstones, metal powders, Anea archidona butterfly wing, dragonfly and cranefly wings, carnelian and hessonite garnets, 2006. Photograph by Sergey Jivetin.

the Hudson River valley in which she lives.[67] The variety of what she collected and then displayed suggest the eighteenth-century cabinet of curios, where gentlemen amateurs would display odd natural specimens. Other necklaces have suggested themes. Rather than being just an aesthetic choice of components, the elements of *Lunaria Necklace* of 2007 have all been chosen for their association with sun

or moonlight. As well as minerals like mica and diamonds that reflect and refract light in different ways, other more humble but iridescent materials like damselfly wings have also been incorporated. Again, the individual lockets are engraved on the back. This use of collection and taxonomy as the basis of work has parallels in 'fine' art with the work of Mark Dion. In his works, he suggests the framework of an archaeological dig or a naturalist collecting specimens so that the audience interacts with it as if it were real. In the jewellery of Wheeler and Trask, there is not that artificial construction of professions and suggested expertise to lure the audience into a system of relational aesthetics. Jewellery, as all craft genres, has always interacted with people, as something to be worn, given or as a vehicle for preserving something precious. The scale has also been a way of intensifying gaze and creating a focus for something special.

In all of the work that has been discussed in this chapter, sight is important. However, underpinning this is the importance of implied touch and the relationship to the everyday, where the echoes of function and memory resonate with the viewer. The materials used in these crafts are frequently commonplace, but the ways in which they have been manipulated and invested with time and care, makes them precious.

6 URBAN CRAFTS IN AMERICA

This chapter will discuss contemporary American craft that reflects the experience of American cities. While there are some parallels to urban work that has been made in England, the forms of American cities, the diversity of climate and society, and the differing artistic influences and social imperatives have meant that there are also distinct differences. Between the wars there was a large influx of architects, designers and makers from continental Europe who brought with them the Bauhaus-inspired, formalist tradition as well as strong ideas about the role of craft in society. While there is an important area of practice that is linked to these influences, another, distinctly American, practice has also developed since the 1960s, which incorporates narrative devices to question politics and society. This chapter will discuss these trends in contemporary work and consider the relationship with its social roots and with contemporary fine art. In order to discuss these areas of practice, the chapter will be divided into two subsections, the first about the links with the material city and the second about narrative devices.

Objects: USA of 1970 was a pivotal touring exhibition of 300 works, which introduced a cross-section of American craft to a broad audience.[1] Although there had been regional juried exhibitions of crafts, this exhibition brought together regional styles and influences into a cohesive pan-American group. It also served to endorse work that had taken craft away from folk art into the world of contemporary art.[2] Many of the exhibiting practitioners were concerned with exploring the possibilities of the materials, but of most interest for this chapter were the cross-disciplinary conceptual threads associated with the urban environment. These include the use of the surface for narrative, the use of found objects, anti-establishment Funk and the formal qualities of geometry.

THE GRID AND GEOMETRY

The look and feel of the urban environment provides the context of the lives of the inhabitants and reflects back on to them who they are.[3] Until the urban crisis of the 1960s cities were thought to epitomize America, through the energy, mechanization, hard surfaces and corporate power. The surface of this, the aesthetic, changes rapidly with what Baudrillard has described as the 'obsolescence of desirability', but the eternal structural elements – the underlying geometry and links with serial

production – remain intrinsic to urban surroundings.[4] It is these elements that formed the basis of the Bauhaus, Swedish and other northern European vocabularies, together with the ideological role of craft working for industry. These were also the influences manifested in the early work of English makers like Michael Rowe and Glenys Barton.[5] The huge influx of designers, architects and crafts practitioners from Germany, Holland and Scandinavia before the Second World War had a great influence on post-war American practice.[6]

Cranbrook Academy of Art was one of the foremost educational establishments promoting the links between art and industry. It was founded by George Booth and the Finnish architect Eliel Saarinen in 1932. Booth had been influenced by the ideas of the Arts and Crafts movement of good design for all and honest craftsmanship as a basis for a responsible collective life.[7] However, like many from northern Europe, rather than looking to styles of the past, he believed that in order to improve the quality of manufactured goods, there needed to be the input of those with design and material knowledge. Booth persuaded Saarinen to become president of the college, with the aim of educating students to design craft for industrial production.[8] As a result, many of their graduates designed objects that reflected the simplicity, geometry and functionality intrinsic to an industrial aesthetic, and were intended for urban domestic spaces or corporate arenas. By the late 1930s, the first generation of emerging students included the eminent furniture-makers Charles and Ray Eames and Eero Saarinen and, a decade later, the basket-maker Ed Rossbach and the fabric designer Jack Lenor Larsen, who was to become a vital figure in forging links between craft and industry.[9]

Larsen graduated from Cranbrook in 1951, after which he moved to New York and founded the Larsen Design Studios. While at Cranbrook, he used a power loom extensively as a means of translating experiments initiated on his handloom to textiles for mass production.[10] As the textile workshop at the Bauhaus discovered, a work developed on a handloom can grow organically and be unique, but when developed for industry it needs a plan and the capacity to be altered.[11] Larsen was to continue to create ideas on the handloom prior to their translation for industry throughout his career. Writing in 1961, he commented that at a time of automation and space travel the idea of weaving by hand, and cutting up and piecing together fabrics was archaic and limited. He believed that craft needed to reassess its ideas.[12]

Larsen initially aspired to be an architect and, like the Bauhaus textile designers, has used unusual combinations of materials, densities and structures to provide tactile and visual counterpoints to architectural forms. Like Anni Albers, he felt that designers should make a disciplined response to the material, think about the practical functions as well as create work that visually warmed the immediate environment.[13] In spite of designing for industrial production, his work has never been slick and uniform. Revealing the links with hand production, his designs have included 'knubbly random-weave upholstery fabrics, bold and grainy batiks, springy mohairs, rugs of tufted leather, sensuous velours and velvets, airy cotton hangings'.[14]

Some of Larsen's works were created in response to individual commissions, and many of these were for hard-edged, modernist interiors and public spaces. As such, they have differing roles. For instance, the series of wool panels he designed for the Unitarian Church in Rochester in 1962 needed to reflect the mood of spiritual contemplation and warm the grey concrete surfaces. This plain modernist building designed by Louis Kahn, was top lit and very reverberant. Reflecting the Bauhaus experiments with texture, colour, material and weight to make textiles suitable for different purposes, the heavily textured rectangular panels hung on three of the walls and, through combining yellow, red and blue yarns, covered the full colour spectrum. Thick batting was hung behind them to dampen the sound.[15] Larsen made another series of panels for the lobby of Sears Bank and Trust in Chicago of 1974. Here people would have either been passing through or waiting in a queue. Like the church, however, the textiles also needed to dampen the sound that echoed from the hard surfaces.[16] The twenty-eight bright, grid-like, quilted silk hangings were made for an environment of marble, glass and steel. Their soft texture contrasted with the square elements and warmed the uncompromising architecture.

Like many American fabric designers of the era, such as Margaret Burlew, Kay Sekimachi and Elien Siegel, Larsen also designed open-weave materials to hang in the large windows of Modernist buildings. Rather than having thick curtains that blocked the light and views, or works that were designed to attract attention, these translucent fabrics provided three-dimensional interest without dominating the rooms. It also meant that the exteriors of the buildings were not contaminated by the visual interference of heavy curtains. *Bahia Blind* of 1959/2001 was woven with twelve-inch weft floats between spaced warps, with the result that the material hangs with rhythmic cascades and casts fine shadow patterns (Figure 6.1).

6.1 Jack Lenor Larsen, *Bahia Blind*, linen, silk, rayon, 1959/2001. Photograph by Molly Chappellet © 2007, courtesy of Long House Reserve.

Cumulus and *Nimbus* both from 1991 combine clear saran monofilament yarns with those that shrink, so that when treated a waffle-like effect is created.[17] The open weave of both casts shadows that soften corporate interiors.

As well as craft and design providing a visual counterpoint to the hard-edged material city, many practitioners have made gallery objects that encapsulate the forms of the urban environment. America during the early twentieth century was the powerhouse of industry, with Manhattan being the home of industrial design between the wars. The national pride in this work, which placed American design ahead of the rest of the world, was underscored in the East Coast exhibition of 1932, *Design for the Machine*.[18] However, some of this was an illusion as many of the objects shown, which appeared to have been manufactured, were actually one-off pieces.[19]

Many of the contemporary practitioners who have chosen to make their work reflect industrial forms and hard surfaces have worked in metal. Jewellery, with its history of Art Deco geometry, its frequent use of synthetic materials and small, repetitive elements lends itself to the evocation of large-scale urban structures. The early developments were from northern Europe, as in the use of industrial materials by the Dutch makers Emmy van Leersum and Gijs Bakker in the late 1960s, the geometric and rational brooches of Swedish designer Siggurd Persson or the work of the Danish designer Bent Exner. There were three main trends in American studio jewellery in the 1970s: the use of organic shape, the referencing of non-Western tribal traditions and the use of architectonic and rational forms.

Recent American jewellers who have made work with a machine aesthetic in-clude Zack Peabody, Claire Dinsmore and Eva Eisler. Like the others, Zack Peabody suggests the formal structures of bridges, skyscrapers and scaffolding in his precise, engineered and logical brooches. His *Brooch 348* and *Brooch 534* of 1992 and 1993 respectively consist of machine-produced geometric elements fastened together like complex building structures. The incorporation of small nuts and bolts makes their construction – indeed over-construction – obvious in a similar manner to a mini-ature engineering kit.[20] In these apparently industrially produced works, there is a paradox. They are individual pieces that have been constructed by hand, but the maker's mark is denied and the seemingly endless repetition possible for the elements suggests, like mass production, the lack of an original.

The jeweller Boris Bally has engaged with both the social and mechanical aspects of urban life. Like Peabody and unlike works made in England, which from the 1980s have tended to use tough and gritty vocabularies, these works are made with precision and they gleam. This form of beauty, which in Europe has become almost a taboo, is prevalent in American practice and used for a variety of ends.[21] In the case of Bally, he is interested in medical equipment – an aspect that has personal meaning – and likes to contrast structural and mechanical components with high and low materials.[22] He has made a number of *Artform* pieces that use mechanical devices to compress the arm. The latest, *Fixator Artform*, mocks medical paraphernalia by

including elements that are usually the reserve of heavy machinery like the external rods tipped with hoist lift eyelets.[23]

The series of tripod wearable sculptures was initiated in the late 1980s, and included ones that suggest robotic parts, medical equipment, or go beyond this by suggesting the possibility of crushing the arm. *Constrictor Artform* of 1990 was unusual at the time in that it was born from the idea of a voice-activated claw that would open up and caress the wearer via sensing devices (Figure 6.2).[24]

6.2 Boris Bally, *Constrictor Armform*, silver, brass, titanium (fabricated, cold-joined, tube-settings, oxidized), rubies, 11 in. × 11 in. × 2 in., 1990. Photograph by Dean Powell.

As well as the important traditional element of touch in jewellery, the medical precision of the three components that mechanically hold the circular form away from the arm take it away from the sensuous towards the coldly medical. However, the materials of sterling silver, rubies, oxidized brass, anodized titanium and stainless steel springs also suggest an ambiguity between precious jewellery and medical practices. This rich mix of materials, both high and low, precious and everyday, confounds the traditional ideas of status in a manner similar to works from the Neo-Dada movement in Switzerland. The shiny precision of the combined elements also creates the illusion of a web of coherence.

In contrast to this hard urban aesthetic, Sandra Enterline has made jewellery that dampens the precision and uncompromising geometry of her work through combinations of materials, as well as softening the surface through sanding and brushing. She has done this in her *Caged Sphere Bracelet Series* of 1992, which combined gold balls trapped in sterling silver frames. As is usual in her works, there is a complex play between interior and exterior. However, rather than being hard and challenging, these works are surprisingly poetic.[25]

In all of these works, the industrial look was created through building on a modernist aesthetic of precision, repetition, loss of the obvious hand of the author and geometry. The original European movements of Constructivism and Bauhaus that are suggested in these works, contested the bourgeois principles of art being autonomous and made by an expressive artist, through rationalization and the use of industrial materials.[26] For them, the machine promised a new future. However, although the aesthetics of the contemporary works and those from the earlier movements are similar, the conceptual ideas are different. Rather than the utopian visions of de Stijl or the Bauhaus, works made in the post-modern, post-industrial era reflect individual approaches. Behind the appearance of non-subjectivity there is a maker who has tamed the materials and forms to reflect, or create, a dialogue with the lived environment.

NARRATING THE CITY

Storytelling has always been intrinsic to American culture. In nineteenth-century crafts this was seen particularly in quilts, where stories of social relevance were often illustrated. The importance of the narration of everyday events using means that appealed to everyone was shown in the popularity of sentimental novels, bawdy irreverent almanacs, titillating crime pamphlets and bodice-ripping novels.[27] This omnipresence of 'trash' in the nineteenth century was the beginning of a cultural revolution that took culture and art out of the narrow confines decreed by the educated elite and into the arena of mass entertainment. This trend was to be continued in the twentieth century.[28]

The resurgence of popular imagery in crafts as well as fine art again came to the fore during the 1960s and 1970s in a backlash against European influences and a search for vocabularies that were specifically American. During those decades the American dream was shaken by political assassinations, the new militancy of African-Americans and other minority groups, the Vietnam War and economic crises.[29] These events fuelled new forms of political expression across the arts, with artists like Roland Haeberle and Hans Haacke making work that cut to the core of political power and decision making.[30] Pop artists like Andy Warhol and Roy Lichtenstein made gallery works that questioned accepted political, military and police powers. Richard Kostelanetz wrote that the younger generation of artists, musicians, choreographers and film-makers were rebelling against the apparent

decadence and irrelevance of established art. Art should no longer be about self-expression that would communicate with a select audience, but should relate directly to issues and debates current in the world.[31] One of the main tools used in the visual arts was irony, which was adopted by the artists of the Funk movement in California.[32] The ceramic works shown in their first exhibition in 1967 were irreverent, anti-establishment and satirical. Although fundamentally a West Coast movement, it was to be influential throughout the States.[33] Funk was not meant to be intellectual but, as Harold Paris wrote, 'It's a groove to stick your finger down your throat and see what comes up.'[34] Drawing on Dada and Surrealism, as well as more recent art movements, Funk artists wanted to challenge the perceptions of the world by putting familiar objects into unfamiliar contexts.[35] They showed their stance not only through the imagery itself, but through reacting against discipline-led skilful practice.

This revelling in uncouthness, in not conforming to established rules and using non-standard language as a means of critique was not new, but again had its roots in the literature of the nineteenth century.[36] By using image, narration, wit and satire, craft was positioning itself alongside fine art in a way that was impossible when Abstract Expressionism was at its height.[37] What was also important was that, unlike in England, there was a large anti-pottery faction that scorned the vessel form in favour of sculpture, and so marginalized the practice or discussion of 'craft', 'function' or 'pot' until the late 1970s.[38]

Robert Arneson, the father of Funk, created works which focused on scatological references like toilets and penises. Not only was the imagery crude, but the techniques and finish meant that these works appeared unrefined. His clumsy penis teapots and crudely painted genital trophies were statements of exorcism against the fine production and narrow ideas that underpinned the systems of juries and invitational exhibitions. His *John Figure*, a rather surreal, organic toilet that appeared as though it might devour the incumbent, was not accepted by the 1963 Oakland exhibition as it was thought to be an attack on American capitalism.[39]

The humorous use of comic book imagery in ceramics and fine art was paralleled in another movement that emanated from the West Coast: finely wrought ceramics that used visual gags to comment on society. Ron Nagle and Jim Melchert helped this move from stoneware to fine-grade white work in the early 1960s, where the surface could be used for a variety of treatments and images.[40] Richard Shaw, for instance, created the detailed and highly finished *Sofa* series that included *Ocean Liner Sinking into a Sofa* of 1966. Patti Warashina made *Car Kiln* in 1970, which was a speeding brick car with golden hair streaming out of the windows. The name and image is a pun about a type of ceramic kiln as well as being a witty depiction of the type of person who would have owned the car.[41] In the works of both Shaw and Warashina, they placed their characters acting out a fragment of life or a drama made up of a pun onto miniature stages. These humorous juxtapositions owe as much to the irreverence of Funk as to a Surrealist slippage of reality, and were as much about

ways of seeing the world as what is seen.[42] Rather than being a sequence of events, here the storytelling is through paradox as used by poets or dramatists.[43] Matt Nolen is one of a number of makers, like Red Weldon-Sandlin, who has continued this tradition of finely formed china and narrative. While using the functional form of the vessel, his objects are elaborately painted in bright colours and consider serious issues about politics and society.[44] His *Apothecary Jar no 2: Ozone* of 1992, for instance, uses the surface of the vessel to consider the issue of pollution. Reflecting narrative devices that date back to ancient Greek ceramics but using contemporary forms of imagery, a frieze of cars drives around the rim, belching exhaust fumes, a sunblock bottle blocks out the sun's rays, and a skull and cross bones acts as a lid handle. Like the previous makers, he uses direct imagery and humour to make his point, but here it is less about word games or witty juxtaposition, but the use of a light touch to say something serious about a contemporary issue.

Ceramics are not the only discipline that has used finely detailed illusion to make witty comments about contemporary life. Both John Cenderquist and Wendell Castle have made furniture that use *tromp l'oeil*, but Cenderquist has also frequently used cartoon styles, such as his *Steamer (Cabinet)* of 2001 with hard-edged illustrative steam decorating the surface or *Ghost Boy* of 1992 with its decorative and illusory fragments from the history of fine furniture and associated bourgeois taste. In all of his works he plays games, using craft to mock craft and scorning the distinction between fine and popular art.[45] As much as 'fine' art critics like Clement Greenberg attempted to warn art against the trap of kitsch – the art of the urban masses – from the 1960s it became a powerful influence across the fine and applied arts.[46]

One of the brashest works of craft that combines found everyday popular objects is Larry Fuente's *Game Fish* of 1988. This large collage in the shape of a fish and hung like a trophy on a wall, is made up of patterns created by rows of plastic beads, small pieces from board games, shiny areas of overlapping coins, a set of false teeth and a glass eye, as well as plastic figures from cartoons like Popeye and Superman. The banality of the objects representing all that is superficial in capitalism were transformed through their position within the Renwick Gallery. Through being in the most prestigious craft museum in America, this work, like those by Pop Artists shown in national museums, moves from being a conglomeration of overlooked and trite objects into something that provokes thought in the viewer. However, this was part of a continuum of assertive practice that was being pursued by social groups that felt unassimilated by broader society. The incorporation of overlooked and despised trash into objects, that included the outrageous customization of cars, was a way of saying 'This is our experience'. [47] Like the dime novels of the nineteenth century, the elements are the objects of popular entertainment. Unlike those novels, these have been absorbed by 'high' culture as an ironic comment about the dominant culture.[48]

The use of everyday debris has obvious links with Fluxus, the art movement from the 1960s that had followers in the United States, Europe and Japan. The Fluxus

manifesto of 1963 wanted to purge the world of 'dead' art and the elitist notion of authorship. They wanted people to gain their art experience from the everyday, and looked to Duchamp and the ready-made object, and to contemporary figures like John Cage, George Brecht and Ben Vautier.[49] However, like the loss of the original utopian visions contained in contemporary modernist aesthetic, the social ideas underpinning Dada had also changed, and what was Dada during the early part of the twentieth century, by the 1960s had become just art.[50] The metalsmith J. Fred Woell remembers Cage giving a talk, where he read from his book entitled *Silence*. He was fascinated by the idea that everything, from swallowing to striking a match could be thought of as music.[51] Cage's ideas were akin to those of a musical *flâneur*, noting and highlighting the natural and man-made sounds that form the panoply of life and incorporating them into his work. Woell also became aware of the work of potters like Peter Voulkos who was tearing his vessels apart, jewellers like Christian Schmidt, who had made a work out of a steak bone, an old sheriffs badge and other found items and also Ed Higgin who incorporated plastic toy parts into his pieces.[52]

One of Woell's most influential early works was *Come Alive, You're in the Pepsi Generation* of 1967. Combining images and found objects, he emulated television advertisements through juxtaposing a photograph of an all-American smiling woman and Pepsi bottle caps. Taking advantage of an accident in the studio that damaged the work, he cracked the lens over the woman's face and burned the caps to create a more ambivalent message about society.[53]

Woell was and remains concerned with the environment and where the political priorities are for society.[54] Unlike functional objects, where the meaning resides in the role that they have in day-to-day life, Woell, like many contemporary artists, has used his works to question society. He does not build a narrative through illustrated parody and satire but through the juxtaposition of found objects. The title of a recent work, *The Late Great Disposable Society*, was a play on Lyndon Johnson's 'Great Society' speech of 1964, but was meant as an ironic statement to consider what is happening to the world through increased consumption and disposal of goods.[55] Lyndon Johnson had put forward a vision for American society that balanced economic growth with the importance of community, learning, an end to racism and a search for beauty in life.[56] The 8-inch panel that Woell constructed was a combination of cigarette butts, broken glass, pop cans, lids and bullet shells that all look as though they would fall onto the floor.

The greed and consumption of society, especially during the 1980s, has been commented upon by a number of crafts practitioners and was the subject of an exhibition in 1990, *Explorations: The Aesthetic of Excess*.[57] The opening of the text discussed the 1980s as a decade of excess and decadence, where society grabbed as much as it could as quickly as possible. Wealth was paraded in an ostentatious manner, which in craft was equated with elaborate ornament, decorative excess and glossy surfaces.[58]

In her series *City Flora City Flotsam* from the 1990s, the jeweller Jan Yager considered excess, the commodification of wealth, and historical and contemporary power systems through collecting debris from the pavements near her studio in Philadelphia and incorporating the elements into a series of necklaces.[59] During a sabbatical year prior to starting *City Flora, City Flotsam*, Yager travelled widely looking at jewellery from other cultures. Seeing a Native American bone necklace on her travels, she realized that the maker had used readily available elements, and decided to create an urban equivalent. Recognizing the role in identity that jewellery has always held, she looked at her local environment and saw the traces of other people's overlooked lives. While being shiny and attractive and close in scale to the elements of jewellery, the numerous bullets, crack vials and other objects she found on the street spoke of a system of exploitation and greed.[60] When combined, the attractive qualities seduce the viewer into looking, whereas the messages are complex. Like Grayson Perry, she believes that there needs to be a tension between ornament and uncomfortable truths in order that people will stop to look.[61]

Jewellery has been implicated in many instances of exploitation, from the glass beads used to buy slaves to the chunky and ostentatious gold necklaces worn by contemporary drugs dealers. As Yager has said, art is political, but it is also part of a continuum of life.[62] She discovered that the Lenni Lenape Indians once lived in what is now Pennsylvania, and thinking about the history of the area she found an ironic connection between past and present. William Penn's treaty with the Native Americans of 1682, which was the ratification of the sale of land, was signed close by. Tamanend gave Penn a wampum belt to signal the expectation of peaceful relations between the tribes and incomers.[63] While wampum beads were tokens of exchange, the belts were documents of important agreements. Although Penn might have made a fair agreement, the Lenni Lenape were first decimated by disease and then driven west by successive administrations.[64] Yager wanted to create memory aids through using contemporary objects of exchange.[65] *American Breastplate* is in the form of a Plains Indian pipe-bone breastplate and includes 188 found crack vials and 222 found crack tops. The cylindrical forms of the vials reflect the forms of the wampum beads. *American Collar* of 1996–1999 by Yager, which includes 139 found crack vials, 222 found crack caps and parts of two syringes, was made in a form reminiscent of Masai collars and refers to the exchange of glass beads for slaves. *Rainbow's End Collar* of 2005 is similar in form, but through being formed predominantly by the caps to the vials, is ironically bright and decorative (Figure 6.3).

It is the historical cheapness of lives that were transported around the world and enslaved to make goods, in what has become known as the slave triangle, that is suggested here. The quantity of bullets and vials found on pavements speaks of contemporary violence that is outside the law. The names and forms of the different necklaces in the series: *American Blues, American Rainbow, American Collar, American Breastplate*, all simultaneously suggest the cultural past and nationalism that still have implications today.

6.3 Jan Yager, *Rainbow's End Collar (City Flotsam Series)*, used plastic crack cocaine caps, insulin syringes, sterling silver, steel wire, 46.5 cm diameter, 2005, © Jan Yager. Photograph by Jack Ramsdale.

Pierre Nora, a historian who Yager read with interest prior to beginning the series, discusses the play between memory and history. Whereas previous societies, like the Native Americans, had memories handed down in an organic fashion over generations, contemporary Western society has lost this through urbanization and fragmentation. In its place institutional spaces, like museums and databases, exist to create a scaffolding of memory, a place where the individual can find a cultural identity.[66] Rather than being affirmative, the works by both Yager and Woell use institutional spaces to question society and its multiple identities.

Both use the attractive qualities of materials in order to seduce the audience into looking. Glossy surfaces have also been used by other makers in different disciplines, like the basket-maker John Garrett. Through using bright colours and reflective materials in his baskets, he suggests a festive quality that alludes to the excitement of city lights, parties and discos that are part of the Los Angeles environment.[67] However, Los Angeles exists in an area that would otherwise be a desert, and his interpretation is of a place with multiple layers of garish commercial clutter and imported lush vegetation. Like the Navajo weaving and Pueblo pottery that inspired him, he made his baskets from what he found at hand. Unlike their natural materials, his works include vinyl covered wallpaper, plastic bags, plastic-covered wires, copper and aluminium. *Vulcan Vine Basket* of 1986 had an underlying wire mesh structure that has been almost covered by a dense layering of other elements. The corkscrew wire growth suggests nature, but this is countered by the material. A couple of years

earlier in *Shell Basket* he incorporated toy guns into the bright plastic assemblage. Like the work of Yager, he was making a comment on the violence of society and how this has been made into a commodity.[68] Also like her, he has used the idea of drawing the viewer into the work with a bright, attractive surface and then creating the friction through the implied violence.

Joyce Scott uses the attractive material of beads to create diminutive scenes that are frequently related to the physical and emotional violence connected with being African-American.[69] Her *Nanny Now, Nigger Later* of 1986, for instance, shows a doll-sized figure of a black woman holding a white baby. The baby might be happy to nestle now, but as she grows up, she will see race before human qualities.[70] Scott's *Nuclear Nanny* of 1983–1984 also considers violence, but here it is more global (Figure 6.4). Still diminutive in scale and using bright and shiny beads, she was questioning the misuse of nuclear power that might detrimentally affect the planet and future generations.[71] Nannies protect, but here the figure is skeletal. Like Yager, Scott uses the shininess and alluring qualities of the materials to seduce the viewer into looking, before realizing that the messages are uneasy. Scott does not use backing or internal armature, as used by the Yoruba, but for her sculptures she wants the light to shine through to make them more enticing.[72] *Nuclear Nanny* is not a sculpture, but a flat embroidery like a Mola. Yet again the brightness of the cloth, stitchery, sequins and beads draw the viewer in and can be read at several levels. Molas are the bright blouses of the Kuna tribes who live off the coast of Panama and Columbia and their textiles show swirls of embroidered linear designs.[73] Just as the beads in Yager's *American Collar* referred to the slave trade, here the beads are related to the ritual content of African and Native American cultures. As well as the material qualities, the small scale of the works is also important. Susan Sontag has written that smallness can be both distancing and, conversely, emotionally charged. Violence and oppression are things that are frequently kept private, so that smallness can suggest shame.[74] Although all of the works are domestic in scale, they would be uncomfortable in those surroundings. The narratives simply hold too much weight.

This chapter has concentrated on craft that has used the experience of the city to consider larger issues. While the geometry and hard-edged quality of the work linked to a modernist aesthetic was fundamentally European, the works with a narrative content draw on distinctly American traditions. However, this is as complex as American society is diverse socially and ethnically. Since the 1970s minority groups have been asserting their voices, and this increased awareness and visibility of different craft traditions has had a great impact on the diversity of styles and ideas that are displayed in contemporary American crafts. The fact that craft has been integral to the lives of different groups gives it an important voice to articulate difficult cultural issues. As Joyce Scott has articulated 'It is important to me to use art in a manner that incites people to look and then carry something home ... I can, hopefully, help get you ... to open your brain. I think that's what all artists do.'[75]

6.4 Joyce Scott, *MOLA, Nuclear Nanny*, mola (fabric, embroidery thread), sequins, beads, 82.6 × 59.7 cm, 1983–1984, Baltimore Museum of Art: Amalie and Randolph Rothschild Accession Fund (BMA 1984.63).

7 URBAN CRAFTS IN ENGLAND

This chapter will discuss craft that has been made in response to the urban sphere in England, either conceptually or in relation to the physical environment. The practitioners discussed have all been through higher education, so that their work acknowledges international influences and draws on contemporary debates from across the visual arts. The numerous international exhibitions, the growth in the number of galleries since the 1970s that show continental design and craft, as well as the lively craft culture that has drawn in makers from abroad, have all contributed to this rich area of practice. Unlike American craft where narrative is an important element, urban craft produced in England has tended either to be related to architecture and other constructed elements through the use of materials and hard-edged geometry, or to utilize found debris and images from the street life of cities. The former has links with pre-war modernist formalism of Northern Europe, and the latter with neo-Dada, which is a more recent continental influence for English designer-makers. In order to consider these areas of practice, this chapter will be divided into two, with the former being about the material culture and the latter about the contemporary *flâneur*.

The material city with its hard pavements, regular intersections, towering buildings and bright lights, frames the lives and consciousnesses of its inhabitants. However, as well as these physical elements, the city also embodies crowds, diversity, and the overlapping of personal and collective lives. Although cities are not uniform and are made up of different zones of activity, building types and communities, much art and design of the twentieth century has flattened these aspects into images that suggest common themes and concerns. The *papiers collés* of Picasso and Braque and the collages of the Dada artists were comprised of 'real' elements, including newspaper clippings, which spoke of city life: café music, shopping or a bus ride. The Purists and Bauhaus artists and designers affirmed the importance of geometry and order in their works, which were underpinned by their ideas that machines and rationality offered the best solutions to the social problems of the era. These artists lived and worked in city environments, and most of the practitioners discussed here do the same, revealing the links to their environments through debates around a 'pure' geometric aesthetic, or through considering social relationships.

MATERIAL CITY

The impact of modernism's machine aesthetic on craft was profound. While much inter-war writing reflected a nostalgia towards traditional materials and skills that were felt to be endangered, the public wanted to buy objects that represented 'progress', which inevitably meant machine-produced.[1] Not only was this shown in domestic ware but also in the produce that people bought. As people moved away from shopping in markets with all their associated smells and irregular piles of fruit and vegetables, they became used to goods that were made without apparently ever being touched by human hands. In this climate, handmade crafts with their nuances, natural materials and lack of bright decoration appeared reactionary.[2]

When Lucie Rie arrived in England from Vienna in 1938, her light and elegant vessels, which reflected the Wiener Werkstaat ideals of design and architecture working harmoniously together, were already gaining an audience on the continent.[3] However, in comparison to the heavy, obviously handmade earthenware pottery of Bernard Leach and his followers, they appeared to be lacking in humanity. Through turning the walls to a seemingly fragile thinness and smoothing the hand marks away, her vessels were refined, restrained and urban. Her influence, together with that of Hans Coper, who arrived from Germany before the war and taught at the Camberwell School of Art and the Royal College of Art during the 1960s, was profound. Neither of them made works that were primarily utilitarian, nor were they making links with a rural, vernacular tradition but they were drawing on international ideas from across the arts.

The new generation of graduates from the Royal College of Art and other regional art schools in the 1960s and 1970s, including Elizabeth Fritch, Alison Britton, Jacqui Poncelet and Michael Rowe, consciously positioned themselves away from an aesthetic based on Bernard Leach and Arts and Crafts principles. By 1981, 18.3 per cent of the crafts population were living and working in Greater London, where there were the frameworks to support their more international stance and conceptual bias.[4] One of the texts that discussed the different sides of the function versus concept debate was the catalogue for *Beyond the Dovetail* in 1991. Peter Dormer argued that function, skill and tradition are important as bridges of understanding between the object and the public.[5] Alison Britton's reply was that crafts need to be relevant in an era when the machine has made commonplace what would previously have been thought of as skilful, well-finished work. Although traditional forms and skills could be a basis, she felt that craft needed to move beyond these in order to be relevant.[6]

Two of the earliest practitioners to reflect these new ideals were the ceramicist Glenys Barton and silversmith Michael Rowe. Both had trained at the Royal College of Art, and then worked in London and produced studio craft as well as providing designs for industry. In Barton's first interview in *Crafts* in the 1970s, the fact that

she was working in London and reflecting the city environment in her work was discussed at length.[7] Barton had grown up in Stoke-on-Trent and so had been surrounded by the ceramics industry. When interviewed, she was investigating the possibilities of incorporating industrial techniques into her objects.[8] As well as working on a ceramic mural for the London Hilton which was geometric, precise and sober, she also made studio work on a domestic scale. These were small ceramic pyramids and cubes, with geometric patterns applied by using commercial transfers.[9] Rowe's work from this time had a literal, although dreamlike and surreal, link with architecture. Rather in the manner of a Piranesi *Prison*, his silver inkwells and pomanders from the mid-1970s created labyrinthine and dramatic architectural worlds of steps and forms within forms.[10]

Rowe's precise, geometrical, flawless vessels from the late 1970s appear to be machine-made. They conceal the hand of the author, as well as the time and skill required to make the objects, and made the link with architecture altogether more abstract. While having the traditional polished silver surface that is associated with preciousness, the only adornment are the thin bands of copper that accentuate the forms. In a manner similar to the Constructivists, whose work he admires, he has rejected superfluous details and obvious manual flamboyance in favour of engineering curves, sharp-edged angles, structure and a loss of subjective creativity.[11] The forms are also misleading, with the vessels playing with the optical effects of two and three dimensions, echoing function rather than being functional. In contrast to Leach's or Lethaby's notions of craft, where objects were created as a result of a direct engagement with the material and with the process being explicit in the final object, Rowe works out his designs first, using engineering drawings, before making the works according to those specifications. The detailing and spare surfaces have all the precision of one of Norman Foster's high-tech buildings.

While an urban craft aesthetic that linked onto broader historical and theoretical debates was new in England, many of the ideas had been prevalent on the continent for decades. At the beginning of the twentieth century, Hermann Muthesius, for instance, along with other German intellectuals like Friedrich Naumann and social theorists like Georg Simmel, had sought answers to the spiritual crisis brought about through rampant industrialization.[12] Rather than following the Arts and Crafts emphasis on handmade work that looked to the past, they sought to unite art and industry in the Deutsche Werkbund and the Bauhaus. By ordering and rationalizing design into beautiful object types, they felt that fashions and consumerism would be neutralized and social harmony restored.[13] They also wanted to create works that reflected an industrial aesthetic suitable to the era and that was universal and international. These ideas were also followed in the Dutch movement de Stijl, and in Sweden in the Svenska Slöjdföreningen.[14] This thriving continental design culture was important both for the first wave of English graduates looking for receptive markets as well as being influential in style and ideas. For instance, Glenys Barton's ceramic cubes sold well in Denmark, where they were in tune with the aesthetics

MATERIAL CITY

The impact of modernism's machine aesthetic on craft was profound. While much inter-war writing reflected a nostalgia towards traditional materials and skills that were felt to be endangered, the public wanted to buy objects that represented 'progress', which inevitably meant machine-produced.[1] Not only was this shown in domestic ware but also in the produce that people bought. As people moved away from shopping in markets with all their associated smells and irregular piles of fruit and vegetables, they became used to goods that were made without apparently ever being touched by human hands. In this climate, handmade crafts with their nuances, natural materials and lack of bright decoration appeared reactionary.[2]

When Lucie Rie arrived in England from Vienna in 1938, her light and elegant vessels, which reflected the Wiener Werkstaat ideals of design and architecture working harmoniously together, were already gaining an audience on the continent.[3] However, in comparison to the heavy, obviously handmade earthenware pottery of Bernard Leach and his followers, they appeared to be lacking in humanity. Through turning the walls to a seemingly fragile thinness and smoothing the hand marks away, her vessels were refined, restrained and urban. Her influence, together with that of Hans Coper, who arrived from Germany before the war and taught at the Camberwell School of Art and the Royal College of Art during the 1960s, was profound. Neither of them made works that were primarily utilitarian, nor were they making links with a rural, vernacular tradition but they were drawing on international ideas from across the arts.

The new generation of graduates from the Royal College of Art and other regional art schools in the 1960s and 1970s, including Elizabeth Fritch, Alison Britton, Jacqui Poncelet and Michael Rowe, consciously positioned themselves away from an aesthetic based on Bernard Leach and Arts and Crafts principles. By 1981, 18.3 per cent of the crafts population were living and working in Greater London, where there were the frameworks to support their more international stance and conceptual bias.[4] One of the texts that discussed the different sides of the function versus concept debate was the catalogue for *Beyond the Dovetail* in 1991. Peter Dormer argued that function, skill and tradition are important as bridges of understanding between the object and the public.[5] Alison Britton's reply was that crafts need to be relevant in an era when the machine has made commonplace what would previously have been thought of as skilful, well-finished work. Although traditional forms and skills could be a basis, she felt that craft needed to move beyond these in order to be relevant.[6]

Two of the earliest practitioners to reflect these new ideals were the ceramicist Glenys Barton and silversmith Michael Rowe. Both had trained at the Royal College of Art, and then worked in London and produced studio craft as well as providing designs for industry. In Barton's first interview in *Crafts* in the 1970s, the fact that

she was working in London and reflecting the city environment in her work was discussed at length.[7] Barton had grown up in Stoke-on-Trent and so had been surrounded by the ceramics industry. When interviewed, she was investigating the possibilities of incorporating industrial techniques into her objects.[8] As well as working on a ceramic mural for the London Hilton which was geometric, precise and sober, she also made studio work on a domestic scale. These were small ceramic pyramids and cubes, with geometric patterns applied by using commercial transfers.[9] Rowe's work from this time had a literal, although dreamlike and surreal, link with architecture. Rather in the manner of a Piranesi *Prison*, his silver inkwells and pomanders from the mid-1970s created labyrinthine and dramatic architectural worlds of steps and forms within forms.[10]

Rowe's precise, geometrical, flawless vessels from the late 1970s appear to be machine-made. They conceal the hand of the author, as well as the time and skill required to make the objects, and made the link with architecture altogether more abstract. While having the traditional polished silver surface that is associated with preciousness, the only adornment are the thin bands of copper that accentuate the forms. In a manner similar to the Constructivists, whose work he admires, he has rejected superfluous details and obvious manual flamboyance in favour of engineering curves, sharp-edged angles, structure and a loss of subjective creativity.[11] The forms are also misleading, with the vessels playing with the optical effects of two and three dimensions, echoing function rather than being functional. In contrast to Leach's or Lethaby's notions of craft, where objects were created as a result of a direct engagement with the material and with the process being explicit in the final object, Rowe works out his designs first, using engineering drawings, before making the works according to those specifications. The detailing and spare surfaces have all the precision of one of Norman Foster's high-tech buildings.

While an urban craft aesthetic that linked onto broader historical and theoretical debates was new in England, many of the ideas had been prevalent on the continent for decades. At the beginning of the twentieth century, Hermann Muthesius, for instance, along with other German intellectuals like Friedrich Naumann and social theorists like Georg Simmel, had sought answers to the spiritual crisis brought about through rampant industrialization.[12] Rather than following the Arts and Crafts emphasis on handmade work that looked to the past, they sought to unite art and industry in the Deutsche Werkbund and the Bauhaus. By ordering and rationalizing design into beautiful object types, they felt that fashions and consumerism would be neutralized and social harmony restored.[13] They also wanted to create works that reflected an industrial aesthetic suitable to the era and that was universal and international. These ideas were also followed in the Dutch movement de Stijl, and in Sweden in the Svenska Slöjdföreningen.[14] This thriving continental design culture was important both for the first wave of English graduates looking for receptive markets as well as being influential in style and ideas. For instance, Glenys Barton's ceramic cubes sold well in Denmark, where they were in tune with the aesthetics

of contemporary Danish makers like Karen Bennicke, who made geometrical stoneware vases with linear designs.[15] Jacqui Poncelet worked at Bing and Grondahl in Denmark during the mid-1980s and also sold her work in Copenhagen.[16] British ceramics were also being actively collected on the continent, so that the holdings at the Stedelijk Museum have grown impressively since the first exhibition there of British studio potters in 1953. The overlaps between the work of urban-based, cutting-edge practitioners from northern continental Europe and England remain great, in concepts, forms and use of materials.[17]

The exhibition *New Art Objects from Britain and Holland* of 1988, which was held in London, revealed some of these overlaps. As Gert Staal wrote, these artists were on the borders of craft and art, and were using craft materials with frequently an echo of function, but were self-aware and individual in style and ideas.[18] As the work was at the forefront of the practice of the day, little had been written about these ideas and, unlike fine art, the language underpinning and explaining them had not been developed.[19] *Paar*, by Helly Oestreicher, which was part of a series of *Townspeople*, was a pair of columns made up of found ceramic bricks and other building materials with a torn ceramic vessel on top of each. Like the untitled work by Onno Boekhoudt, made from wood, lead, paper and paint, and arranged like a still life, it reflected the link of the materials of craft to the city fabric. Gabriël Barlag's untitled work made from stiff and angular steel wire suggested pylons. Some makers, like Michael Rowe, while not alluding in a direct manner to architectural materials and forms, used geometric elements to suggest an urban vocabulary. Agnus Suttie saw his work as a protest against what he saw as government stripping everything down to function.[20] So, all the makers were considering urban themes in their own manner and using materials that linked them to the urban environment. In the essay accompanying this catalogue, Martina Margetts wrote about the recent phenomenon of urban craft.[21] In contrast to rural crafts practitioners, these works were made about city life and for an urban audience.

One of the dramatic shifts of the 1980s was the increased recognition of mixing materials and using non-precious materials for expressive means. Richard Hughes and Michael Rowe's *The Colouring and Patination of Metals* published in 1982, was crucial in this move for metalwork.[22] This thick volume set out recipes for achieving different surface results, complete with colour pictures of samples taken over time and using different combinations of chemicals. As well as recipes for silver, the reactions of chemicals to the surfaces of other materials like bronze, gilding metal and copper were also investigated with scientific thoroughness. These possibilities of texture and colour, articulated and illustrated within one book, inspired many to move away from the traditional metal finishes and their associated forms and experiment with sculptural possibilities.

Many practitioners in England, while not making vessels for functional use, kept this form as an anchor for ideas and as a means for conveying understanding about the experience of the world. Michael Rowe has discussed vessels as fundamental to

human existence and, reflecting his interest in architecture, his vessels respond to some of these concerns. 'We live and move in a world of containers, we put things into containers, we contain things and we ourselves are contained ... forms within forms.'[23] These concepts became important in English crafts during the 1980s and were discussed in the groundbreaking exhibition and its accompanying text, *The Abstract Vessel* of 1991.[24] In this, John Houston questioned the role of the vessel for contemporary crafts in a post-industrial era, as it is such a basic, timeless and archetypal prop of civilization, and yet its preciousness has been debased through mechanization. However, rather than emphasizing the craft tradition, he found that contemporary makers had looked to ideas that had been articulated in relation to other arts, such as architecture, sculpture and painting. As such, they were embracing the incongruity and awkwardness necessary in disrupting the unified safe narratives implicit in modernist forms.[25] Although the exhibition was limited to work in clay, the sculptural, material and conceptual qualities linked to debates that were current across many craft disciplines.

One of those who exhibited was Ken Eastman. His works, which combined sharply defined, intersecting forms, walls of different thicknesses and abstract painted surfaces create what Houston terms '*unfamiliar*' forms that have an internal sense of activity.[26] When discussing the work of Eastman, Alison Britton also discussed how container forms have acquired the metaphoric attachments to other things like the body or buildings.[27] In houses, the manipulation of the inner spaces is important. In Eastman's vessels, as in some works by Rowe, parts can be hidden from certain viewpoints, so that inner walls trap passages.

Rowe's complex forms, like the series of *Bowls* from the early 1980s and *Cylindrical Vessel* from 1984, appear as amalgams of structural elements that suggest the fragmentation of deconstructivist architecture (Figure 7.1). Like the architectural works of Bernard Tschumi and Peter Eisenman, Rowe's vessels can be thought of as an interlinking of parts and open to interpretation. Like them, his works disrupt the familiar functional aesthetic of modernism, so that function itself gains a broader perspective. These are not humble and noble pots, but are questions about space, with the forms and shadows emanating from within and outside the containing space. It is not only the links to broader debates and the sharply defined forms that make these works urban. The surfaces in the work of Eastman and Rowe do not reveal the hand of the maker or the 'honest' expression of the material, but are manipulated to resonate with the forms and become integral with the meaning.

This disruption to a modernist order created from a single performance at a wheel, or a unified, raised metal bowl, also questioned ideas of beauty. During the 1980s and 1990s many makers wanted to go beyond the idea of a skilfully made craft object that comforted, was a pleasure to use and was integral to life. At a time when so much in the 'fine' arts was also concerned with the everyday, with critiquing society, its habits and rituals, to remain making safe objects for a bourgeois audience was seen as tame. As Jorunn Veiteberg has discussed, 'beauty' and 'nice' became

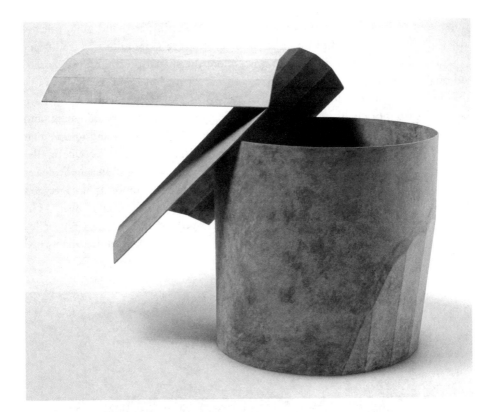

7.1 Michael Rowe, *Cylindrical Vessel*, brass, green patina, 1984. Photograph by Ian Haigh.

pejorative terms in crafts during those decades.[28] The aesthetic and timeless appeal of form being appropriate to function, of the tactile being as important as the visual, of materials being used in the best way for that discipline, which had all underpinned craft from the beginning, was being usurped by the idea of aesthetic debates separate from functional need. Kant had separated the aesthetic delight incurred from a beautiful object that had no purpose, from that where the aesthetic experience was related to an object's function.[29] This separation of the aesthetic hierarchies, which had always placed craft at a weaker position in relation to 'fine' (purposeless) art, was being challenged, both through an enlargement of the idea of function and through the engagement with broader debates.

The ceramicist Martin Smith became interested in architecture, in particular the city squares in Bergamo and Arezzo, during the 1980s.[30] His vessels, like those of Rowe are developed from precise engineering drawings, are sharp-edged, geometrical and reveal no author's hand. Also like Rowe, the forms can be deceptive as, linked to his interest in geometric tile patterns, they can play with notions of two and three dimensions. *Ceramic Object* of 1990 for instance, is about the relationships of parts, with the foil-coated interiors reflecting light inwards, and the different elements

reacting to each other. Like the works of Alison Britton, his are hand-built, but the clay body, with its pitted but smoothed surface, reflects a more industrial tradition.

The ceramicist David Binns does not explore the spatial possibilities of vessels, although there is always a hint of a vessel in his forms, but he relates his work to the built environment through material and form. So many English cities have been built from brick, like Manchester, Cambridge, London and Birmingham, and then adorned with terracotta or brick detailing. Each has a colour and texture that comes from the local materials and the way that they have been fired. Terracotta tiles are also omnipresent for housing, with the patterns and rhythms altering as newer materials are increasingly being used. Binns uses his own compounds of aggregates in the clay body, which he electronically sands to a smooth and precise finish.[31] His work, especially the boat-shaped objects like *Long Standing Form* of 1999 or his pierced blocks like *Small Pierced Black Form* of 1997, are linked to the unadorned elements of urban architecture, while also remaining sculptural (Figure 7.2).

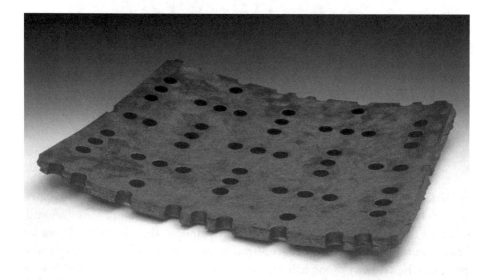

7.2 David Binns, *Small Pierced Black Form*, 1997. Drape-moulded stoneware clay with copper engobe. Photograph by Dewi Tannatt Lloyd.

Indeed, he was a technical consultant to a large tile company, has spent time with mould-makers in a brick factory and has been influenced by the visual aspects of engineering projects.[32] Like the work of Felicity Aylieff, with whom he has exhibited, the added aggregates and highly polished surfaces embody the unseen inner composition. However, while Aylieff has been drawn towards the formalized elements of architectural detailing, Binns's sculptural forms speak both of themselves as sculptures and suggest the elements of buildings. His work is minimal, as he likes the idea of striving for a quality that cannot be improved by further reduction.[33]

The grid and the repetition of geometric elements is an inherent part of the details of the built environment, from windows, to bricks and the rhythm of arcades. Many avant-garde artists from the beginning of the twentieth century used a grid as a starting point in order to distance themselves from observed reality. For Juan Gris or Jacques Lipchitz, structuring the canvas or sculpture prior to making the work was part of a 'call to order', a rationalizing discipline at the time of intense upheaval.[34] For Rosalind Krauss, this approach was a ground zero, a 'prison in which the caged artist feels at liberty'.[35] While it is restrictive and inevitably invites endless repetition, she felt that it is also a way of revealing the originary status of the woven infrastructure of the canvas.[36]

The textile artist Sally Freshwater has based her work on mathematical proportions that ensure the same lack of hierarchy that is visible in sky scrapers. She often starts a design by drawing on graph paper, using repeated motifs that track changes in the sequences of elements.[37] *Proposal* of 2001, for instance, was an architectural work made up of squares of canvas held in tension, that were themselves subdivided into grids of squares (Figure 7.3). The grid is also inherent in the materials used, with the warp and weft forming that structure. Each element is part of a spiral around a curved hanging pole. These repetitive elements link back to minimalism in that each element contributes to the whole in which no part is dominant. These apparently mechanical textile works by Freshwater show less of an affinity with embroidery or traditional textiles, than to kites, sails and membrane architecture. The geometry subverts any notion of the 'homespun', although sewing is important to her.[38] It is this regulation of material and thread that neutralizes any possible symbolic signification and forces the sculpture to be read as the sum of the parts.

As well as the geometrical base, Freshwater also uses different materials in unusual ways in her gallery work. When using sheet lead, the softness of the material allows it to be formed over regular raised bumps. However, different materials react to this discipline in different ways. *Blue Jeddah* of 2004, for instance, is made of metallic foil-covered lycra that has been forced outwards by a regular grid of protruding nipples and pulled back by blue threads. Lycra, as a material, gives whereas the foil covering fails at points of tension, creating cracks and showing traces of the hidden material. While not actually describing particular urban features, she likes the idea that they might suggest pylons or bridges. Ultimately, the ambiguity leaves space for the viewer to interpret the works.[39]

It is the suggestive elements that link all of these crafts practitioners. None simplistically depict architecture, but all suggest the urban environment. In this, they are close to the prevalent trend in sculpture in the 1980s and 1990s, where exhibited objects subverted any idea of hand craft.[40] Like the material city, the surfaces of the craft objects were left unadorned, the hand mark denied and the forms rationalized. The link of geometric uniformity, clarity and lucidity in all of their works suggests the Enlightenment preferment of sight over the other senses.[41] The visual sense

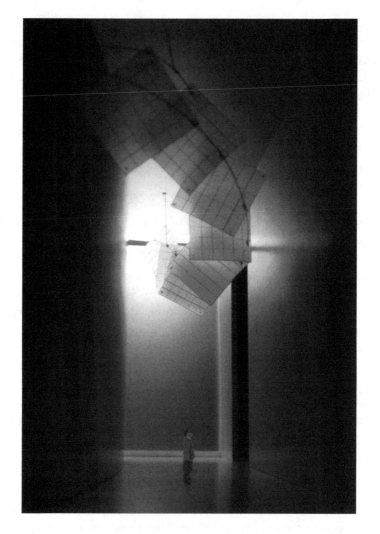

7.3 Sally Freshwater, *Proposal Front Model*, 2001. Photograph by Sally Freshwater.

allows people to take possession of environments, for the world to be controlled at a distance, which combines both detachment and mastery – an urban way of being on the street.[42] However, above this there is also the tactile element in all of the craft objects, which links with the material qualities of the built environment, where sight is supported by the sense of touch.[43]

URBAN FLÂNEUR

In this next section, I will be discussing craft makers whose works are connected to the idea of the *flâneur*. It was Baudelaire who originally urged artists to look to the urban streets of Paris for inspiration.[44] In 'The Painter of Modern Life', he outlined

the concept of the figure who is at home in the crowd; in the world and observing the throng and yet remaining unseen.[45] In his poetry, the masses are ever present though rarely described. Occasionally there might be a glance at a passer-by, but it is the crowd that Baudelaire and his *flâneur* endow with soul.[46] This observer of life was evident in many of his poems, especially in *Tableaux Parisiens,* where chance encounters, the glance of a woman and the experience of walking the streets were traces that were collected and utilized.[47]

This idea was continued by writers and poets like Guillaume Apollinaire in *Le Flâneur des Deux Rives,* but mutated in the writing of Walter Benjamin. For him, the *flâneur* activity became imbued with memory and personal associations. In 'A Berlin Chronicle', for instance, Benjamin invites us to experience with him the sights and sounds remembered from his childhood walks.[48] These idiosyncratic memories were described with the heightened sensibilities of a child who experiences things for the first time. More recently, the *flâneur* has informed the writing of Peter Ackroyd and Iain Sinclair, whose restless walks around London have been integral with their investigations into the connections between people and places.[49] These writers, as with the crafts practitioners that will be discussed, live in and are embedded within the life of the city. As they move about the streets, look at the media and live their lives, they overhear, view and confront the lives of others who are experiencing their own narratives of life.

Much of the craft made in England that follows this concept is linked to the continental neo-Dada movement. The original Dada and Cubist artists had collected debris from the streets and cuttings from newspapers to suggest urban life. Kurt Schwitters, for instance, included newspaper scraps, tickets and other found objects in *Frühlingsbild* of 1920. More recently, these ideas have been revived in Switzerland by craft artists such as Bernard Schobinger, who began as a gold and silversmith in the 1960s. Zurich was the original home of Dada and, at the time of social upheaval during the late 1960s, these ideas were rediscovered.[50] Against the background of student revolts, pop music and non-conformist tendencies, Schobinger moved away from creating fine jewellery to making work by manipulating found materials.[51] Through combining shards of glass, fragments of toys, bottle tops and other common refuse with precious materials, he hoped to both enhance their individual qualities as well as undermine ideas of quality and preciousness.[52]

1982 was a pivotal year for the New Jewellery scene in London. Wendy Ramshaw had an exhibition at the Design Museum, Gerd Rothman, Bernard Schobinger and Group Nou all had exhibitions at the Electrum Gallery and the international exhibition, *Jewellery Redefined,* was shown at the British Crafts Centre. Pierre Degen also had a show at the Crafts Council Gallery.[53] Since then Britain, and London in particular, has become the home of many designer-makers and crafts practitioners from the continent, including Hans Stofer, Mah Rahna and Pierre Degen.

Degen's show at the Crafts Council in 1982 included a performance where he produced witty, wearable assemblages of anything that could be attached to the

body, including ladders, sticks and balloons.[54] Rather like Umberto Boccioni's *Fusion of Head and Window* of 1912, where he attached a plaster head onto a real window frame in a combination of art and the everyday, Degen carried around these environments. His works used unglamorous materials – the left-over debris of urban life – and was part of a broader trend in the visual arts that focused on dystopian visions, as in the films *Blade Runner* and *Terminator*, or made fashionable in the gritty designs of Ron Arad. *Stealing Beauty: British Design Now*, held at the Institute for Contemporary Arts in 1999, which showed everyday objects that had not been appropriated by style mongers, was also part of the reaction during the 1980s and 1990s against over-designed, super-slick consumer objects.[55]

Degen's encounters with homeless people in the Charing Cross area of London in the 1990s encouraged him to make jewellery from the basic source of food for the poor – the tin can. The polished tin, combined with rubber flooring, carpet underlay and inner tube, of his works from 1995 are reminiscent of Dada strategies.[56] Degen's materials were gathered from skips, garages, the street, friends and jumble sales for both their inherent qualities as well as their economic and environmental advantages.[57] In Judy Attfield's terms, the original objects are 'things', the overlooked debris of everyday existence which, although they do not attain the manufactured qualities of 'design', none the less, through being self-consciously manipulated and combined, gain the status of being worthy of concentrated consideration.[58] Degen's collages of found materials also suggest art movements like Arte Povera from Italy, where artists like Jannis Kounellis explored the links between art and life, using a broad range of everyday materials in open-ended ways, where cultural ideas about value were undermined.

By contrast, Grayson Perry uses traditional ideas about beauty as 'guerilla tactics' to seduce the viewer into looking and considering uncomfortable subjects.[59] Jorunn Veiteberg has discussed one aspect of beauty as being its shininess, from which the German word for beauty is derived: *schönheit*.[60] Perry plays on the human attraction to surfaces that reflect light, as well as using domestic scale, classically shaped pots as vessels for his ideas.[61] These apparently innocuous objects are the canvas for scenes of domestic violence, personal narrative, war and sex that he has culled from newspapers and web sites. The multimedia artist Hew Locke uses a similar technique, exploring aspects like gang violence and guns through textiles, including homespun crotchet throws and small children's toys.[62] *Menace to Society*, for instance, incorporated plastic dolls, toy guns, artificial flowers and crocheted squares into brightly coloured work, which was inspired by the fear and excitement of gang culture that was stirred up by the media.[63]

Perry not only depicts difficult subjects, but makes the viewer complicit as a voyeur. As Baudelaire warned, it is very easy to wallow in the spectacle of other peoples lives. This type of viewing, which Baudelaire called 'armchair terrorism', is common in relation to television chat shows and has been satirized by both Perry and other British artists like Tracy Emin.[64] In *We've Found the Body of Your Child*

of 2000, Perry has brought together a number of small scenes and phrases, which require a focused gaze so that, like watching disturbing news items, there is a tension between understanding the story and an invasion of privacy. The mother on the pot is being restrained by a group of men, while giving away to her grief at the sight of her dead baby. Ninety-five per cent of child murders are committed by a parent, so Perry juxtaposed the images with inscribed words that suggest the aural violence that surrounds some children, including 'never have kids' and 'you fucking little shit'. Perry wanted the viewers to think about their own actions and words and how these habits can be the first steps towards physical violence.[65]

Perry made *Barbaric Splendour* in 2003 as a commemoration of the death of Princes Diana (Figure 7.4). This again reflects the power of the media which both

7.4 Grayson Perry, *Barbaric Splendour*, glazed ceramic, 67 × 35.5 cm, 2003, © the artist, courtesy of Victoria Miro Gallery.

Princess Diana and the audience used. Mirzoeff has argued that work and leisure are increasing centred on visual media, so that the endless swirl of screen imagery has increasingly undermined the boundary between reality and image.[66] It is estimated that 2.5 billion people watched the television coverage of the funeral, and although few had actually met her, Kensington Gardens were filled with a mass of flowers and tributes. All through her married life Princess Diana had courted the media to the extent that people believed they knew her, so that they felt personally bereaved when she died. Like Marilyn Monroe, the images that appeared during Diana's life were choreographed to create a seamless narrative of her life. Warhol used the mechanical repetition of screen prints that he manipulated into crude and blurred images to suggest the veneer of accepted glamour that surrounded Monroe. Perry has used the shininess and decorative appeal of the vessel to suggest the media-led narrative about Diana's life and death.

Unlike the gritty emblems of street life or the pristine shine of media imagery, Lucy Casson has used domestic and overlooked materials in order to depict everyday and whimsical scenes since the 1980s. These are not the scenes that receive media focus, but are closer to Baudelaire's glance – that fleeting moment when a scene is caught out of the corner of the eye. These are the scarcely remembered, background parts of everyday life that matter but generally escape attention. Using recycled tin scavenged from scrap yards, restaurants and pavements, and constructing the scenes using minimal means, her works are the antithesis of high tech or highly finished status works.[67] Many retain the original patterns of the tins, so that *Fierce Animals*, for instance, shows leaping animals made from a well-known brand of gas lighter refillers.[68] The objects retain, as in some architectural redevelopments like Tate Liverpool, the vestiges of the old visible within the new. Sometimes she rubs back the surface a little or paints into it, but fundamentally the original pattern and colour are visible and crucial. Recycling in her art work is part of her ecological awareness, so that searching the streets looking for pleasing ranges of colours in her found objects is part of a continuum of life.[69]

Naum Gabo wrote that materials set the emotional foundations for interpreting sculpture and define the parameters of the aesthetic effect.[70] The everyday scenes that Casson depicted, especially during the 1980s and 1990s, are reflected in the commonplace materials and the informality of their manipulation. *Factory Tea Break* of 1998 shows people sitting outside a factory and *Waiting in the Launderette* again depicts a common but overlooked theme from life (Figure 7.5).[71] Both show small islands of pleasure in mundane lives. *Factory Tea Break* suggests a continuation of everyday scenes that Camden Town artists painted at the beginning of the twentieth century, where those depicted are caught unawares during the natural process of life. Spencer Gore, for instance, painted scenes from his upstairs window and from balconies of theatres in order to capture fleeting life. These moments were also caught by Impressionist artists like Berthe Morisot and Mary Cassatt, who showed women bathing or drinking cups of tea. Unlike these paintings, though, Casson's subjects

7.5 Lucy Casson, *Factory Tea Break*, recycled tin, 80 × 55 × 20 cm, 1998, collection Lucy Askew. Photograph by Lucy Casson.

of the overlooked are paralleled in the materials and techniques used. Scavenged 'things' have been transformed into a new aesthetic world where the means and subject support each other.

This chapter has highlighted some of the ways that the urban sphere has been articulated in craft and design. It has considered the way that international, conceptual thinking from different art movements and from across the visual arts have influenced the aesthetics of makers, be it in the use of geometry, narrative or the use of scavenged materials. It has also discussed how different use of materials and techniques resonate with the subjects in order to communicate ideas. However, in all of these different means, it is the experience of everyday urban living that is suggested.

8 CRAFTS IN THE ENVIRONMENT: PHILADELPHIA CASE STUDY

This chapter will discuss recent applied arts commissions that have been made for the city of Philadelphia and its surrounding parks, in relation to purpose and site. Unlike the objects discussed in earlier chapters, these are in the public domain and were commissioned to bring communities together and give a sense of place. However, many of the ideas that underpin the works are related to those discussed earlier in the book. The chapter is divided into three subsections. The first will consider those works made for the large and picturesque parks situated outside the city centre. These are the lungs of the city, providing peace and easy access to nature. Into these wooded areas sculptures and design that blend into and enhance the experience of being in the surroundings have been placed. The second part will consider works made for different neighbourhoods away from the city centre, where the applied arts have been used as parts of regeneration schemes; and the third part will discuss those works in the central area.

The works that I have chosen to discuss all have a degree of function, which necessarily removes them from the completely disinterested aesthetic appreciation of fine art. Although American anthologies of craft have not tended to include works that have been made for the outside, their utility, materials, integration with their setting and the way they are consumed through bodily contact suggest design and the applied arts. During the 1960s, Rosalind Krauss argued that sculpture had entered a no man's land, where it was what was near a building but *not* part of the architecture, or was in the landscape but was *not* the landscape.[1] Public sculpture in the 1970s was no longer separated from the world by being elevated on plinths and neither did it commemorate worthy people and events, but engaged with the broader society through inviting touch and being increasingly site-specific. I would argue that these ideas would also apply to much outdoor design. Design has traditionally had a negotiating role between humans and their surroundings, and between the object and its setting. As notions of function have become more fluid,

the boundaries between sculpture and design have in their turn become increasingly permeable.

This fluidity has also been integral to the working portfolio of many practitioners. For example, both Martin Puryear and Albert Paley create work for gallery, domestic and external spaces. Paley's studios make small decorative works like candlesticks and tables, architectural sculpture as well as fulfilling outdoor commissions. Both artists work in materials that lend themselves to a variety of contexts, with Puryear working in wood and Paley in metal. Unlike the heroic interventions of American Land Artists such as Robert Smithson, Michael Heizer or James Turrell, who have continued to make works since the 1970s that are removed from economic and social context, require a pilgrimage to visit and earth-moving equipment to make, the work discussed in this chapter reference the sites, uses craft materials and enhance everyday experiences.

I have chosen Philadelphia as a case study, as it has always had more public art than any other American city, with the commissioning of fountains, sculpture and design dating back into the nineteenth century.[2] These adorn squares, provide punctuation points along pavements and abut architecture, as well as being sited within the parks. Outside the urban area is Fairmount Park, which is one of the world's pre-eminent park systems. This is made up of playing fields, historic houses, gardens and large swathes of apparently natural meadows, streams and woods that cover nearly nine thousand acres, or about 10 per cent of the area of the city.[3] Again, fountains, benches and sculpture that date from the nineteenth century to contemporary times adorn these areas.

Fairmount Park was established to meet the public need for pure water when, in 1799, water was pumped from the Schuykill River into the city centre. 'Fair Mount Gardens', which was opened in 1825, surrounded the waterworks and became a popular recreation area for the city dwellers. The original thirty acres quickly grew beyond the Schuykill River and into Wissahickon Gorge, and the new park was landscaped with informal paths.[4] In order to protect public lands, the Fairmount Park Commission was formed in 1867, which developed into the Fairmount Park Art Association in 1871. This made Philadelphia the first American city to form a private society to raise funds to embellish the park and urban areas with fountains, sculpture and 'similar ornament, such as good taste shall dictate'.[5] Their plans were ambitious. Not only did they aim to promote the knowledge and patronage of sculpture for the city, but they wanted to foster American talent.[6] Although previously there had been a strong European influence, from this time there was an increased emphasis on American themes with American political figures and images of Native Americans. This matched the ambition of the city, as Philadelphia had incorporated the surrounding boroughs into the city in the 1850s under one municipal body, and from this time became one of the most important cities in America.

The funds for the society were built up from variable subscriptions and organized events and these paid for public sculptures as well as urban design.[7] In 1900, for

instance, the Fairmount Park Commission met with the Finance Committee of the City Council to consider the triangle at Spring Road and Green Street to make the approach to the park more attractive.[8] The earliest decorative fountain in the city commissioned using public funds was *Water Nymph and Bittern* of 1809 by William Rush, and surrounding benches were added for people to stop and rest.[9] Clearly good design, urban art and the creation of a unifying identity through cultural means was considered important for a large swathe of the city's population.

In addition to the remaining importance of the Fairmount Park Art Association, which has been instrumental in commissioning contemporary public art, Philadelphia adopted a percentage for art scheme in 1959. All development required 1 per cent of construction costs to be spent on public art, not only to integrate art and architecture, but to be viewed and appreciated by those passing by and, hopefully, to enrich their lives.[10] There were two different schemes: one for city construction and the other for redeveloped property. It was to be carried out by the project architect and approved by the Redevelopment Authority's Fine Arts Committee.[11]

What I intend to consider in this chapter is the importance of some of the recent public design that has been created for the city, both within the urban and park areas. I will also consider how the objects are used and, therefore, how they relate to people's individual and collective identities.

OUTLYING PARKS

Fairmount Park is a wooded area that runs from the Philadelphia Museum of Art, along the Schuykill River and its tributary, Wissahickon Creek. These woodlands are the remnants of the original forest that would have stretched far into the State. In spite of the roads that also run along the rivers, there are areas that feel remote. For the inhabitants of the city, the park is a place where one can picnic, go hiking, watch birds and just sit and enjoy the surroundings.[12] A recent pamphlet published by the commission quotes Emerson as the best summary for the purpose of natural areas for city dwellers:

> To the mind and body which have been cramped by noxious work or company, nature is medicinal and restores their tone. The tradesman, the attorney comes out of the din and craft of the street and sees the sky and woods, and is a man again. In their eternal calm, he finds himself.[13]

These ideas have also been developed more recently, with open space and unstructured time being considered important as a break from the over-stimulation of the city. In being a place where people relax, their experiences can be widened, groups of people can meet and an increased understanding of one's place in the environment can be developed.[14]

In 1980, as part of the 300-year celebrations of the city, Fairmount Park Art Association proposed *Form and Function,* where fourteen well-known artists were

invited to submit proposals for specific sites in both the parks and urban areas of Philadelphia. Each was asked to consider a new matrix for making work rather than starting with preconceived ideas. The underlying intentions of this project were to bridge the gap between public art and everyday life, to be utilitarian as well as to speak to the physical characteristics and the spirit of the place.[15] In this they were capturing the prevailing mood of contemporary public art, where integration with the community and place was important. A selection of the sculptures and design works were installed in 1982, and some more were developed and built over the subsequent years.[16]

Jody Pinto designed the *Triple Tongue Pier* at Wises Mill Dam on the Wissahickon Creek for the competition. This work was a functional set of fishing piers and seating areas that responded to the activities of the area. However, rather than being just functional in form, it was a response to the site and was influenced by the river and surrounding vegetation.[17] From this proposal the project developed, and she was commissioned to make the *Fingerspan Bridge* that crosses the creek at Livezey Dam (Figure 8.1). Constructed from weathered steel, it provides a safe, enclosed crossing that suggests covered wagons or an aviary. Shaped like a long finger, she thought of it as a symbolic expression, which people could pass through as if they were the muscle and bone marrow.[18] Clearly, this is not meant as a purely optical piece. The public walks through the tunnel bridge, touches it and experiences the journey above the river. As it is a mesh construction the air passes through, and its situation beneath the

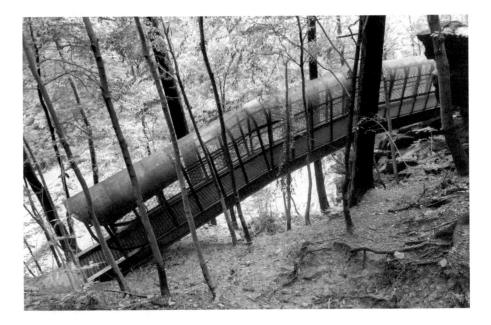

8.1 | Jody Pinto, *Fingerspan Bridge* (1987). Photograph by Wayne Cozzolino © 1987, courtesy Fairmount Park Art Association.

tree canopy means that the dappled light echoes the open surface pattern. It becomes a continuation and expansion of being in nature. Echoing phenomenological ideas, she states that 'the body is the central source of information, of everything we understand, everything we see'.[19]

The matrix for *Form and Function* included suggestions about possible use by the public of the art that included rest, recreation, mapping, human experience, meditation, as well as the more practical aspects like security, providing community focus and identity, and connection.[20] Within these parameters, Pinto's work was both practical as well as experiential. The original plans of creating seating areas for fishermen both suggested a sense of community and enabled comfort. Crossing the creek within *Fingerspan Bridge* allows the visitor to gain a new experience of the space that is above the water and forest floor and that also connects two areas.

Martin Puryear's *Pavilion in the Trees* was installed in the Landsdown Glen Horticultural Center in 1992 as his contribution to *Form and Function* (Figure 8.2). The final version has a ramp leading up to a wooden platform enclosed in a wooden lattice mesh, which is situated at the height of the tree canopy. It has become a place where people come for quiet contemplation.[21] Puryear considers that it is the physical object, where the means used in construction determine the form and its experience that set the parameters of this and all of his works.[22] Here it suggests the child-like dream of a tree house, a place of refuge from the adult world.

Three types of American timber were used in the construction: Pennsylvania white oak, red cedar from Washington State and redwood from northern California, and,

8.2 Martin Puryear, *Pavilion in the Trees*, 1992. Photograph by Wayne Cozzolino © 1992, courtesy Fairmount Park Art Association.

as in all his works, there is an ambiguity between the natural and the man-made. In both his studio works and those made for the outdoors, there are suggestions of huts, boats and tents. His sculptures allude to the natural and to nature, but they are all invented forms that also indicate man's intervention in the world. Unlike some over-decorative woodwork, his practice upends the usual notions of high and low. His practical use of wood harks back to his influences that include working with traditional societies in Sierra Leone and the Arctic, as well as learning Danish furniture making and his studies in Sweden.[23] In none of these cultures is wood treated as either a sanitized, industrial material or as shiny, elaborate and decorative, but as something that can be celebrated for its natural properties.

Suzi Gablik wrote in the 1990s that humans need to lose some of their imposed logic and embrace other aspects of being human – namely, the imagination, myth, dream and vision. She felt that art and ritual were the ways to regain a sense of enchantment and counteract the effects of modernist rationalism.[24] Certainly both Puryear's and Pinto's contributions to *Form and Function* – in contrast to the modernist name – embrace this idea of dream places that are to be experienced in a broad sensory manner. In contrast to the imposing and distant earthworks of the 1960s and 1970s or to traditional public art of worthies on plinths, these are accessible and promote personal responses to the work and setting. They are also part of a broader network of public art and design across America, where the works are both relevant for the site and invite a bodily engagement with the object. Anthea Tacha's *Streams* of 1974–1976 in a park in Oberlin, Ohio, was made of small cement blocks interspersed with rough boulders that followed the form of a small stream. Their spacing forced the visitor to concentrate on the rhythms of walking. Lloyd Hamrol's *Log Ramps* of 1974 at the University of Washington was a series of four slanting ramps angled to form an enclosure. The area within was a place of quiet, and the log-faced ramps provided seating and a focus for groups to meet.[25] Within these works, as with those by Pinto and Puryear, it is the bodily interaction of the audience with object that gives the works meaning and, in turn, adds meaning to the place.

Julian Holloway has discussed the relationship between spiritual practice and performed ritualization. Echoing Gablik's rejection of the Descartian concept of the mind as the only legitimate source of knowledge and the body as inactive, Holloway embeds his argument in the phenomenological ideals of the body as being both central in creating understanding as well as forming the basis for symbolic and representational thought.[26] People make sense of the world through moving through the environment and through ritualized practices. Through repetition and reflection, certain sites become places that represent a spiritual way of being-in-the-world.[27] While the construction of both Pinto's and Puryear's works were not the same direct and personal outcome of being in the site that is discussed in the work at Grizedale – both worked with the engineer and architect Samuel Harris from the firm Kieran, Timberlake and Harris to construct their work – none the less, their

works directly reference their respective settings. They also actively engage the public in a way outlined by Holloway, in that they have become places to go to for solitude, quiet and to be in nature.

Ed Levine's *Embodying Thoreau: Dwelling, Setting, Watching,* set in Pennypack Park continues with many of these ideas. Made as a result of the Fairmount Park Art Association's initiative, *New.Land.Marks* of 2001, it was inspired by Thoreau's *Walden*. The underlying principle of *New.Land.Marks* was to make work that responded to the desires of the relevant communities. In this case it was the park community, and it was their decision to use *Walden* as the initiation for his work. For Levine, this book clarified the way that humans must see themselves as guests of nature and dwell in, rather than impose oneself upon, the natural world.[28] At the opening in 2003, extracts from the book were read.[29]

The three related wooden structures explore the different ways that humans and nature relate. One suggests a building with open sides and a symbolic hearth (Figure 8.3). It has the same scale as Thoreau's cabin at Walden Pond, a modest structure of ten by fifteen feet which contained the bare essentials for a comfortable existence.

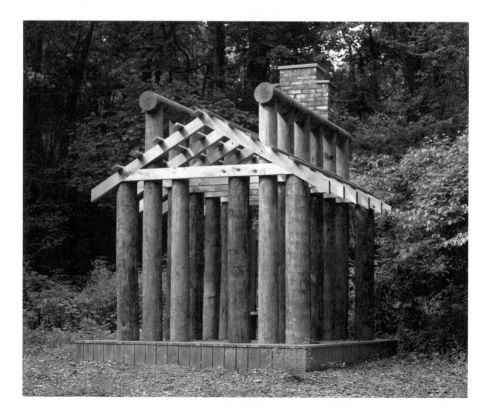

8.3 Ed Levine, *Thoreau's Hut*, 2003. Photograph by FPAA Staff © 2004, courtesy Fairmount Park Art Association.

The second is a lookout for birdwatching. The outside is of woven wood, whereas the inside resembles a building. The third consists of three benches which, although each is meant for one person and they are grouped so that they face each other, are large in scale, dwarfing the occupant. They are also tilted back so that one can easily look at the sky. All three works are about the relationship between interior space/consciousness and external nature. They suggest the different ways that we engage with the world, through living in it, observing its forms and resting. Through exposing ourselves to nature, just as Thoreau suggested, a dynamic relationship between nature and culture can be established.[30]

PARKS IN URBAN COMMUNITIES

Like many cities in America, Philadelphia has large pockets of deprivation where communities are fractured. Many works discussed in Chapter 6, like those by Jan Yager, reflect the violence, exploitation and greed that are manifested on American urban streets. Although not all neighbourhoods are challenging, there are some in all of the major cities that remain socially disadvantaged and that have the accompanying drug and crime problems. As we have discussed, craft has always been central to the functioning of society. In America, it has also been used as a tool for helping different communities in both urban and rural America. Many murals, fountains, design objects and sculptures were constructed in the public arena as part of the Works Progress Administration during the 1930s and early 1940s, both as an aid to artists and industry as well as to enhance the environment. The encouragement of making small craft objects for sale was another means used by philanthropic groups during the depression to alleviate poverty.[31]

Many of the recent commissions in Philadelphia have been neither for the wooded parks nor in the city centre, but for suburban areas in need of regeneration. However, rather than the paternalistic emphasis of the pre-war period, public consultation was the imperative of *New.Land.Marks*. Meetings were held in libraries and other local cultural venues where, among other things, the communities were asked what they would like to leave to future generations in the neighbourhood.[32] In many ways, this also harkens back to the roots of the Fairmount Park Art Association, which was funded by many individuals from across society who wanted to contribute to the improvement of the city.

One of the projects realized for *New.Land.Marks* was *Church Lot*, which was developed by John Stone and the community in North Central Philadelphia. The church, St Elizabeth's, which had been the hub of the local community was destroyed by fire in 1995. The residents wanted the now vacant lot to cater to both spiritual as well as practical needs.[33] In order to achieve this, the team decided to include a performance area, which could be a focus for events, a sanctuary with a fountain for quiet, and a common room where aural and visual material about the area could be

archived. Like the commissions for *Form and Function,* the works considered the fluid idea of function to answer both practical and aesthetic needs. Underpinning this is the protective iron fence into which words including 'strength', 'love' and 'hope' have been added. In addition, marble tablets that have been engraved with quotations by the residents have been incorporated. The proposal was accepted by the commissioners in 1999. Unlike the schemes in the centre of Birmingham or Philadelphia, at the heart of the way that this project was developed was the concept of art as a tool for social cohesion. While being linked with a particular place, this was as much through the incorporation of memories and aspirations as through the formal design.

Clearly, in a poor neighbourhood, design elements within a park can only be part of a solution. However, there is a consensus that public well-being is enhanced by good art that involves the community.[34] The anthropologist Ellen Dissanayake has made a case for the arts being a necessary part of being human.[35] Most art, until relatively recently has been public, related to ceremonies and to making something special. Through the time and care taken in making the objects and then through the resulting objects being used within rituals, she has written that art can be a focus for developing and maintaining a sense of personal and community identity, as well as providing a medium for dealing with anxiety, giving pleasure and awakening a deeper sense of understanding.[36] Project H.O.M.E. worked with the artists and community for *Church Lot* as part of the regeneration programme. It is a non-profit organization that has helped to revitalize neighbourhoods in north central Philadelphia through outreach programmes, developing housing strategies and health-care programmes. In integrating the scheme for *Church Lot* within a broader housing project, the aim was to use design as a way of making sustainable communities through scale, relationship with street and character. The rebuilding of the vacant lot into a usable park was part of a continuum of revitalizing the neighbourhood, economically as well as socially.[37]

Another project for *New.Land.Marks* was proposed for Baltimore Avenue in Western Philadelphia. Michael Cochran worked with a coalition of local residents, businesses and institutions to design some ironwork planters to improve the cityscape. In 1998 he also asked people to fill in a questionnaire on an Internet newsletter, so that he could gather memories and botanical information about the area and study old images taken prior to 1960.[38] The result was the design of trolley-bus shelters and a series of steel and iron lattice-motif sculptures that would support plants which would be grown and tended by the community (Figure 8.4).

Not only were the planters to be part of the greening initiatives for the area, but the community would be brought together through gardening and congregating while waiting for the buses. The forms of the planters were based on designs that date back to the nineteenth century and so refer to traditional Philadelphia ironwork and again affirm a sense of place. Indeed, Samuel Yellin's Arch Street Metalworkers

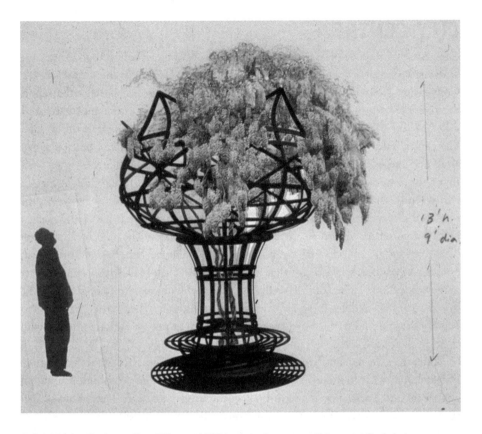

8.4 Malcolm Cochran, *Grand Planter*, 1999, proposal, courtesy Fairmount Park Art Association.

studio is located in the area.[39] Yellin was the best-known craftsman working in hand-wrought iron in the inter-war period working in a European style.[40] The new planters reflected those styles.

These different projects that were made in conjunction with local communities underline the importance of urban public spaces. Rather than just being made for the central part of the city, these initiatives were designed for residential neighbourhoods where people work, live and experience everyday life. Cities are a physical expression of a culture that shape people's experiences, memories and imaginations. Parks and roads are where people participate in communal life and have the freedom to develop different selves.[41] By enabling the communities to come together through the process of design, and empowering them to care for the works, the traditional use of art in rituals and community identity that Dissanayake discussed were brought together.

CITY CENTRE

The centre of Philadelphia is large and consists of different zones: that around the University of Pennsylvania, the central business area including the City Hall, the Convention Center and Rittenhouse Square, and the Historic District that abuts the Delaware River. Each of these districts has a different purpose and therefore a different audience. That by the river is quieter and predominantly caters for tourists. The central area has some of the original houses, streets and squares, but it also has sleek and impersonal high-rises for the business community. Like the other areas that have been discussed, there are many examples of public art and design, each of which tend to have formal links that reflect the architecture or history. However, the model of direct engagement between artist and community that had been enacted in Fairmount Park and in north Philadelphia was not used here. What I will not be discussing are objects that are fundamentally enlarged gallery sculptures, such as Claes Oldenberg's *Clothespin* that is sited outside City Hall. However, there are many works that can be considered design, in that they have a functional aspect, use design materials and are integral with their surroundings. They both speak of their neighbourhood and perform in a way that means that people directly interact with them in their daily lives.

Water has been a unifying aspect to much of the public art and design in Philadelphia, with fountains being the original commissions, combining function and aesthetics. These have tended to reflect the history and architecture of the site, so that the *Filter Square* fountain, for instance echoes the Victorian domestic scale of the surrounding architecture and can be enjoyed sitting on one of the surrounding benches. The *Swann Memorial* fountain is a complete contrast in that it boasts mythological figures, giant frogs and water jets that are 50 feet high, which, being set at Logan Square along the Benjamin Franklin Parkway, reflects the aspirations of the city in the early twentieth century.

Fountains from the latter half of the twentieth century have also been site-specific in that they have made links to the surrounding architecture. As the city centre has few pedestrian areas, there have been attempts to place some symbolic meaning or an aesthetic focus into the spaces between the corporate architecture. The *Voyage of Ulysses* fountain from 1976 is situated in the square adjoining the Federal Building along North 6th Street. The artist David von Schleggell was given the commission and, unlike the works for *New.Land.Marks*, was able to answer the brief according to his ideas. He wanted the experience of the place to be heightened by the fountain, so that it mediated between the person and place.[42] It is a dark site, with the surrounding buildings being covered with tinted glass, so that the stainless steel forms of the fountain, which contain and order the water flow, act like gleaming mirrors. The more recent *Commerce Square* fountain between 21st and 22nd streets echoes the surrounding buildings in materials and deeply shadowed forms. It is the focus of a small park which also has planters and seating, and which continue with the same

materials and forms as the fountain. Again surrounded by tall buildings, the square has been made into somewhere to stop and rest. Both of these fountains relied on the modernist idea of materials and forms creating the meaning. Neither suggested the history of their respective areas, nor are they the outcome of discussions with neighbourhood groups. However, in being site-specific and creating areas for quiet in the everyday lives of people who work there, they do become part of personal and collective memories.[43]

Some of the route by the Delaware River has been pedestrianized, and seating, planters and other practical works as well as larger sculptures have been commissioned. Andrew Leicester designed *Riverwalk at Piers 3 and 5* in 1990 for this area. A public artist, he had already designed large and fanciful works in Cincinnati and a paved area in Washington State University, both featuring water.[44] Those he designed for the walkway in Philadelphia are also fanciful, but refer back to the importance of shipping and the sea for the development of Philadelphia as a pre-eminent city. There are also a number of fountains and sculpture gardens along the riverside, some of which boast carvings from other countries, like the small, twelfth- and thirteenth-century fountain sculptures from Java in *Five Water Spouts, Frog, and Lintel,* or the pre-Columbian granite monolith from Costa Rica, which has also been incorporated into a fountain.

All of these works, which according to Krauss would be *not* sculpture, *not* landscape and *not* architecture, are close to design in their importance of involving people and, through materials and utility, helping the sensory understanding of the world. In pictorially and synecdochically alluding to the power of trade relations and the sea, the works by Leicester also become important for embedding the place back in time. It helps to add to the scaffolding of memory that is learned through museums and history books. In forming part of the permanent landscape, they help to create a sense of place for the users and add to the symbolic economy of the commissioners. In de Certeau's terms they are integral with the narrative of the place and help to make the distinction between the everyday and something special.[45]

Gates can denote the parameters of an area, can reflect what is contained, can be ceremonial as well as offering security. Christopher Ray's *Wissahickon Valley Gates* are situated on either side of a small square park at 13th and Chestnut streets (Figure 8.5). In their present position, they keep the park secure, while suggesting the natural world and allowing the natural foliage to be seen. Rather than incorporating imagery about the history of society, the gates reference the area that they were originally intended to adorn, which was a carpark along the valley. The larger gate has images from the natural life of the creek and the smaller has representations of tidal wetlands.[46] Rather than the design being on one plane, forged iron foliage curves back and forth, and the boulders and fish are three-dimensional. Looking through the gates set within their present urban surroundings, the sinuous shapes echo the foliage of the park and soften the hard edges of the architecture and the high walls that surround the park.

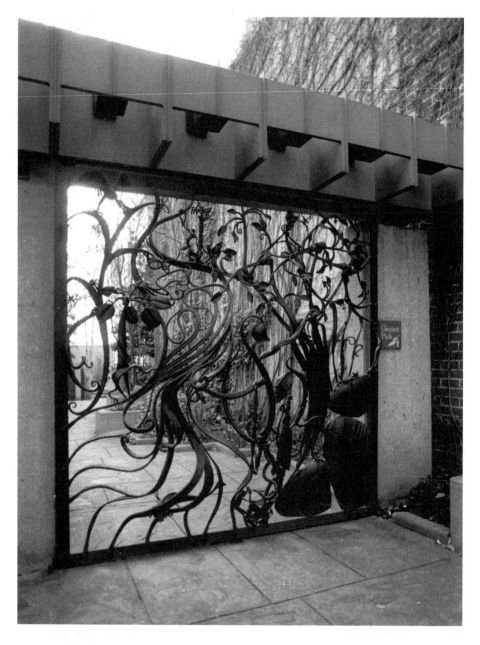

8.5 Christopher Ray, *Wissahickon Valley Gate*, 1979. Photograph by Gary McKinnis © 1992, courtesy Fairmount Park Art Association.

Albert Paley's *Proposal for Synergy, an Archway Sculpture for Museum Towers*, of 1986, employs his iconic ribbon-like flowing forms to act as high arches over the roadway. Rather than forming a complete arch, the two 25-foot high, painted steel forms cantilever towards each other. Unlike the gates by Ray, these are not meant to be looked at for their details. They are for driving under, a metallic flourish of art nouveau forms that defy the solidity of the material. This is only one of over fifty substantial site-specific works that Paley's atelier has forged over the last three decades and, typically, the expansive gestures express movement and emotion. He feels that his ironwork mimics his feelings and captures his experiences in a non-literal way.[47] Gates can also be symbolic. The *Ceremonial Gate* that Paley made for Arizona State University in 1991 only functions for public celebrations. At other times they are kept closed, but the area to either side is open.[48] Paley has described gates in general as being a metaphor. 'They are the dividing line between the inside and the outside, between light and dark, night and day, life and death and that whole passage we go through in life.'[49] In the same way, *Synergy* expresses the entrance. It is a bridging point between one area and another.

This chapter has discussed the different types of public artistic design that have recently been built in Philadelphia. In the wooded areas, the function was to allow and enhance the interface between man and nature. In the urban neighbourhoods, the sculptures and design were part of a continuum of measures that brought communities together. In the city centre the public works reflect the surrounding architecture and promote the rich history of Philadelphia. However, through all of these aspects there is the important thread that above the aesthetic elements, these works are meant to be touched, used and understood in a broadly sensual manner. Through employing the full range of the senses and relating the works to their surroundings, the complexities of the world as well as what it is to be human within a community, can be more fully negotiated.

9 CRAFTS IN THE ENVIRONMENT: BIRMINGHAM AND GRIZEDALE FOREST CASE STUDIES

This chapter will discuss the applied arts and design commissioned for Birmingham city centre and Grizedale Forest. Unlike Philadelphia, the focus of public art and design in Birmingham has been concentrated in the central area, and the many parks in the city have been adorned with plants rather than design or art. So, to parallel the works made for Fairmount Park, I have chosen to discuss those commissioned for Grizedale Forest Park in the Lake District between the 1970s and the 1990s. This park has some similarities to Fairmount Park, in that it is a large wooded area that has been designed with meandering paths where people go to relax and walk. Also like Fairmount Park, there is a variety of work set within the landscape, which fit into the site and add to the experience of being in the place, as well as frequently having utilitarian functions. Both projects have a national standing. Birmingham was the first city in England to use the Percent for Art scheme and became a model for other development and regeneration projects around the country. Grizedale has also been an inspiration for similar schemes in other forests, as well as for the placement of outdoor furniture and sculptures along cycle paths and footpaths. As such, the issues discussed in relation to these two projects embody a certain way that the English have developed to enhance the environment.

In the Introduction I wrote that one of the defining elements of craft practice was the integration of craft and society. Throughout the ages, craft has been identified with the outside, from railings and seating to thatching and wheel making. As discussed in the previous chapter, site-specific works in the public arena function in the permeable area between art, craft and design. Just as in America, many practitioners have a broad portfolio that may include outdoor commissions as well as domestic-scale objects. Wendy Ramshaw is an example of this. She combines her

jewellery practice with outdoor commissions, and many of the vocabularies that she uses in small-scale work are equally appropriate when enlarged for inclusion in gates and other outdoor furniture. Likewise, Jim Partridge makes small wooden vessels and large seats, bridges and other open air works to commission.

However, it is the scale of the growth in public outdoor commissions that is a recent phenomenon. Arts Council England has distributed around £2 billion from the National Lottery into the arts since the lottery was started in 1994.[1] Many of these schemes provided commissions for applied arts and sculpture to be placed in public areas to attract people into spending time there. The Percent for Art scheme has also been important. This was initiated in 1988 by The Arts Council of Great Britain, and advocated that a designated percentage of any major new architectural development should be set aside for commissioning new art works.[2] The successful implementation of similar schemes since the 1960s in America acted as a spur for many councils to adopt similar ways of raising funds for public art and craft.

BIRMINGHAM

Birmingham was the first council in England to use this way of raising money and has inspired many others to follow suit. Like many of the cities which have since emulated Birmingham's use of public art as an integral factor in urban regeneration, Birmingham is a large industrial city that grew rapidly in the nineteenth century from a relatively small town. Unlike most American cities, those in England are not rational spaces where roads meet at right angles. The focus of central Birmingham moved from the original settlement by the River Rea, which is now Digbeth, to a new site up the hill, where there is a bustling shopping centre, market, a cathedral and church, as well as imposing nineteenth-century municipal buildings. During the nineteenth century, Birmingham had been famed for its jewellery, guns and large metal industries, and was buoyant until the slump of the 1970s when employment dropped by 29 per cent.[3] Originally dubbed the 'Workshop of the World', by the late 1970s and early 1980s Birmingham and the West Midlands had become synonymous with its unhappy reputation for producing unreliable vehicles and of having a militant workforce.[4] With the poverty that accompanied unemployment, the centre of the city became uninviting for visitors and locals alike. As well as the derelict buildings, cars choked the narrow roads making it difficult for pedestrians to move along the packed pavements. In addition, the ring road that had been built beginning in the 1950s had cut the centre from the surrounding areas and stifled development. In spite of some wonderful Victorian buildings, a repertory theatre, a symphony orchestra and a major museum, by the mid-1980s, Birmingham had a serious image problem.[5]

Between 1987 and the mid-1990s Birmingham carried out its decision to change its image through the redevelopment of the city centre, which included new

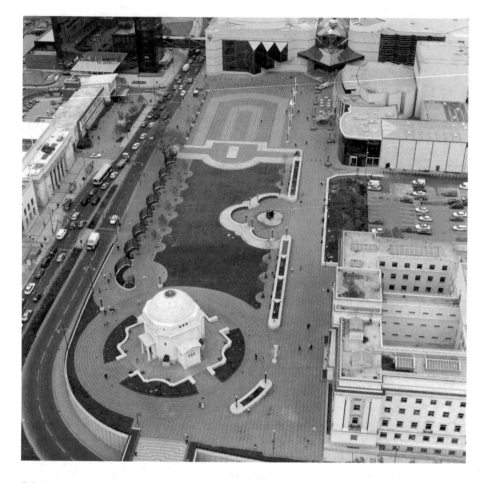

9.1 *Aerial view of Centenary Square, Birmingham,* showing paving, stonework, railings, seating, lighting etc., 1991. Tess Jaray in collaboration with Tom Lomax and Birmingham City Council. Photograph by Birmingham City Council.

buildings, public art and design. Central to this vision was the creation of a new square beyond the ring road in a run-down area of derelict warehouses, canals and dubious open space, which also housed the city council offices in Baskerville House, the Repertory Theatre and the Registry Office (Figure 9.1).

This new area became known as Centenary Square, to celebrate the anniversary of Birmingham being made a city in 1889, and was joined to the city centre by a bridge. The paving, pedestrianization and new works of art and design continued into the shopping and business districts. In addition to clearing and refurbishing the derelict parts, the International Convention Centre – the ICC – and a Hyatt Hotel were built. Together with the art and design that were commissioned, it was the largest public sector development in the United Kingdom at the time and was the first Percent for Art scheme implemented by a local authority.[6] By the 1990s

Birmingham had become renowned for the importance of public art to urban redevelopment in Britain.[7] Like the projects in Philadelphia, the art and design was meant to create both a better identity for the city and to 'bridge the yawning gap between contemporary art and the ordinary citizens'.[8] However, although these sentiments echo those expressed for *Form and Function* and *New.Land.Marks,* there was not the same degree of public consultation as the development was not just for local benefit. The plan of 1982 stated that as well as requiring suitable buildings to house new businesses, the visual impact was important for attracting business travellers and tourists, as well as conferences.[9]

The need to attract a broad audience and create a unifying image of the city for people with a variety of backgrounds created a challenge for the planners. Birmingham has a mixed population, ethnically and socially, with diverse visions. Business tourists also have their expectations about how a city with international aspirations should look and function. The new development needed to somehow speak to this broad audience as well as fit into the existing architectural sites, so that Birmingham – its history, industry and aspirations – became the unifying aspect and the focus of identity. As well as the materials of the existing infrastructure of metal and brick being used, the history of the people and industry were also incorporated into the works so that a uniformity of brand and a pride in the city itself could be suggested. *The Furnished Landscape,* the catalogue that accompanied the Crafts Council's exhibition which promoted the Percent for Art scheme, suggested that design within a built environment can help to create places that 'affirm our sense of belonging or remind us where we are'.[10]

This sense of belonging needed to be inculcated in some way. Unlike the European model of cities where businesses and housing exist side by side, Birmingham had clear-cut zones of activity. Before the 1980s most people commuted to their jobs in the centre from the suburbs, so although it was crowded during the day, after office hours it was dead. The requirement was to entice people to live and work in the city through improving the environment.

Cities are not just physical entities, they fulfil different symbolic and practical functions.[11] Unlike studio crafts where the urban environment is suggested in an abstract manner, applied arts for public spaces are site-specific and have the role of aesthetically bringing architecture and art together and facilitating the functioning of the area. Mikel Dufrenne has discussed how this constructed world can be made convincing.[12] Just as in a play or a novel, a complete aesthetic world – the scenery and background details – has to be constructed in order that the audience will believe the story within which the heroes can pursue their ends. Only if this mesh of meaning is intact will the audience believe the story.[13] If we take the 'heroes' as being the public, then Michel de Certeau's idea of how the 'ordinary man' negotiates the urban everyday becomes relevant.[14] He has articulated the overlapping paths that people create as they go on their personal journeys, each person's step overlaying those of others.[15] He has also explored the link between walking in the city and narrative.[16]

Both occupy linear time and are organized in our minds through metaphorical frontiers, bridges, main routes and punctuation points. The physical punctuation points then become embodied through personal memories, anecdotes of meeting people, and through public narratives as embedded in popular myth, news or the media.[17]

My point is that in order for Birmingham to radically change the prevailing perceptions about itself, the aesthetics as well as the functions of the new architecture and design needed to create a convincing and coherent message with which all could feel some affinity.[18] One advantage for Birmingham over Philadelphia is the compact size of the central area. The shopping and municipal buildings abut each other and, rather than being spread along a grid, follow a winding, medieval road pattern, with many narrow alleyways. The areas that people would naturally have frequented during the 1980s were focused in a small geographical area, which meant that the transformation could be dramatic. Since then, the gentrification of the Jewellery Quarter and other surrounding districts, as well as the increased wealth of the city that has brought in businesses, has enlarged the area of focus. The other factor is the political system that meant that many bodies, artistic as well as those related to the transport system and the city council, could come together to enable the changes.[19] Maps in the council plans show the different phases of the schemes that involved bringing down some buildings, moving some monuments, re-routing traffic and then commissioning the art and design.

Tess Jaray, who had already completed a number of projects, including those for Victoria Station in 1980 and Stoke-on-Trent Garden Festival in 1986, was appointed with the sculptor Tom Lomax to work with the city architects design team. They had overall responsibility for the design of Centenary Square.[20] Brick paving, which now stretches all over the centre of Birmingham, created the foundation for the new sculpture and applied arts. While the sculptures and fountains provided highlights of interest, it is the functional works that unify the spaces and enable people to linger.

The new sculptures, like David Patten's *Industry and Genius: Monument to John Baskerville* of 1990, Tom Lomax's fountain, *Spirit of Enterprise* of 1991 and Raymond Mason's *Forward*, also of 1991, which were all set in Centenary Square, became the focus of media attention, with different people writing to the newspapers to air their views and journalists commenting on the sculptures as they were unveiled.[21] Echoing the ideas of de Certeau and Dufrenne, people began to change their views of the city through memories as well as media coverage. Like the sculptures, the applied arts also build a narrative with Birmingham's heritage, with the brick reflecting the material of the many distinguished Victorian buildings, and the iron-work linking to the styles of the nineteenth-century bridges along the renovated canals. The lamp stands, seats, rubbish bins, railings, bollards and tree guards that Tess Jaray designed for the square echo each other through the detailing based on complete and fragmented circles. This emphasis on the circle is carried through to

the plan of the railings that forms a series of semicircles which echo those of the war memorial: the *Hall of Memory*. The stone of the lamp plinths and planters echo the Portland stone used for the Hall of Memory, Baskerville House and *Industry and Genius*. In these ways, both formal and material, the different elements combine to unite the immediate space and the surrounding buildings.

Different coloured bricks in the paving have been laid in a pattern that forms an abstract design. Rather than just being one undifferentiated whole, certain parts of the pattern, as well as the placement of seats bins and planters, encourage walking through the square, whereas other sections are for sitting, loitering and for the staging of events. As Kim Williams has pointed out:

> At its best ... pavement design is not mere ornamentation, but ... can help define our experience of the shape of a space, and our movement through it. It can determine the velocity of our walk, the direction in which we move, the direction our eyes follow.[22]

Jaray studied the different bonds and brick patterns from the city's architecture, but changed the proportions of the new pavers to 2:1.[23] From above, the pattern design is like a carpet. From the ground, the fluid patterns that were made possible through the change in brick proportion, appear as waves that change as one walks across the site. Jaray enjoys this confounding of expectation, and likes her paving patterns to result in the users becoming more aware of themselves within the environment.[24]

Running through the ICC is a public right of way leading from Centenary Square to the canals and Brindley Place beyond, which is punctuated with steps, plants and small eating areas where people sit and meet friends. At the far end is the vast *Glass Piece* by Alexander Beleschenko that was commissioned after a competition in 1991 (Figure 9.2). Beleschenko has created a number of architectural works around Britain, including *Glass Wall, Cone Wall* for the concourse of Southwark Tube station. Rather than aspiring to create hermetic gallery works, his windows are designed to complement and enliven architecture, so that all may enjoy the spaces as they pass through.[25] *Glass Piece* is a set of panels that screen the end glass wall with a myriad of small, brightly coloured rectangles which reflect onto the marble in a mosaic of coloured light. The colours and the structure correspond with those of the glass atrium and mark the entrance to the cultural area.

Since these projects, which helped to bring people back to the centre of Birmingham, there have been many others, some that have been supported by council initiatives and others by businesses. Some have been large in scale, like those linked to the recent developments around the Bull Ring, and others have been small. The Birmingham Alliance, in conjunction with Free Form, have invested £2 million in public art and design over the last few years as part of the redevelopment of the Bull Ring centre at the other end of the city. Artists involved with this include Cornelia Parker, Peter Fink and Laurence Broderick.[26] Martin Dolin was

9.2 Alexander Beleschenko, *Glass Piece, ICC Birmingham*, 1991. Photograph by Alexander Beleschenko.

commissioned in 2003 to make an enamelled glass wall for the shopping centre at the New Street Station entrance. The design was based on people moving around the centre, which was then abstracted into small overlain dots of glass within an organic shape. Because the glass is at the entrance, it changes according to different lighting conditions.[27] Anu Patel made colourful railings to link two train stations in the city. The panels have images that narrate a history of Birmingham and its contemporary cultural life.[28]

Both of these commissions are part of a broader arts programme designed for a particular area. However, the increase in businesses has also meant that there have been smaller self-contained commissions. For instance, Wendy Ramshaw was asked to make the handles for the rehearsal rooms of the City of Birmingham Symphony Orchestra, the CBSO Centre in 1998. The circular motifs of the etched glass doors and black metal handles suggest the outward movement of sound waves and are integrated with directional and musical symbols. The relationship of design to place is important in her work, as can be seen in many other of her commissioned pieces. In keeping with the importance of tactile surfaces in craft, the handle is matt and pleasant to the touch.[29]

All of these works have been crucial in the enhancing of Birmingham's image, and as the status of the city has changed new opportunities for makers have developed. Other cities have also used design and art to develop their urban environments, so that Sheffield, for instance, has had railings, planters, screens and other metal works created in the public environment in schemes like the Castle Square Project of 1995 and the Metal Heaven Project of 1997. In both of these, and within the subsequent metal trails around the city, the local hand-crafting and designing skills were highlighted.[30] Just as with Birmingham, the traditional materials of industry have been utilized but given a modern face in order to enhance the urban sphere.

GRIZEDALE FOREST

In order to create a parallel with Fairmount Park in Philadelphia, I have chosen a park that is large by English standards, has a range of contemporary sculptures and applied arts, and is very popular with the general public. Like the public art and design in Birmingham, the works made for Grizedale Sculpture Park were commissioned to raise the profile of the forest and to increase the numbers of tourists. Many of these – currently around 230,000 annually – come from cities, either as day trippers or as part of a visit to the Lake District National Park in the north-west of England.[31]

National Parks in England were developed after the Second World War as an answer to the inter-war pressures for access to the countryside – which included the mass trespass of Kinder Scout in the Derbyshire Peak District in 1932 – and as part of the programme of reconstruction. They could never be large tracts of unpopulated mountain or forest as in Canada or the United States; there simply is not the room. However, the aims were to secure certain areas for public open-air enjoyment while protecting the environment and livelihoods of the inhabitants for future generations.[32] These characteristics acknowledge the duality articulated by Hobhouse in his report of 1947, which stated that England's 'richly varied landscape is a product of natural growth and man's cultivation'.[33]

Grizedale is a working forest, so that the regular plantations are even in age and species. It therefore falls outside the romantic notion of the fells that were loved by Wordsworth, Coleridge and others, and which formed the predominant type of landscape initially protected by National Park designation. In order to entice people into the forest, walking trails and nature events had been initiated in the 1930s. This coincided with the formation of many new organizations, like the Ramblers Association and the Youth Hostelling Association, which promoted access to the countryside for the masses.[34] In the 1970s the idea of providing residencies at Grizedale, where artists would live and work in the forest, was proposed by Northern Arts, one of the regional groups of the Arts Council.[35] The outcome has been about a hundred sculptures and open-air furniture set within the forest adjacent to the paths.

Rather than being abrupt interventions in the landscape, all of the works made between the 1970s and 1990s are sympathetic to the forest. They are neither grand statements, like so many monuments within the parks of stately homes, nor are they impressive permanent landmarks like those of American Land Artists. The initial English Land Artists who worked there, such as David Nash and Andy Goldsworthy, continue to make work that, as with the makers discussed in Chapter 4, are a direct outcome of place. As I have previously articulated, this thread of idea goes back to the eighteenth century and is revealed in works that are sensitive to nature, place and to the indigenous worked landscape. None make interventions that impose themselves onto the land but, through respecting the traditions of husbandry, sit comfortably within the worked landscape. In their guide books, William Gilpin, William Wordsworth and Thomas West praised indigenous scenery and plantings, and condemned garish gardens and imported plants that provided too much of a contrast to the natural simplicity of English landscape.[36] As Wordsworth wrote, 'The rule is simple; with respect to grounds – work, where you can, in the spirit of Nature, with an invisible hand of art'.[37]

This sensibility was also promoted by writers from the Arts and Crafts movement, who saw rural crafts practitioners and house builders as practical people who reacted to the materials at hand and made things that were an outcome of inherited local traditions. [38] These ideas also underpin the traditional crafts discussed in Chapter 2. William Lethaby, for instance, railed against designers who recombined features on paper, but did not have a profound knowledge of the possibilities of materials. It was this division from making, from really understanding the setting and being able to manipulate materials, that Morris, Lethaby, and later Eric Gill, argued against. They wanted to encourage a delight in doing and making.[39] The resulting objects they considered to be 'human spirit made visible'.[40]

David Nash was one of the first artists to gain a residency, and lived there for three months from early spring in 1978.[41] The idea was that the artists had time to develop an understanding of the forest and to feel the changes through the seasons. They were left in peace to let the works evolve from the artists' interactions with the forest, using the materials at hand.[42] As Andy Goldsworthy has stated, his work is the outcome of instinctive impulses. He needs the 'shock of touch, the resistance of place, materials and weather… It is a collaboration, a meeting point between my own and earth's nature'.[43]

Like the work of Binns, Cousens and Beavan, this work is the outcome of being in a particular place. However, rather than being an empathetic abstraction, the works of Nash and Goldsworthy directly reference traditional husbandry techniques. *Taking a Wall for a Walk* of 1990 by Goldsworthy, for instance, incorporated the techniques of building drystone walls that are intrinsic to the area. The use of local stone to make the meandering wall suggests function, but it is an echo, an intervention into the landscape that suggests the millennia of the artisan skills of agricultural workers who have left their marks upon the English landscape.

Jim Partridge was the first crafts maker to be commissioned to create work in the park, and between 1986 and 1992 he returned to the forest repeatedly with his working partner, Liz Walmsley, building entrances, bridges and seats that suggest de Certeau's punctuation points for those walking in the forest.[44] Like Nash and Goldsworthy, he works with the materials at hand, using the parts that are normally overlooked by those managing the forest. Also like Nash and Goldsworthy, he encourages the materials to speak of their lived lives so that again there is a tension between nature and culture.

Larch Arch of 1990 by Partridge and Walmsley is situated at the entrance to Ridding Wood Trail, a tarmac path that provides a short walk into the forest (Figure 9.3). The trail is situated close to the car park and other facilities, and has seating, sculptures and other design works along it, making it suitable for those of all physical abilities as well as being an accessible introduction to the broader arts within the forest.[45] The arch is made from an upturned cleft of two branches, and serves as the bridging point between car park and forest. Partridge and Walmsley also made the *Sheltered Seat* along the trail in 1991, which has an overhanging roof with the huge lengths of wood anchored into the hill behind. This is typical of his work in that the wood is used in large masses rather than as struts, which makes them visually imposing.[46] Both works reflect the managed nature of the forest. As he has written, 'We chose materials out of the landscape and forms that would sit comfortably back into it. We ... were trying to make things that have a strong but quiet presence.'[47]

Partridge found the commissions that they received were more circumscribed than those given to the sculptors, so that seating was 'to go on this path; a bridge over this stream that will enable wheelchair access along the path; sheltered seating'.[48] This is a real difference between the sculptural works and those that are considered applied arts. The works by Goldsworthy, Nash and Partridge reveal links with husbandry and use natural materials with minimal means, but the functional requirements of the works by Partridge add another dimension. However, this is not to say that the ideas behind the works were less considered than those by Nash or Goldsworthy. Partridge likes to engage the audience through prompting certain ideas. Bridges are crossings, for instance, that have parallels in the mental journeys of life.[49] In using overlooked materials in an organic fashion, visitors are also reminded of the origin of the wood and its previous life.

Unlike the works of Puryear and Pinto that were discussed in the previous chapter, the seats, bridges and other practical works in Grizedale Forest were not intended to create an alternative spatial dimension for understanding the forest, but were placed to allow the visitors to enjoy it as it is. Whereas the works in Fairmount Park allow visitors space to mentally expand through being removed from the everyday, those in Grizedale tend to use the works themselves as vehicles to prompt thoughts about the environment.

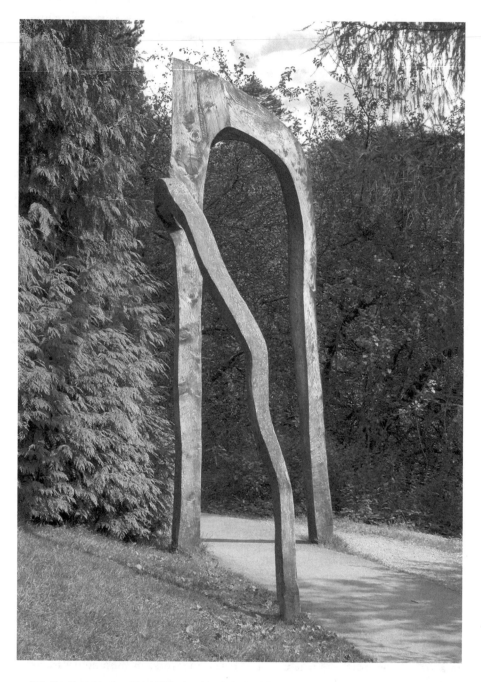

9.3 Jim Partridge and Liz Walmsley, *Larch Arch*, 1990. Photograph by Michael Wolchover.

Will Glanfield and Nigel Ross have also made seats for the Ridding Wood Trail. Unlike many of the sculptures that keep the attention within the woods, some of the seats are positioned for the gaze to spread beyond. This is so of Ross's *Dunkeld Seat* of 1995, which overlooks a picturesque ideal – pasture land, the forest beyond and some rustic stone buildings (Figure 9.4). The two practitioners reveal different ideals of making and being in the forest. Ross's *Dunkeld Seat* and *John Mackie Seat* also of 1995 reflect the forms of the original trees, with their natural growth incorporated into the works, so that again the cycles of life as well as the tensions between nature and culture are suggested. This is true also of his more recent work where he sculpts organic shapes from fallen trees.[50] The *Pacus* seat by Will Glanfield of 1991 is, however, more formal and emphasizes the idea of sitting through being raised on a stone platform and sheltered by a stone wall. It is made from timber that has been 'tamed' by milling and carving, so echoing many park seats over the years.

The works of all of these practitioners are the outcome of the place, and the audience is required to go for a walk in order to experience the works in that place as well. Christopher Tilley has described how perceptual space is constructed through

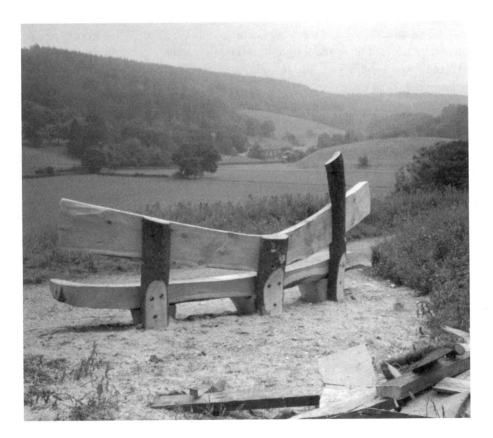

9.4 Nigel Ross, *Dunkeld Seat*, larch, 1994. Photograph by Nigel Ross.

the experience of individuals, and this relationship to place constantly evolves through movement and daily activities. Through repeated patterns of individual intentions and bodily movement, which help to develop memories and their linked emotions, a deep and growing bond is formed with particular places.[51] For the artists and crafts practitioners, the attachment to the forest gave rise to the works. For the audience, theirs is inevitably a less involved engagement. However, walking up the steep trails helps to shape and embody the enjoyment of leisure, and the objects themselves are features that help to locate memories.[52]

Just as the artists feel that they are part of a lineage of English sensibilities, so walking has also been embedded in English culture. Not only has it been the initiating point of the works by Binns, Beavan and Cousens, but it has also been officially promoted. Between the wars, government bodies and organizations such as the Forestry Commission felt that promoting leisure activities that united the beauties of the English countryside with physical activity would encourage the intellectual, spiritual, physical and moral health of the nation.[53] Rambling remains a popular pursuit in England and Wales. Fourteen per cent of the 50 million annual visitors to the country cite long walks as their principal reason for being there.[54] Edensor has argued that walking in the countryside, as well as being a means of escaping the confines of urban life, is a way of reawakening a sense of the self.[55] The recent opening up of large tracts of rural land for public access is a further response to the democratic demand for the ability to roam. It is also a reflection of the institutionalization of walking as a social practice outlined by HMSO.[56]

This chapter has discussed the way that design and sculpture have been used to transform the perceptions of their respective sites. In Birmingham they were used to create an ambience that would draw people to the city as well as sending out the message of the city's aspirations. In Grizedale, the sculpture and design were ways to encourage the leisure visitor and, while not adhering to the wild moorland of the rest of the national park, none the less it has become popular through engaging with other strands of English ideas. What has also been discussed is the permeability of the boundaries between art and design through the relationships with site and ideas, as well as through audience engagement.

AFTERWORD

This book has explored a range of contemporary craft practice where the objects are manifestations of ideas related to the city and the country. Although America and England do have strong historical and cultural links, the differences of geography, social and ethnic groups, as well as the distinct cultural myths that have developed over the last few centuries, have resulted in different uses of vocabularies and interpretations of themes.

I started the book by considering utilitarian craft that in England represented a continuation of a practice initiated by the Arts and Crafts movement, and in America represented a mixing of this influence with others. These practices are related to lifestyle and also express a belief in making things well using good quality materials. Craft workers in both countries are pragmatic, and American makers as well as younger makers in England have tended to expand and extend their practices and exploit the ease of modern communication in order to make their livings. However, there are still many working in England who have retained an established vocabulary with a direct lineage from the Arts and Crafts movement.

In considering cutting-edge craft that is about the rural environment, the differences in geography and ethnic influences are apparent. In England, walking and the manipulated landscape are important, which is translated into a particular range of practice. In this work, the experience of being in the environment is manifested using the qualities of particular materials as the means of communication. In America, the manipulation of materials as an end in itself began earlier, and became the means by which they could be used in a symbolic fashion. At the heart of both practices was an empathetic affinity with the land and a critique about how humans have developed myths about the rural environment and attempted to control nature.

In crafts about the urban sphere, both countries have an area of practice that is derived from continental modernism, although the way that this has been manifested is different. In America, the use of pristine surfaces and small geometric elements that suggest industrial components is evident. In England, this use of geometry became interwoven with more gritty vocabularies from the Continent. The critique of society was again manifested in different ways that reveal the different cultural roots of the two countries. American practitioners were bolder in using narrative ideas, including wit, irony and brash statements, which have a direct lineage from nineteenth-century literature. This use of popular imagery and bold forms aligned

crafts with ideas that were being explored in the fine arts. Both England and America incorporate ideas from the *flâneur*, but whereas American practitioners use attraction to lure the audience into considering uncomfortable truths, objects made in England tend to use a variety of means which reflect the broad range of urban subjects.

Crafts that were designed for public areas have tended to continue with the artistic and social ideas that were manifested in gallery works. However, these were made to commission for the general public. The way that craft was used as a cohesive social tool in Philadelphia reflected the use that has been made of the genre during the twentieth century. In Birmingham and Grizedale, the works were used as a bridge between the environments and the public.

Although this book is by no means comprehensive, it has attempted to cover a large range of ideas and means. As Paul Greenhalgh has argued, we are living in an age of complexity, where globalization and interdisciplinarity permeate the cultural condition.[1] He is excited at the possibilities that this provides for crafts. Because crafts have their roots in society, it is a constantly evolving practice that echoes the concerns of different social and ethnic mixes at any one time and in any one place. The breadth of practice that is now exhibited in both countries, from utilitarian to conceptual, from discipline-specific to those incorporating other materials and processes, speaks of this process.

Contemporary craft practice is at a pivotal point, where makers are free from constraints of utility and can use its roots to conceptualize ideas. With the ease of communication, the increase in international exhibitions, and the ability to cross the discipline and genre boundaries, the developments over the next few years are sure to be very exciting.

NOTES

INTRODUCTION

1. www.craftscouncil.org.uk/about/socio_econ_survey.pdf. More than one-third of the 32,000 crafts workers in Wales and England have a portfolio of work.
2. Sir Christopher Frayling, 'United Kingdom', *Crafts* 181 (March/April 2003): 28.
3. Ibid.
4. David Revere McFadden, 'United States', *Crafts* 181 (March/April 2003): 30.
5. Ibid.: 31.
6. Howard Risatti, 'Metaphysical implications of function, material, and technique in craft', in *Skilled Work. American Craft in the Renwick Gallery* (Washington/London: Smithsonian Institute Press, 1998), pp. 34–5.
7. Ibid., pp. 40–2.
8. Bruce Metcalf, 'The problem of the fountain', *Metalsmith* 20 (Summer 2000): 32.
9. Paul Greenhalgh, 'The genre', in Paul Greenhalgh (ed.), *The Persistence of Craft* (London: A&C Black/Rutgers University Press, 2002), p. 18.
10. Paul Greenhalgh, 'Introduction: Craft in a changing world', in Paul Greenhalgh (ed.), *The Persistence of Craft*, p. 1
11. 'Making it in the 21st century: A socio-economic survey of crafts in England and Wales in 2002–2003', www.craftscouncil.org.uk/about/socio_econ_survey.pdf.
12. 'Introductory remarks', ibid. p. 2.
13. http://www.cmog.org/collection/main.php?module=objects.
14. http://www.sofaexpo.com/.
15. http://www.craftscouncil.org.uk/collect/about.html.
16. http://www.craftsonline.org.uk/about_origin.
17. Tanya Harrod, *The Crafts in Britain in the Twentieth Century* (Yale University Press, 1999).
18. Pamela Johnson (ed.), *Ideas in the Making: Practice in Theory* (Crafts Council, 1998),
19. Paul Greenhalgh (ed.), *The Persistence of Craft*.
20. Louise Taylor, 'Forward', *No Picnic* (London: Crafts Council, 1998).
21. Lloyd Harman and Matthew Kangas, *Tales and Traditions: Storytelling in Twentieth Century American Crafts* (Craft Alliance, 1993).
22. *Explorations: The Aesthetic of Excess* (American Craft Museum, New York, 1990).
23. Simon Olding, *Urban Field* (Crafts Study Centre, Farnham, 2007).
24. Julia Ellis (ed.), *Get Real. Romanticism and New Landscapes in Art* (University of Wolverhampton Press, 2000).

CHAPTER I CONTEMPORARY CRAFTS AND CULTURAL MYTHS

1. Barbara Mayer, *Contemporary American Craft Art: A Collector's Guide* (Gibbs M. Smith, 1988), p. 37.
2. Ibid., p. 41.
3. Joshua C. Taylor, *America as Art* (Smithsonian Institute Press, 1976), pp. 220–21.
4. Meyer, Contemporary American Craft Art, pp. 45–7.
5. www.alan-lomax.com/home_loc.html.
6. Carleton L. Safford and Robert Bishop, *America's Quilts and Coverlets* (E.P. Dutton, 1972), p. 9.
7. Jean Lipman, Foreward, *American Folk Art in Wood, Metal and Stone* (Pantheon, 1948).
8. Mayer, *Contemporary American Craft Art*, p. 46. There were two books published: Erwin O. Christesen, *The Index of American Design* and Clarence P. Hornung, *Treasury of American Design*.
9. Kardon, 'Craft in the Machine Age', in Janet Kardon (ed.), *Craft in the Machine Age, 1920–1945. The History of Twentieth Century American Craft* (Harry N. Abrams, 1995), p. 24.
10. Ibid., pp. 26–7.
11. Julie Hall, *Tradition and Change. The New American Craftsman* (E.P. Dutton, 1977), p. 17.
12. Robert Judson Clark, 'Cranbrook and the Search for Twentieth Century Form', in Joan Master et al., *Design in America: The Cranbrook Vision 1925–1950* (Harry N. Abrams, 1983), pp. 23–7.
13. Lee Nordness, *Objects: USA* (Thames and Hudson, 1971), pp. 13–14.
14. Harvey Green, 'Culture and Crisis: Americans and the Craft Revival', in Janet Kardon (ed.), *Revivals! Diverse Traditions, The History of Twentieth Century American Crafts, 1920–1945* (Harry N. Abrams, 1994), pp. 32–40.
15. Ibid., p. 33.
16. Ralph T. Coe, 'Native American Craft', in Kardon (ed.), *Revivals!*, p. 65.
17. Barbaralee Diamonstein, *Handmade in America. Conversations with Fourteen Craftmasters* (Harry N. Abrams, 1983/1995), p. 12.
18. H.H. 'Fourth National Conference of American Craftsmen', *Craft Horizons* (November/December 1961), p. 27.
19. Alice Adams, 'The Fabric as Culture', *Craft Horizons* (September/October 1961), p. 6.
20. David Campbell, Introductory paragraph to 'Fabrics International – an exhibition co-sponsored by the Museum of Contemporary Crafts and the Philadelphia Museum College of Art and circulated by the American Federation of Arts', *Craft Horizons* (September/October 1961), p. 5.
21. Ibid., p. 12.
22. Kenneth R. Trapp, 'Dedicated to art: Twenty-five years at the Renwick Gallery', in *Skilled Work. American Craft in the Renwick Gallery* (Smithsonian Institution Press, 1998), p. 16.
23. Ibid., p. 19.
24. Thomas S. Buechner, 'Foreword', Susanne K. Frantz, *Contemporary Glass* (Harry N. Abrams, 1989), p. 6.
25. Nordness, *Objects: USA*.
26. David Pye, *The Nature and Art of Workmanship* (Cambridge University Press, 1968), p. 1.
27. For details about this see Tanya Harrod, *The Crafts in Britain in the Twentieth Century* (Yale University Press, 1999), pp. 238–41.
28. Ibid., pp. 369–403.
29. D'Este Bond, 'Michael Rowe', *Crafts* (March 1973), pp. 22–5.
30. Plantaganet Somerset Fry, 'Back to Thatch', *Crafts* (March 1973), pp. 18–20.
31. Paul Greenhalgh, 'Introduction: Craft in a Changing World', in Paul Greenhalgh (ed.), *The Persistence of Craft* (A&C Black and Rutgers University Press, 2002), p. 10.
32. John Physick, *The Victoria and Albert Museum: The History of its Building* (Phaidon/Christies, 1982), p. 13.

33. Anna Somers Cocks, *The Victoria and Albert Museum: The Making of the Collection* (Windward, 1980), p. 15.

34. Harrod, *The Crafts in Britain in the Twentieth Century*, pp. 384–5.

35. Amanda Fielding, 'A Culture of Collecting: Silver and metalwork in the public domain', *Jerwood Applied Arts Prize, 2005: Metal* (Crafts Council, 2005), pp. 12–13.

36. http://www.twmuseums.org.uk/shipley/whatistheretosee/.

37. Sparke, *An Introduction to Design and Culture* (2004), p. 122. Wendy Ramshaw and David Watkins, *The Paper Jewelry Collection. Pop Out Artwear* (Thames and Hudson, 2000).

38. Arline Fisch, 'Detail', *American Craft* (December 1980/January 1981), pp. 20–2.

39. Harrod, *The Crafts in Britain in the 20th Century*, pp. 126–35.

40. Ralf Turner, *Jewellery in Europe and America. New Times, New Thinking* (Thames and Hudson, 1996), p. 9.

41. John Houston, 'Recent British Jewellery', *Crafts* (July/August 1973), pp. 31–2.

42. 'In brief', *Crafts* (May/June1974), p. 10.

43. Caroline Mornement (ed.), *Craft Galleries. A Directory of English Galleries and their Craftspeople* (Tony Williams Publishers, 1993). Caroline Mornement (ed.), *Craft Galleries Guide. A Selection of British Galleries and their Craftspeople* (BCF Books, 2002)

44. L.W. 'The gallery of Helen Drutt', *American Craft* (August/September 1979), pp. 30–1.

45. Ibid.

46. Advertisement for Convergence, *American Craft* (February/March 1983), p. 47.

47. Harrod, *The Crafts in Britain in the Twentieth Century*, p. 449.

48. Ibid., p. 457.

49. Martina Margetts, 'Strangely familiar', *Michael Rowe* (Birmingham Museum and Art Gallery/Lund Humphries, 2003), p. 26.

50. Harrod, *The Crafts in Britain in the Twentieth Century*, p. 448.

51. Mayer, *Contemporary American Craft Art*, p. 41.

52. Elena Canavier, 'Introduction', *American Crafts at the White House* (Los Angeles Craft/Folk Museum, 1977), n.p.

53. Ibid.

54. Crafts Advisory Committee, *Craftsmen of Quality* (Crafts Advisory Committee, 1976)

55. Crafts Advisory Committee, 'How to use this book', in ibid., n.p.

56. Peter Fuller, 'Review of *Fabric and Form*', a British Council touring exhibition, *Crafts* (November/December 1982), pp. 43–4.

57. Michael Brennand-Wood, 'Reply to Peter Fuller', *Crafts* (November/December 1982), pp. 44–5.

58. Letter from Audrey Walker in 'Letters', *Crafts* (January/February 1983), pp. 8–9.

59. Cherry Ann Knott, *Crafts in the 1990s. An Independent Socio-Economic Study of Craftspeople in England, Scotland and Wales* (Crafts Council, 1994), p. 15.

60. Ibid., p. 79.

61. Ibid., p. 333.

62. *Making it in the 21st Century. A Summary of the Main Findings and Related Trends* (Crafts Council, 2003), p. 12.

63. *Making it in the 21st Century*, p. 6.

64. Anon, 'Craft World. Collecting: Indianapolis Museum of Art', *American Craft* (February/March 1992), p. 8.

65. Anon, 'Craft World. A Movement's Foundation: Centenary Project Begins', *American Craft* (February/March 1991), pp. 10–11.

66. Joanna Foster, 'Forwards', *Collect* (Scala Publishers, 2008), p. 9.

67. Lloyd E. Herman, *Looking Forward Glancing Back, Northwest Designer Craftsmen at 50* (University of Washington Press, 2004), pp. 20–1.

68. Ibid.

69. For an overview of the development of towns, see David W. Lloyd, *The Making of English Towns. 2000 Years of Evolution* (Victor Gollancz, 1984). For an overview of the development of English countryside, see W.C. Hoskins, *The Making of the English Landscape*, new edition (Penguin, 1991)

70. See, for instance, Peter B. High, *An Outline of American Literature* (Longman, 1986), p. 27. Frances K. Pohl, *Framing America. A Social History of American Art* (Thames and Hudson, 2002), p. 74.

71. James E. Vance, Jr, 'Democratic Utopia and the American Landscape', in Michael P. Conzen (ed.), *The Making of the American Landscape* (Routledge, 1990), p. 209.

72. Pierce F. Lewis, 'The Northeast and the Making of American Geographical Habits', in Conzen (ed.), *The Making of the American Landscape*, 86.

73. Ibid., p. 91.

74. Ibid., p. 87–91.

75. Alice Marie O'Mara, *Urban Metaphor in American Art and Literature, 1910–1930* (PhD thesis: Northwestern University, 1982), pp. 2–4. See also Janet Kardon, 'Craft in the Machine Age', in Kardon (ed.), *Craft in the Machine Age, 1920–1945*, p. 24.

76. Jane M. Farmer, 'The Image of Urban Optimism' in *The Image of Urban Optimism* (Smithsonian Institute Travelling Exhibition Service, 1977), pp. 9, 14–26.

77. www.statistics.gov.uk/articles/population_trends/popreview_pt112.pdf; www.cia.gov/cia/publications/factbook/print/us.html; http://encarta.msn.com/encyclopedia_761572205/England.html.

78. Alun Howkins, *The Death of Rural England. A Social History of the Countryside since 1900* (Routledge, 2003), pp. 173–182.

79. For an overview the National Parks in America, see http://www.nps.gov.

80. William Gilpin, *Three Essays: On Picturesque Beauty, On Picturesque Travel: and On Sketching Landscape*, Essay 2 (Blamire, M.DCC.XCII), 45; Essay 1, pp. 14–15.

81. Gilpin, *Three Essays*, Essay 2, pp. 49–50.

82. Robert Woof, 'The Matter of Fact Paradise', *The Lake District: A Sort of National Property* (Countryside Commission/V&A, 1984), p. 9.

83. William Wordsworth, *Guide to the Lakes* (Open University Press, 1977), p. 1.

84. William Hazlitt, 'On going on a Journey', p. 71, and 'On the Love of the Country', pp. 6–7, both in Geoffrey Keynes (ed.), *Selected Essays of William Hazlitt, 1778:1830* (Nonsuch Press, 1930).

85. Wendy Joy Derby, *Landscape and Identity* (Berg, 2000), pp. 54–6.

86. Joel Porte, 'Introduction: Representing America – the Emerson Legacy', in Joel Porte and Saundra Morris, *The Cambridge Companion to Ralf Waldo Emerson* (Cambridge University Press, 1999), pp. 6–7.

87. Ibid., p. 6

88. David M. Robinson, 'Transcendentalism and its Times' in Joel Porte and Saundra Morris, *The Cambridge Companion to Ralf Waldo Emerson*, p. 18.

89. Merton M. Sealts, Jr, and Alfred R Ferguson, *Emerson's Nature. Origin, Growth, Meaning* (Southern Illinois University Press, 1969), p. 7.

90. Robinson, 'Transcendentalism and its Times', pp. 15–17.

91. Sealts Jr, and Ferguson, *Emerson's Nature*, p. 19.

92. Robert Richardson Jr, 'Thoreau's Concord', in Joel Myerson, *The Cambridge Companion to Henry David Thoreau* (Cambridge University Press, 1995), p. 22.

93. John F. Sears, *Sacred Places. American Tourist Attractions in the Nineteenth Century* (University of Massachusetts Press, 1989), pp. 3–7.

94. Barbara Novak, *Nature and Culture. American Landscape and Painting, 1825–1875*, revised edition (Oxford University Press, 1995), p. 3.

95. Ibid., p. 17.

96. Ibid., p. 27.

97. Sears, *Sacred Places*, p. 122.

98. Ibid., pp. 12, 49.

99. John Beardsley, 'Gardens of History, Sites of Time', in *Visions of America. Landscape as Metaphor in the Late Twentieth Century* (Denver Art Museum/Columbus Museum of Art, 1994), p. 38.

100. http://www.nps.gov/.

101. Robert D. Richardson Jr, 'Emerson and Nature', in Porte and Morris, *The Cambridge Companion to Ralf Waldo Emerson*, p. 100.

102. Yorke, *The Spirit of Place. Nine Neo Romantic Artists and their Times* (Constable, 1987), p. 17.

CHAPTER 2 CONTEMPORARY ARTS AND CRAFTS MAKERS IN RURAL ENGLAND

1. H.V. Morton, *In Search of England* (Methuen, 1927/2000), p. 1.

2. Ibid., pp. 8–9.

3. For an excellent overview of the changing nature of the countryside, see Alun Howkins, *The Death of Rural England. A Social History of the Countryside since 1900* (Routledge, 2003)

4. Fiona MacCarthy, *The Simple Life. C.R.Ashbee in the Cotswolds* (Lund Humphries, 1981), pp. 9–10.

5. William Morris, 'Art and its Producers', in *William Morris, Art and its Producers and The Arts and Crafts of Today*, two addresses delivered before the National Association for the Advancement of Art (Chiswick Press, 1901), p. 3.

6. Ibid., p. 15.

7. Morris, 'The Arts and Crafts of Today', ibid., pp. 25–26.

8. W.R. Lethaby, *Home and Country Arts* (Home and Country, 1930 [1923]), pp. 13–16.

9. W.R. Lethaby, 'Ernest Gimson's London Days', in W.R. Lethaby, Alfred H. Powell and F.L. Griggs, *Ernest Gimson: His Life and Work* (Shakespeare Head Press, 1924), pp. 3–4.

10. Ibid.

11. Ibid., p. 5.

12. Jacqueline Sarsby, 'Alfred Powell: Idealism and Realism in the Cotswolds', *Journal of Design History* (Vol. 10, no. 4, 1997), p. 391.

13. Alfred Powell, 'Ernest Gimson's Gloucestershire Days', in Powell and Griggs, *Ernest Gimson: His Life and Work*, pp. 12–14.

14. Many of his lectures portray this dream; however, see William Morris, 'The Lesser Arts', William Morris, 'The Beauty of Life', William Morris, 'How We Live and How We Might Live', all in G.D.H. Cole (ed), *William Morris, Prose, Verse, Lecture and Essays* (Random House, Nonsuch Press, 1974), pp. 494–516, 538–64, 565–87.

15. Eric Gill, 'Art', in Eric Gill, *Selected Essays. It All Goes Together* (Books for Libraries Press, 1944/1977), pp. 113–21. W.R. Lethaby, 'Art and Workmanship', reprinted from *The Imprint*, 1913, by Birmingham School of Printing, 1930, p. 3.

16. Eric Gill, 'Private Property' and 'Peace and Poverty', both in Gill, *Selected Essays*, pp. 128–34, 142–7.

17. Eric Gill, 'Clothing without Cloth', in Gill, *Selected Essays*, p. 35.

18. Tanya Harrod, *The Crafts in Britain in the 20th Century* (Yale University Press, 1999), pp. 369–403.

19. 'In Brief', *Crafts* (May/June 1975), pp. 9–10. In this year they were given to a book-maker, a hand block printer and resist dyer, a potter, a furniture-maker, a book-binder and a jeweller.

20. Simon Roodhouse, 'Yorkshire commentary', *Crafts* (May/June 1980), p. 44.

21. 'Crafts in and around Newcastle', *Crafts* (July/August 1978), p. 9.

22. Tanya Harrod, *The Crafts in Britain in the 20ᵗʰ Century*, pp. 392–3.

23. 'Paul Caton Bowl Maker', Photographs by Phil Sayers, *Crafts* (July/August 1979), pp. 17–21.

24. Anthony Horrocks, 'A Craft Community', *Crafts* (March 1973), pp. 15–16.

25. Peter Dormer 'Dyed in the Wool', *Crafts* (July/August 1984), pp. 12–13.

26. Ibid., p. 12. He used the quotation marks around the word craft.

27. Edward Lucie-Smith, 'A New Vocabulary', *Crafts* (January/February 1977), p. 29.

28. Christopher Frayling and Helen Sowden, 'The Myth of the Happy Artisan', *Crafts* (January/February 1982), pp. 16–17.

29. Ibid., p.16.

30. Harrod, *The Crafts in Britain in the 20ᵗʰ Century*, pp. 370–371.

31. Ibid., p. 371.

32. Jonathan Porritt and David Winner, *The Coming of the Greens* (Fontana Paperbacks, 1988), p. 179.

33. Ibid., p.179.

34. Research done by Christine McNulty, quoted in ibid., p. 172.

35. Ibid.

36. Linda Sandino, 'Field Notes', in Simon Olding (ed.), *Urban Field* (Crafts Study Centre, 2007), p. 13. John Seymour, 'Wonder of work', in Sandy Brown and Maya Kumar Mitchell, *The Beauty of Craft. A Resurgence Anthology* (Chelsea Green Publishing, 2004), pp. 26–29.

37. Garth Clark, *Michael Cardew, a Portrait* (Kodansha International, 1976), p. 31.

38. Reginald G. Haggar, *English Country Pottery* (Phoenix House, 1950), p. 127. Wattisfield Pottery in North Suffolk was one of these.

39. Peter Brears, *The English Country Pottery. Its History and Techniques* (David and Charles, 1971), p. 72.

40. Bernard Leach, *A Potter's Book* (Transatlantic Arts, 1965), p. 2.

41. Ibid., pp. 2–4.

42. Ibid., p. 6, note 1.

43. William Morris, 'The Lesser Arts of Life', in William Morris, *Architecture, Industry and Wealth, Collected Papers by William Morris* (Longmans Green, 1902), p. 43.

44. William Morris, 'The Lesser Arts of Life', ibid., pp. 38–9.

45. Len Dutton, 'Michael Cardew at 75', *Ceramic Review* (July/August 1976), pp. 9–10.

46. Ron Wheeler, *Winchcombe Pottery. The Cardew–Finch Tradition* (White Cockade Publishing, 1998), pp. 31–32.

47. Ibid., p. 32.

48. John Edgelar (ed.), *Ray Finch Craftsman Potter of the Modern Age* (Cotswold Living Publications, 2006), p. 12; Wheeler, *Winchcombe Pottery*, p.14.

49. Jaqueline Sarsby, 'Pots of Life: Winchcombe Pottery 1926–1998. Cheltenham Art Gallery and Museum', *Crafts* (March/April 1999), pp. 61–62.

50. Interview with David Wilson, June 2006

51. Interview with David Wilson, June 2006.

52. Peter Dormer, *The Art of the Maker. Skill and its Meaning in Art, Craft and Design* (Thames and Hudson, 1994), p. 24.

53. Dutton, 'Michael Cardew at 75', p. 8.

54. Marigold Coleman, 'On being a potter. Interview with Mick Casson', *Crafts* (January/February 1976), p. 37. He ran a vocational potting course at Harrow School of Art, which included the training in repetition throwing, so that potters would emerge able to support themselves.

55. Daniel Rhodes, 'A Potter's Philosophy', *Crafts* (November/December 1978), p. 21.

56. Maurice Merleau-Ponty, *Phenomenology of Perception*, translated by Colin Smith (Routledge, 2002), pp. 86–87 and 112–117.

57. Ibid., pp. 121.
58. Quoted in Clive Edwards, 'The Castration of Skill?', in Tanya Harrod, *Obscure Objects of Desire* (Crafts Council, 1997), p. 350; see also Eric Gill, 'Art and Education', 'Private Property' and 'Against Mass Production', all in Gill, *Selected Essays*, pp. 148–50, 128–134, 112–121.
59. Dormer, *The Art of the Maker*, p. 64.
60. MacCarthy, *The Simple Life*, p. 15.
61. Annette Carruthers and Mary Greensted, *Simplicity and Splendour. Arts and Crafts Living: Objects from the Cheltenham Collections* (Cheltenham Art Gallery and Museums in association with Lund Humphries, 1999), p. 147.
62. Interview with David Hart, August 2007.
63. Alan Crawford, *C.R. Ashbee, Architect, Designer and Romantic Socialist* (Yale University Press, 1985), p. 325.
64. Ibid., p. 327.
65. Interview with David Hart, August 2007.
66. Crawford, *C.R. Ashbee, Architect, Designer and Romantic Socialist*, pp. 331, 340.
67. Interview with Jeff Humpage, August 2007.
68. Interview with David Hart, August 2007.
69. See http://www.lawrencenealchairs.co.uk/index,htm. See also Godfrey Beaton 'Thinking about Chairs', *Crafts* (May/June 1978), p. 23.
70. Mary Comino Gimson and the Barnsleys. 'Wonderful Furniture of a Commonplace Kind' (Evans Brothers, 1980), p. 121.
71. Ibid, p. 123.
72. Annette Carruthers, *Edward Barnsley and his Workshop. Arts and Crafts in the Twentieth Century* (White Cockade Publishing, 1992/4), p. 136.
73. Carruthers, *Edward Barnsley and his Workshop*, pp. 99–102.
74. Interview with William Hall, June 2006.
75. Interview with William Hall, June 2006.
76. Visit to workshop, August 2007.
77. http://www.basketassoc.org/pages/basketmaking.php.
78. http://www.englishwillowbaskets.co.uk.
79. http://www.basketassoc.org/index.php.
80. Barbara J. Bloemink, 'David Drew: Britain's Master Basketmaker', *Fiberarts* (Summer 1992), p. 30.
81. Ibid., p. 31.
82. Richard Boston, 'David Drew, Basketmaker', in *David Drew: Baskets* (Crafts Council, 1986), p. 7.
83. Ibid., p. 13.
84. http://www.jennycrisp.co.uk/Site/about%20jenny.html.
85. Telephone conversation with Jenny Crisp, March 2008.
86. For a discussion about the potency of framing images, see Brian Spooner, 'Weavers and Dealers: The Authenticity of an Oriental Carpet', in Arjun Appadurai, *The Social Life of Things. Commodities in Cultural Perspective* (Cambridge University Press, 1997), pp. 197–8; John Tozer, 'Repeat after Me', in Emmanuel Cooper and Louise Taylor (*Un)limited* (Crafts Council, 1999), p. 10.
87. Interview with author with David Hart, August 2007.
88. Seymour, 'Wonder of Work', Brown and Mitchell (eds), *The Beauty of Craft*, pp. 26–29.
89. Garth Clark, 'The future of functional pottery. Part Two: Bernard's orphans searching for neo in classical', in John Pagliaro (ed.), *Shards. Garth Clark on Ceramic Art* (Ceramics Art Foundation and Distributed Art Foundation, 2003), pp. 389–390.
90. Ibid., p. 396.
91. Ibid., p. 391.

92. Jean Baudrillard, 'The System of Objects', in Mark Poster (ed.), *Jean Baudrillard. Selected Writings* (Stanford University Press, 1988), p. 10.

93. Carruthers, *Edward Barnsley and his Workshop*, p. 14.

94. http://www.johnleachpottery.co.uk/about.asp.

95. John Houston, 'Middle Class Art?', *Crafts* (May/June 1989), p. 17.

96. Ibid.

97. Ibid.

98. Eric Hobsbawm, 'Introduction: Inventing Traditions', in Eric Hobsbawm and Terence Ranger (eds), *The Invention of Tradition* (Cambridge University Press, 1983).

99. Ibid., p. 4.

100. Ibid., p. 9.

101. Gill Valentine, 'Imagined Geographies: Geographical knowledge of self and other in everyday life', in Doreen Massey, John Allen and Philip Sarre (eds), *Human Geography Today* (Polity Press, 1999), p. 48.

CHAPTER 3 THE ARTISAN TRADITION IN RURAL AMERICA

1. Timothy D. Rieman, 'Shaker Design, Superfluities Doomed', in Timothy Rieman, *Shaker: The Art of Craftsmanship* (Art Services International, 1995), pp. 32, 37.

2. Edward R. Bosley, 'Two Sides of the River: Morris and American Arts and Crafts', in Dianne Waggoner (ed.), *William Morris and the Art of Design* (Thames and Hudson, 2003), pp. 137–139.

3. Wendy Kaplan, 'America: The Quest for Democratic Design', in Wendy Kaplan, *The Arts and Crafts Movement in Europe and America: Design for the Modern World* (Thames and Hudson 2004), p. 258.

4. Anon, 'Craftsmen USA '66 – Northeast Region', *Craft Horizons* (June 1966), pp. 75–77, 109.

5. See Chapter 1.

6. Michael Bunce, 'Reproducing Rural Idylls', in Paul Cloke (ed.), *Country Visions* (Pearson Education, 2003), p. 16.

7. Barbara Mayer, *Contemporary American Craft Art: A Collector's Guide* (Gibbs M. Smith, 1988), p. 41.

8. Ibid., pp. 37–38.

9. Simone Abram, 'The Rural Gaze', in Cloke (ed.), *Country Visions*, p. 35.

10. Interview with Jean Weller, April 2007.

11. Interview with Kenny Lafond, April 2007.

12. William Daley, 'Thoughts on Craft and Learning' in *Craft and Learning Symposium* at Haystack Mountain School of Crafts, 1991, p. 6.

13. Interview with Kenny Lafond, April 2007.

14. http://www.hidden-hills.com/basketshop/

15. http://williamsburgblacksmiths.com/shopping/customer/home.php.

16. Ronny Cohen, 'Jack Earl', *American Craft* (August/September, 1985), p. 22.

17. Maldwyn A. Jones, *The Limits of Liberty. American History 1607–1992* (Oxford University Press, 1995), p. 524.

18. Lee Nordness, *Objects: USA* (Thames and Hudson, 1970), pp. 11–12.

19. Jones, *The Limits of Liberty* (Oxford University Press, 1995), pp. 576–7.

20. Paul J. Smith, 'Handmade by Design', in Paul J. Smith, *Objects for Use: Handmade by Design* (Harry N. Abrams and American Craft Museum, 2001), p. 16.

21. Jack Lenor Larsen, 'The American Crafts Council Evolves', *Craft Horizons* (December 1973), p. 8.

22. Rose Slivka, 'Affirmation. The American Craftsman 1971', *Craft Horizons* (December 1970), p. 11.

23. Ibid.

24. Rose Slivka, 'The New Ceramic Presence', *Craft Horizons* (July/August 1961), pp. 31–33.

25. Cheryl Robertson, 'House and Home in the Arts and Crafts Era: Reforms for Simpler Living', in Wendy Kaplan, *The Art that is Life. The Arts and Crafts Movement in America 1875–1920* (Little, Brown, 1987), pp. 337–338.

26. http://www.taunton.com/thetauntonpress/our_culture.asp.

27. Interview with Jim Picardi, April 2007.

28. http://www.taunton.com/thetauntonpress/about_us.asp.

29. Jeanne Braham, *Made by Hand. Art and Craft in the Heartland of New England* (Commonwealth Editions, 2004), p. 6.

30. www.shelburnefalls.com/directory.php?webcat=Shopping%253A%2BArtists%2Band%2B Galleries.

31. Braham, *Made by Hand*, p. 4.

32. Vivian Kline, 'Craft Centre Fact Sheet: A Sampling', *Craft Horizons* (April 1973) pp. 43–59.

33. Kline, 'Craft Centre Fact Sheet: A Sampling', p. 58.

34. Interview with Jonathan Winfisky, April 2007.

35. http://www.craftcouncil.org/

36. Smith, 'Handmade by Design', pp. 18–19.

37. http://www.hidden-hills.com/hilltownartisans/

38. Akiko Busch, 'Perspectives on Craft and Design', in Paul J. Smith (ed.), *Objects for Use*, p. 8.

39. Garth Clark, 'Betty Woodman: Storm in a Teacup: An Anecdotal Discussion of Function', in John Pagliaro (ed.), *Shards: Garth Clark on Ceramic Art* (Ceramics Art Foundation and Distributed Art Publications, 2003), p. 250.

40. Telephone discussion with Mark Shapiro, March 2008.

41. http://www.mayamachinpottery.com.

42. Telephone conversation with Tom Kuklinski, March 2008.

43. Smith (ed.), *Objects for Use*.

44. Herman, *Art that Works*, p. 17.

45. See Chapter 2.

46. Smith, 'Handmade by Design', pp. 12–14.

47. Interview with Jim Picardi, April 2007.

48. Interview with Andrew Quient, April 2007.

49. Interview with Peggy Hart, April 2007.

50. Interview with Jonathan Winfiski, April 2007.

51. Interview with Tom Kuklinski, April 2007.

52. http://stonepoolpottery.com.index.htm.

53. Telephone conversation with Mark Shapiro, March 2008.

54. Telephone conversation with Mark Shapiro, March 2008.

55. Telephone conversation with Mark Shapiro, March 2008.

56. Telephone conversation with Tom Kuklinski, March 2008.

57. Telephone conversation with Tom Kuklinski, March 2008.

58. Interview with Peggy Hart, April 2007.

59. Interview with Jim Picardi, April 2007.

60. Interview with Peggy Hart, April 2007.

61. Jack Lenor Larsen, 'The American Crafts Council Evolves', *Craft Horizons* (December 1973), p. 8.

62. Interview Jonathan Winfisky, April 2007

63. Interview with Becky Ashenden, April 2007.

64. http://www.hidden-hills.com/beverlybowman/

65. Charles Guignon, *On Being Authentic* (Routledge, 2004), p. 18.

66. Ibid., pp. 126–145.

67. Ibid., pp. 126–127.

68. Mark Schapiro in Smith (ed.), *Objects for Use*, p. 114.

CHAPTER 4 CRITIQUE AND EMBODIMENT IN RURAL ENGLAND

1. See Chapter 1.

2. David Queensberry, quoted in Tanya Harrod, *The Crafts in Britain in the 20th Century* (Yale University Press, 1999), p. 371.

3. David Hamilton, 'No Man's Land', *Crafts* (July/August 1975), p. 42.

4. Interview with Jenny Beavan, April 2006.

5. Polly Binns, 'Vision and Process in Textile Art: A Personal Response to a Particular Landscape', unpublished PhD thesis, University of Teeside, 1997, pp. 12–13.

6. W.R. Lethaby, *Philip Webb and his Work* (Rowen Oak Press, 1974 [1935]), pp. 127–128.

7. Simone Abram, 'The Rural Gaze', in Paul Cloke, *Country Visions* (Pearson Education, 2003), p. 35.

8. Lesley Jackson, 'Commissions', *Crafts* (March/April 2006), pp. 22–23.

9. Mary Schoester, 'Bucking the Trend' in *Michael Brennand-Wood. Field of Centres* (Harley Gallery and Gallery Ruthin Craft Centre, 2004), p. 22.

10. Norman Bryson, *Looking at the Overlooked. Four Essays on Still Life Painting* (Reaktion Books, 1990), pp. 104–105.

11. Andrea Branzi, 'We are the Primitives', in Victor Margolin (ed.), *Design Discourse. History. Theory. Criticism* (University of Chicago Press, 1989), pp. 37–41.

12. Richard Slee in *Get Real. Romanticism and New Landscape in Art* (University of Wolverhampton, 2001), p. 32.

13. Clement Greenberg, 'The Avant-garde and Kitch', in Charles Harrison and Paul Wood (eds), *Art in Theory, 1900–2000, An Anthology of Changing Ideas* (Blackwell, 2003), p. 543.

14. John Houston, *Richard Slee: Ceramics in Studio* (Bellew Publishing, 1990), p. 19.

15. http://www.nationalgallery.org.uk/about/press/2007/scratch_surface.htm.

16. Okwui Enwezor, 'Tricking the Mind: The Work of Yinka Shonibare', in *Yinka Shonibare. Dressing Down* (Ikon Gallery, 1999), p. 10.

17. Ibid., p. 17.

18. Grayson Perry, *The Charms of Lincolnshire* (The Collection, Lincoln, 2006), pp. 6–7.

19. Ibid., pp. 13–15.

20. Ibid., p. 35.

21. Dorris U Kuyken-Schneider, 'Introduction', in *Gordon Baldwin, Mysterious Volumes* (Museum Boymans van Beuningen, 1989), p. 7.

22. Alison Britton, *Gordon Baldwin* (Contemporary Applied Arts, 1993), n.p.

23. John Houston, *The Abstract Vessel. Ceramics in Studio* (Bellew Publishing, 1991), pp. 9–12.

24. Alison Britton, *Gordon Baldwin*, n.p.

25. Ibid.

26. Jane Perryman, *Naked Clay. Ceramics without Glaze* (A&C Black/University of Pennsylvania Press, 2004), p. 28.

27. Jo Hall, 'Fields of Gold', *Embroidery* (May/June 2005), pp. 31–32.

28. Talk given at Stroudwater Textile Festival, 6 May 2007: Sue Lawty, 'Life and Work of an Artist'.

29. Biography in exhibition catalogue, 'Cynthia Cousens: Shift – Towards New Jewellery' (*International Design*, 2002), p. 46.

30. Liz Hoggard, 'Surface Treatment', *Crafts* (March/April, 2004), p. 27.

31. Christopher Tilley, The Phenomenology of Landscape. Places, Paths and Monuments (Berg, 1994), p. 7.

32. Philip Rawson, *Ceramics* (Oxford University Press, 1971), p. 6.

33. Ibid., pp. 8, 15.

34. Amanda Fielding, 'Making Connection', in *Hands Across the Border* (Ruthin Craft Centre, 2004), p. 15. The exhibition was curated by Judy Dames and included the work of Gordon Baldwin, Dail Behennah, Maxine Bristow, Simon Carroll, Walter Keeler, Alison Morton, Jim Partridge, Pamela Rawnsley and Rupert Spira.

35. Judy Dames, 'Simon Carroll', in *Hands Across the Border*, p. 43.

36. Rawson, *Ceramics*, p. 16.

37. Tilley, *A Phenomenology of Landscape*, p. 16.

38. Binns, *Vision and Process in Textile Art* (my italics). The chapter headings are 'Working from the Landscape', 'Overstrand to Sidestrand, 1992–1994', 'Working in the Landscape, Blakeney, 1994–1996', 'Working with the Landscape, Blakeney, 1996'.

39. Ibid., pp. 41–42.

40. Ibid., pp. 42–43.

41. Pamela Johnson, 'The Poetry of Surface', in *Polly Binns Monograph. Surfacing* (Bury St Edmunds Art Gallery, 2003), p. 11.

42. Tilley, *A Phenomenology of Landscape*, p. 16.

43. Pamela Johnson, 'Immensity in Minutiae', in *Polly Binns Monograph*, p. 33.

44. Binns, *Vision and Process in Textile Art*, p. 28.

45. Johnson, 'The Poetry of Surface', in *Polly Binns Monograph*, p. 35. 'Unthought known' was a term used by Christopher Bollas.

46. Martina Margetts, 'A Natural Journey', in *Cynthia Cousens: Shift – Towards New Jewellery* (Brighton: Royal Pavilion, Libraries and Museums, 2003), pp. 8–9.

47. Pamela Johnson, 'Time Out', *Crafts* (July/August, 1995), pp. 27–28.

48. Martina Margetts, 'A Natural Journey', p. 9.

49. Interview with Jenny Beavan, April 2006.

50. See Jenny Beavan, 'In Transition', *Ceramic Review* (January/February 2003), pp. 36–39.

51. Interview with Jenny Beavan, April 2006.

52. Tilley, *A Phenomenology of Landscape*, p. 14.

53. Interview with David Binns, February 2005.

54. Interview with David Binns, February 2005.

55. Judy Dames, 'Dail Behennah', in *Hands Across the Border*, pp. 35–36.

56. Denis Cosgrove, 'Mapping Meaning', in Denis Cosgrove (ed.), *Mappings* (Reaction Books, 1999), pp. 1–2.

CHAPTER 5 MATERIAL, SPACE AND PLACE IN AMERICA

1. See Chapter 1.

2. Janet Koplos, 'What's Crafts Criticism Anyway?', in *Exploring Contemporary Craft. History Theory and Critical Writing* (Coach House Books, 2002), p. 82.

3. For an overview, see Marcia Manhart and Tom Manhart, 'The Widening Arcs: A Personal History of a Revolution in the Arts', in Marcia Manhart and Tom Manhart, *The Eloquent Object. The Evolution of American Art in Craft Media Since 1945* (Philbrook Museum of Art, 1987), pp. 15–45.

4. Ibid., p. 28.

5. Whitney Halstead, 'Claire Zeisler and the Sculptural Knot', *Craft Horizons* (September/October 1968), p. 10.

6. Bonita Fike, 'The Art Historical Context of Contemporary Glass' in Bonita Fite, *A Passion for Glass. The Ariva and Jack A Robinson Studio Glass Collection* (Detroit Institute of Arts, 1998), p. 14.

7. Dan Klein, *Artists in Glass. Late Twentieth Century Masters in Glass* (Mitchell Beazley, 2001), p. 8.

8. Garth Clark, 'Forward: The Bray Incubator', in Peter Held (ed.), *A Ceramic Continuum: Fifty years of the Archie Bray Influence* (University of Washington Press, 2001), p. 7.

9. Rick Newby and Chjere Jiusto, ' "A Beautiful Spirit": Origins of the Archy Bray Foundation for the Ceramic Arts', in P. Held (ed.), *A Ceramic Continuum* (University of Washington Press, 2001), p. 29.

10. Arthur Danto, 'Between the Utensil and Art: The Ordeal of American Ceramics', in Yvonne Joris (ed.), *Choice from America. Modern American Ceramics* (Het Kruithuis, 1999), pp. 9–10. See also Garth Clark, 'Abstract Expressionism revisited', Parts I and II, in John Pagliaro (ed.), *Shards. Garth Clark on Ceramic Art* (Ceramics Arts Foundation/Distributed Art Publications, 2003), pp. 261–282 and pp. 285–301.

11. John Coplans, *Abstract Expressionist Ceramics* (San Fransisco Museum of Art/University of California Art Gallery, 1966)

12. Clement Greenberg, 'Modernist Art', in Charles Harrison and Paul Wood (eds), *Art in Theory, 1900–2000, An Anthology of Changing Ideas* (Blackwell, 2003), pp. 774–775.

13. Rose Slivka, 'The New Ceramic Presence', *Craft Horizons* (July/August 1961), pp. 31–37.

14. Edward S. Cooke Jr, 'From Manual Training to Freewheeling Craft: The Transformation of Wood Turning 1900–1976', in catalogue, *Wood Turning in North America Since 1930* (Wood Turning Centre/Yale University Art Gallery, 2001), p. 20.

15. Glenn Adamson, 'Circular Logic: Wood Turning 1976 to the present', in ibid., pp. 64–69.

16. See Robert Morris, 'Notes on Sculpture 4: Beyond Objects', *Artforum* (April 1969), pp. 50–54. See also the discussion of the work of David Nash and Andy Goldsworthy in Chapter 9.

17. http://www.burchardstudio.com/words.html.

18. Anon., 'Craft World: Turners in Texas', *American Craft* (October/November 1991), p. 8.

19. Anon., 'Craft World. The Forest and the Trees: Woodworkers Convene on the Tropical Timber Issue', *American Craft* (February/March 1991), pp. 8–9.

20. http://www.burchardstudio.com/words.html.

21. http://www.burchardstudio.com/C.Burchard.pdf.

22. George Santayana, *The Sense of Beauty. Being the Outline of Aesthetic Theory* (Dover, 1955 [1896]), pp. 78–81.

23. Jill Nordfors Clark, 'Seductive Surfaces: Fishskin and Gut', *Surface Design Journal* (Fall 2003), pp. 32–39.

24. Manhart, M. and Manhart, T. 'The Widening Arcs' (Philbrook Museum of Art, 1987), p. 34.

25. Malswin A. Jones, *The Limits of Liberty. American History 1607–1992* (Oxford University Press, 1995), pp. 583–584.

26. http://www.fiberarts.com/article_archive/profiles/jillnordforsclark.asp.

27. Alec Clayton, 'Jill Nordfors Clark: Lace and Gut', *Fiberarts* (November/December 2002), p. 21.

28. Patricia Malarcher, 'A Basket is . . .', *American Craft* (February/March 1990), p. 43.

29. Gaston Bachelard, *The Poetics of Space*, trans. by Maria Jolas (Beacon Press 1994 [1969]), pp. 90–104.

30. Interview with John McQueen in Barbaralee Diamonstein, *Handmade in America: Conversations with Fourteen Craftsmasters* (Harry N. Abrams, 1995), p. 153.

31. See Chapter 4.

32. Interview with John McQueen in Diamonstein, *Handmade in America*, p. 162.

33. Ed Rossbach, 'Containing and Being Contained', in *John McQueen. The Language of Containment* (University of Washington Press/Smithsonian Institute, 1991), p. 13.

34. Vicki Halper, 'The Language of Containment', in *McQueen. The Language of Containment*, p. 44.

35. Email from Gyöngy Laky to author, March 2008.

36. Marion S. Lee, *Gyöngy Laky. Intersections* (San Francisco: Braunstein/Quay Gallery, 2007), pp. 13 and 16.

37. Email from Gyöngy Laky to author, March 2008.

38. Marion S. Lee, *Gyöngy Laky. Intersections*, pp. 10–12.

39. Lloyd E. Herman, *Looking Forward. Glancing Back. Northwest Designer Craftsmen at 50* (Whatcom Museum of History of Art, 2004), p. 20.

40. Leo Marx, 'The American Ideology of Space', in William Howard Adams and Stuart Wrede (eds), *Denatured Visions. Landscape and Culture in the Twentieth Century* (Harry N. Abrams, 1991), p. 66.

41. Arthur C. Danto, 'Between the Utensil and Art', p. 8.

42. Jonathan Holstein, 'American Pieced Quilts', in catalogue, *American Pieced Quilts* (Editions des Massons SA, 1972).

43. Ibid., pp. 11–13.

44. See, for instance, the discussion in Robert Storr, 'A Piece of the Action', in Kirk Varnedoe and Pepe Karmel (eds), *Jackson Pollock. New Approaches* (Harry N. Abrams, 1999), pp. 36–37.

45. See, for instance, C. Kurt Dewhurst, Betty MacDowell and Marsha MacDowell, *Artists in Aprons* (E.P. Dutton/Museum of American Folk Art, 1979); or Schnuppe von Gwinner, *The History of the Patchwork Quilt. Origins, Traditions and Symbols of a Textile Art* (Schiffer Publishing, 1988)

46. Jacqueline M. Atkins, 'Tradition and Transformation. Women Quilt Designers', in Pat Kirkham (ed.), *Women Designers in the USA, 1900–2000. Diversity and Difference* (Yale University Press, 2000), pp. 172–174.

47. Quoted in ibid., p. 175.

48. Michael James, 'Beyond Tradition. The Art of the Studio Quilt', *American Craft* (February/March 1985), p. 18.

49. Nancy Corwin, 'Content in Crafts: Materials in the service of Larger Ideas', in symposium papers, *Craft in the 90s: A Return to Crafts* (Haystack Mountain School of Crafts, 1991), p. 8.

50. Interview with Anne Brauer, April 2007.

51. Catalogue, *Quilt National. Contemporary Designs in Fabric* (Ashville: Lark Books, 1995), p. 80.

52. Michael James, 'Beyond Tradition. The Art of the Studio Quilt', *American Craft* (February/March 1985), p. 18.

53. Interview with Ann Brauer April 2007.

54. Interview with Ann Brauer April 2007.

55. Anne Jarmusch, 'From Mesas through Canyons to the Sea and Back', *American Craft* (April/May 1981), pp. 11–12.

56. Wayne Higby in *Art in Craft Media. The Haystack Tradition* (Bowdoin College Museum of Art, 1981), p. 23.

57. Wayne Higby, 'Expectation: Art, Material and the Photograph', in symposium papers, Haystack Mountain School of Crafts, *Craft in the 1990s: A Return to Materials*, 1991.

58. Bachelard, *The Poetics of Space*, pp. 183–190 and pp. 201–203.

59. See James Trilling, *The Language of Ornament* (Thames and Hudson, 2001), pp. 6–7.

60. Artist's statement, April 1997.

61. Interview with Deb Todd Wheeler, April 2007.

62. Interview with Deb Todd Wheeler, April 2007.

63. Interview with Deb Todd Wheeler April 2007.

64. Interview with Deb Todd Wheeler April 2007.

65. Patricia Harris and David Lyon, 'Mystery and Memory. The Jewellery of Sandra Enterline', *Metalsmith* (Spring 2004), pp. 30–39.

66. Email from Jennifer Trask to author, June 2007.

67. Email from Jennifer Trask to author, June 2007.

CHAPTER 6 URBAN CRAFTS IN AMERICA

1. Lee Nordness, *Objects: USA* (Thames and Hudson, 1971)

2. Ibid., p. 21.

3. See Virginia Postrel, *The Substance of Style. How the Rise of Aesthetic Value is Remaking Commerce, Culture, and Consciousness* (Perennial, 2003), pp. x–xi.

4. Jean Baudrillard, *The System Of Objects*, trans. James Benedict (Verso, 1996), p. 145.

5. See Chapter 7.

6. See Chapter 1.

7. Neil Harris, 'North by Midwest', in Joan Master, Craig Miller, Mary Riordan, Roy Slade, Davina S Taragin, Christa C Mayer Thuman, *Design in America. The Cranbrook Vision, 1925–1950* (Harry N. Abrams, 1983), p. 15.

8. Robert Judson Clark, 'Cranbrook and the Search for Twentieth Century Form', in Master, et al., *Design in America*, pp. 29–30, 108, 205.

9. Ibid., pp. 108, 205.

10. Christina C Mayer-Thurman, 'Textiles' in Master et al., *Design in America*, p. 208.

11. Sigrid Wortmann Weltge, *Bauhaus Textiles. Women Arts and the Weaving Workshop* (Thames and Hudson, 1993), p. 97.

12. Jack Lenor Larsen, 'The Future of the Textile', *Craft Horizons* (September/October, 1961), p. 7.

13. Anni Albers, 'More Serving, Less Expressing', *Craft Horizons* (July/August, 1961), pp. 52–53. Jack Lenor Larsen, 'The American Crafts Council Evolves', *Crafts Horizons* (December 1973), p. 8.

14. David Revere McFadden, 'Surface and Texture', in David Revere McFadden, Mildred Friedman, Lotus Stack and Jack Lenor Larsen, *Jack Lenor Larsen. Creator and Collector* (Merrell, 2004), p. 66.

15. Jack Lenor Larsen, *A Weaver's Memoir* (New York: Harry N. Abrams, 1998), pp. 39–40.

16. David Revere McFadden, 'Context and Commissions', in McFadden, Friedman, Stack and Larsen, *Jack Lenor Larsen. Creator and Collector*, p. 165.

17. Ibid., pp. 50, 57.

18. Janet Kardon, 'Craft in the Machine Age', in Janet Kardon (ed), *Craft in the Machine Age, 1920–1945. The History of Twentieth Century American Craft* (Harry N. Abrams, 1995), p. 29.

19. Ibid., p. 27.

20. Susan Grant Lewin, *American Art Jewelry Today* (Harry N. Abrams, 1994), pp. 172–173.

21. For a discussion of the taboo of beauty in craft in Europe, see Jorunn Veiteberg, *Craft in Transition*, trans. Douglas Ferguson (National Academy of Arts, 2005), pp. 44–61.

22. Email from Boris Bally to author, February 2008.

23. Email from Boris Bally to author, February 2008.

24. Email from Boris Bally to author, February 2008.

25. Grant Lewin, *American Art Jewelry Today*, p. 92.

26. Hal Foster, *The Return of the Real. The Avant-Garde at the End of the Century* (MIT Press, 1996), p. 4.

27. Neal Garbler, *Life: the Movie. How Entertainment Conquered Reality* (Vintage Books, 1998), p. 13.

28. Ibid., pp. 14–15.

29. Maldwyn A. Jones, *The Limits of Liberty. American History 1607–1992* (Oxford University Press, 1995), p. 523.

30. See Paul Wood, Francis Francina, Jonathan Harris, Charles Harrison, *Modernism in Dispute. Art Since the Forties* (Yale University Press/Open University, 1993), especially pp. 106–123 for a useful discussion.

31. Richard Kostelanetz, 'Introduction: On the New Arts in America', in Richard Kostelanetz (ed.), *The New American Arts* (Collier Books, 1967), pp. 22–24.

32. Lloyd E Herman, 'Tales and Traditions 1950–1992', in Matthew Kangas and Lloyd E Herman, *Tales and Traditions: Storytelling in Twentieth Century American Crafts* (Craft Alliance, 1993), p. 35.

33. Ibid., p. 36. See also Garth Clark, *A Century of Ceramics in the United States* (E.P. Dutton/Everson Museum of Art, 1979), p. 159.

34. Quoted in Clark, *A Century of Ceramics in the United States*, p. 159.

35. Elaine Levin, *The History of American Ceramics, From Pipkins and Bean Pots to Contemporary Forms, 1607 to the Present* (Harry N. Abrams, 1988), p. 230.

36. Joshua C. Taylor, *America as Art* (Smithsonian Institute Press, 1976), pp. 40–51.

37. Arthur C. Danto, 'Between the Utensil and Art: The Ordeal of American Ceramics', in Yvonne Joris (ed.), *Choice from America. Modern American Ceramics* (Het Kuithuis, 1999), p. 8.

38. Garth Clark, *American Potters. The Work of Twenty Modern Masters* (Watson Guptill Publications, 1981), pp. 23–24.

39. Levin, T*he History of American Ceramics*, pp. 227–228.

40. Clark, *A Century of Ceramics in the United States*, p. 164.

41. J. Hall, *Tradition and Change. The New American Craftsma*n (E.P. Dutton, 1977), p. 122.

42. *Glen R Brown Intimate Immensity: Recent Works by Patti Warashina* (FOVA Galleries, 1996), p. 10.

43. Matthew Kangas, 'Tales and Traditions 1750–1950', in Herman and Kangas, *Tales and Traditions*, p. 10.

44. http://www.nolenstudios.com/portfolio/sculpture/.

45. Arthur C. Danto, 'Illusion and Comedy: the Art of John Cederquist', in catalogue, *The Art of John Cederquist. Reality of Illusion* (Museum of California, 1997), p. 14.

46. Clement Greenberg, 'The Avant-garde and Kitsch', in Clement Greenberg, *Art and Culture. Critical Essays* (Beacon Press, 1961), pp. 3–21. For a discussion about popular ceramics in the Depression, see Levin, *The History of American Ceramics*, especially pp. 147–155. Some of the examples given were ceramicists like Edris Eckhardt, Vally Wieselthier, Viktor Screckengost and Russell Aitken, who were encouraged to make work that got closer to the people.

47. Marcia Manhart and Tom Manhart, 'The Widening Arcs: A Personal History of a Revolution in the Arts', in Marcia Manhart and Tom Manhart (eds), *The Eloquent Object. The Evolution of American Art in Craft Media since 1945* (Philbrook Museum of Art, 1987), p. 36.

48. Seen at the collection at the Renwick Gallery, Washington.

49. Clive Phillpot and Jon Hendricks, *Fluxus. Selections from the Gilbert and Lila Silverman Collection* (MOMA, 1988), p. 11.

50. John Cage, *Silence* (Calder and Boyars, 1968), p. xi.

51. Donna Gold interviews J. Fred Woell, available at http://archivesofamericanart.si.edu/oralhist/woell01.html (accessed 16 October 2004).

52. Ibid.

53. Ibid.

54. Ibid.

55. Ibid.

56. http://coursesa.matrix.msu.edu/~hst306/documents/great.html (accessed August 2007).

57. Janet Kardon, 'The Aesthetic of Excess', in *Explorations. The Aesthetic of Excess* (American Craft Museum, 1990).

58. Ibid., pp. 9–10, 12–13.

59. Interview with Jan Yager, February 2006.

60. Glen R. Brown, 'Jan Yager, Urban Stigmata', *Ornament USA* 23(2) (Winter 1999): 39.

61. Interview with Jan Yager, February 2006.

62. Interview with Jan Yager, February 2006

63. http://www.web-savvy.com/river/schuylkill/lenape.html.

64. http://lenapedelawarehistory.net/mirror/history.htm.

65. Glen R. Brown, 'Jan Yager, Urban Stigmata', p. 39.

66. Pierre Nora, 'Between Memory and History: Les Lieux de Mémoire,' *Representations* (Spring 1989), p. 12.

67. Shawn P. Brennan, 'John Garrett', in *Explorations. The Aesthetic of Excess*, p. 24.

68. Ibid.

69. 'Joyce Scott', in Nancy Corwin, *The New Narrative. Contemporary Fiber Arts* (North Carolina State University, 1992), p. 52.

70. Curtia James, 'Joyce Scott', Review of an exhibition at Second Street Gallery in Charlottesville, VA, *Sculpture* (January/February, 2003), p. 59.

71. http://www.afro.com/culture/artgallery/archive9/art7.html.

72. Selma Schwartz, 'Joyce Scott', in *The Aesthetic of Excess*, p. 50.

73. http://www.sciencejoywagon.com/kwirt/mola/molas.htm.

74. Corwin, *The New Narrative: Contemporary Fiber Arts*, p. 20.

75. http://www.afro.com/culture/artgallery/archive9/art7.html.

CHAPTER 7 URBAN CRAFTS IN ENGLAND

1. Tanya Harrod, *The Crafts in Britain in the Twentieth Century* (Yale University Press, 1999), pp. 144–147.

2. Penny Sparke, *An Introduction to Design and Culture* (Routledge, 2004), pp. 15–25.

3. Tony Birks, *Lucie Rie* (Marston House, 1994), p. 21.

4. Cherry Ann Knott, *Crafts in the 1990s. An Independent Socio-Economic Study of Craftspeople in England, Scotland and Wales* (Crafts Council, 1994), p. 16, Table 2.3.

5. Peter Dormer, 'Beyond the Dovetail', in Crafts Council, *Beyond the Dovetail. Craft, Skill and Imagination* (Crafts Council, 1991), n.p.

6. Alison Britton, 'The Manipulation of Skill on the Outer Limits of Function', in Crafts Council, *Beyond the Dovetail*, n.p.

7. Fiona Adamceski, 'Outside Tradition', *Crafts* (May 1973), p. 20.

8. Ibid.

9. Ibid.

10. D'Este Bond, 'Michael Rowe', *Crafts* (March 1973), p. 22.

11. Martina Margetts, 'Strangely Familiar', in catalogue *Michael Rowe* (Birmingham Museums and Art Gallery/Lund Humphries, 2003), p. 20. Briony Fer, David Batchelor and Paul Wood, *Realism, Rationalism, Surrealism. Art Between the Wars* (Yale University Press/Open University, 1993), pp. 115–127.

12. Frederic J. Schwartz, *The Werkbund. Design, Theory and Mass Culture before the First World War* (Yale University Press, 1996), p. 16.

13. Ibid., p. 125.

14. Nancy J. Troy, *The De Stijl Environment* (Massachusetts Institute of Technology, 1983), pp. 8–9. Gillian Naylor, 'Swedish Grace… Or the Acceptable Face of Modernism?', in Paul Greenhalgh (ed.), *Modernism in Design* (Reaktion Books, 1990), p. 168.

15. Peter Dormer, *The New Ceramics. Trends and Traditions*, revised edn (Thames and Hudson, 1994), see figures 184, 187, 189.

16. http://www.aber.ac.uk/ceramics/gendered/biographies/madolinekeeler.htm.

17. See Liesbeth Crommelin and Job Meihuizen, *Ceramics in the Stedelijk Museum* (Stedelijk Museum, 1998).

18. Gert Staal, 'Dwellers in a No-Man's-Land', *London, Amsterdam. New Art Objects from Britain and Holland* (Galerie Ra, 1988), especially pp. 9–13.

19. Ibid., p. 17.

20. Martina Margetts, 'Haute Couture Objects', in *London, Amsterdam*, p. 21.

21. Ibid. especially pp. 23–25.

22. Richard Hughes and Michael Rowe, *The Colouring and Patination of Metals* (Crafts Council, 1982).
23. D'Este Bond, 'Michael Rowe', *Crafts* (March 1973), p. 22.
24. John Houston, *The Abstract Vessel* (Bellew Publishing, 1991).
25. Ibid., p. 12.
26. Ibid, p. 53.
27. Alison Britton, *Ken Eastman* (Contemporary Applied Arts, 1990), n.p.
28. Jorunn Veiteberg, *Crafts in Transition*, trans. Douglas Ferguson (Bergen National Academy of the Arts, 2005), pp. 44–45.
29. Ibid., p. 49.
30. Crommelin and Meihuizen, *Ceramics in the Stedelijk Museum*, pp. 220–221.
31. Interview with David Binns, February 2005.
32. Ian Wilson, 'Pushing It', *Crafts* (March/April 2001), p. 25.
33. Ibid., p. 27.
34. Christopher Green, *Cubism and Its Enemies* (Yale University Press, 1987), pp. 25–26.
35. Rosalind Krauss, from 'The Originality of the Avant-garde', quoted in Charles Harrison and Paul Wood (eds), *Art in Theory. 1900–2000. An Anthology of Changing Ideas* (Blackwell Publishing, 2003), p. 1034.
36. Ibid.
37. Linda Theophilus essay in catalogue, *Sally Freshwater. Defining Spaces* (Hub, Centre for Craft, Design and Making, 2004), p. 12.
38. Discussion with Sally Freshwater at Coventry University, May 2005.
39. Discussion with Sally Freshwater at Collect 2005.
40. See, for instance, *Material Culture: The Object in British Art of the 1980s and '90s* (Hayward Gallery, 1997).
41. Martin Jay, *Downcast Eyes. The Denigration of Vision in Twentieth Century French Thought* (University of California Press, 1994), p. 85.
42. John Urry, 'City Life and the Senses', in Gary Bridge and Sophie Watson (eds), *A Companion to the City* (Blackwell, 2003), pp. 389–390.
43. Ken-Ichi Sasaki, 'For whom is City Design, Tactility versus Visuality', in Malcolm Miles, Tim Hall and Iain Borden (eds), *The City Cultures Reader* (Routledge, 2000), p. 43.
44. Charles Baudelaire, 'The Heroism of Modern Life', in *Selected Writings on Art and Artists*, trans. P.E. Charvet (Cambridge University Press, 1988), pp. 104–107.
45. Charles Baudelaire, 'The Painter of Modern Life', in *Selected Writings on Art and Artists*, pp. 399–402.
46. Walter Benjamin, 'On some Motifs in Baudelaire', in *Illuminations*, trans. Harry Zohn (Fontana Press, 1992), p. 191, note 1.
47. Charles Baudelaire, *Complete Poems*, trans. by Walter Martin (Carcanet Press, 1997), pp. 219–267. See, for instance, À une passante, p. 242; L'amour du mensonge, p. 254; and Rêve Parisien, p. 262.
48. Walter Benjamin, 'A Berlin Chronicle', in *One Way Street and Other Writings*, trans. Edmund Jephcott and Kingsley Shorter (Verso, 2000), pp. 293–348.
49. Iain Sinclair, *Light out for the Territory* (Granta Publications, 1997).
50. Ellen Maurer-Zilioli, 'More than Jewellery' in Roger Fayet and Florian Hufnagle (eds), *Bernard Schobinger. Jewels Now* (Arnoldsche Art Publishers, 2003), p. 149.
51. Florian Hufnagle, 'Bernard Schobinger: a Future-Orientated Jewellery Artist', in ibid., p. 12.
52. Roger Fayet, 'A Different Richness: Bernard Schobinger's Jewels and Annelies Straba's Photographs. In Place of a Forward', in ibid., pp. 7–8.
53. http://vads.ahds.ac.uk/learning/designing britain/html/tnj_body2.html. 15.
54. http://vads.ahds.ac.uk/learning/designing britain/html/tnj_body2.html. 15.

55. Judy Atfield, *Wild Things. The Material Culture of Everyday Life* (Berg Publishers, 2000), pp. 17–18.
56. David Watkins, *Design Sourcebook. Jewellery* (New Holland Publishers, 1999), p. 98.
57. *Recycling. Forms for the Next Century – Austerity for Posterity* (Craftspace Touring, 1996), p. 62.
58. Attfield, *Wild Things*, pp. 1, 12, 15.
59. Marjan Boot, Louisa Buck, Rudi Fuchs, Andrew Wilson, *Grayson Perry. Guerrilla Tactics* (NAi Uitgevers, 2002), p. 23.
60. Veiteberg, *Craft in Transition*, pp. 46–47.
61. Boot, Buck, Fuchs and Wilson, *Grayson Perry*, pp. 14 and 23.
62. www.craftscouncil.org.uk/boyswhosew/hew.html.
63. Ibid.
64. Charles Baudelaire, 'Au Lecteur', in Charles Baudelaire, *Complete Poems*, pp. 2–5.
65. Grayson Perry interview on BBC News. Available at http://news.bbc.co.uk/nol/shared/bsp/hijlive_eve.
66. Nicholas Mirzoeff, *An Introduction to Visual Culture* (Routledge, 1998), p. 1.
67. *Recycling, Forms for the Next Century*, p. 48.
68. Ibid., 49.
69. Amanda Fielding, 'Lucy Casson' in *Lucy Casson* (Ruthin Craft Centre, 2001), pp. 4. 25.
70. Amanda Game and Elizabeth Goring, *Jewellery Moves. Ornament for the 21st century* (NMS Publishing, 1998), p. 9.
71. Fielding, *Lucy Casson*, p. 21.

CHAPTER 8 CRAFTS IN THE ENVIRONMENT: CASE STUDY PHILADELPHIA

1. Rosalind Krauss, 'Sculpture in the Expanded Field', in Rosalind Krauss, *The Originality of the Avant-Garde and other Modernist Myths* (MIT Press, 1993), p. 282.
2. John Canaday, 'Philadelphia is a Gallery of Sculpture', *New York Times* (17 November 1974).
3. Fairmount Park Commission, *Fairmount Park System. Natural Lands Restoration Master Plan*, Vol. 1, 1999. Accessed in Philadelphia Free Library.
4. Charles Coleman Sellers, 'William Rush at Fairmount', Fairmount Park Association, *Sculpture of a City, Philadelphia's Treasures in Bronze and Stone* (Walker Publishing, 1974), p. 14.
5. Michael Richman, 'Hudson Bay Wolves', in Fairmount Park Association, *Sculpture of a City*, p. 54.
6. 'Suggestions as to the Aims Proper to a Society for Promoting Sculpture', printed proposal housed in Fairmount Park Association, General Correspondence 1895–1896 at the Archives of the Historical Society of Pennsylvania. Box 51, file 1.
7. Fairmount Park Association, General Correspondence. Box 51, file 2. The annual membership was $2, but many were paying $5 dollars or more.
8. Fairmount Park Art Association. Letter to Lesley V. Miller Esp, 31 January 1900, in General Correspondence, Box 51, file 2.
9. Charles Coleman Sellers, 'William Rush at Fairmount', Fairmount Park Association, *Sculpture of a City*, p. 8.
10. Balkin Bach, *Public Art in Philadelphia* (Temple University Press, 1992), p. 132.
11. Ibid., p. 130.
12. Fairmount Park Commission. *Fairmount Park Gardens and Nature from Central Square to Schuylkill Falls*, Leaflet catalogued 2003, n.p., accessed in Philadelphia Free Library.
13. Quoted in Fairmount Park Commission, *Fairmount Park System. Natural Lands Restoration*, pp. 1–9.
14. Kevin Lynch, 'The Openness of Open Space', in Gyorgy Kepes (ed.), *Arts of the Environment* (George Braziller, 1972), p. 109.

15. http://www.fpaa.org/other_prog.html#forpro. Penny Balkin Bach, 'The Process', in *Form and Function: Proposals for Public Art for Philadelphia* (Pennsylvania Academy of Fine Arts/Fairmount Park Art Association, 1982), pp. 12–14.

16. Richard Boyle, 'Introduction', Penny Balkin Bach, *Form and Function*, p. 5.

17. Balkin Bach, *Form and Function*, pp. 30–31.

18. Balkin Bach, *Public Art in Philadelphia*, pp. 168–169.

19. Ibid., p. 256.

20. Penny Balkin Bach, 'The Process', pp. 12–14.

21. http://www.fpaa.org/child/dpaip_pavilion.html.

22. Nancy Princenthal, 'Martin Puryear', *American Craft* (February/March 1992), p. 34.

23. Edward J. Sozanski, 'Sculptor Martin Puryear Carves out his Spot at the Top', *The Philadelphia Inquirer* (8 November 1992), H01.

24. Suzi Gablik, *The Re-enchantment of Art* (Thames and Hudson, 1991), pp. 42–48.

25. Nancy Foote, 'Sightings in Siting', in *Urban Encounters. Art. Architecture. Audience* (Institute of Contemporary Arts/University of Pennsylvania, 1980), pp. 26–28.

26. Julian Holloway, 'Spiritual Embodiment and Sacred Rural Landscapes', in Paul Cloke (ed.), *Country Visions* (Pearson/Prentice Hall, 2003), p. 164.

27. Ibid., pp. 167–171.

28. Angela Melkisethian, 'Ed Levine. Embodying Thoreau: Dwelling, Sitting, Watching', *Sculpture* (June 2004), p. 26.

29. http://fpaa.org/whatsnew_tho.html.

30. Ed Levine and Pennypack Environmental Center Advisory Council, 'Embodying Thoreau: Dwelling, Sitting, Watching', in Lorene Cary, Lonnie Graham and John Stone, *New.Land.Marks. Public Art, Community and the Meaning of Place* (Fairmont Park Association, 2001), pp. 99–100; see also chapter 5, which discusses other makers who reference this book, and chapter 1 which discusses some of the ideas.

31. See Chapter 1.

32. http://fpaa.org/about_nlm.html.

33. Cary, Graham and Stone, *New.Land.Marks*, p. 57.

34. Janet Kardon, 'Street Wise/Street Foolish', in Lawrence Alloway, Janet Kardon, Nancy Foote, *Urban Encounters. Art. Architecture. Audience* (Institute of Contemporary Art/University of Pennsylvania, 1980), p. 8.

35. Ellen Dissanayake 'Why Public Art is Necessary', in Cary, Graham and Stone, *New.Land.Marks*, p. 26.

36. Ibid., p. 27.

37. http://www.neighborhoodsnowphila.org/challenge.pdf.

38. http://www.uchs.net/Newsletter/newsletter12-98.html.

39. Malcolm Cochran with Baltimore Avenue in Bloom, 'Baltimore Avenue GEMS: Grand Planters, Earthbound Crow's Nest, Midsummers' Fountain, in Cary, Graham and Stone, *New.Land.Marks*, pp. 63–64.

40. William B. Rhoads, 'Colonial Revival in American Craft: Nationalism and the Opposition to Multicultural and Regional Traditions', in Janet Kardon (ed.), *Revivals!, Diverse Traditions, 1920–1945* (Harry N. Abrams, 1994), pp. 48–49.

41. Elizabeth Mossop, 'Public Space: Civilizing the City', in Elizabeth Mossop and Paul Walton (eds), *City Spaces. Art and Design* (Fine Art Publishing, 2001), pp. 10–12. Gary Bridge and Sophie Watson, 'City Imaginaries', in Gary Bridge and Sophie Watson, *A Companion to the City* (Blackwell, 2003), pp. 7–11.

42. 'David von Schlegell' in Donald Thalacker, *The Place of Art in the World of Architecture* (Chelsea House Publishing, 1980), p. 128.

43. For a discussion of this, see Chapter 9.

44. http://www.andrewleicester.com/built.html.

45. See Chapter 9. See also De Certeau, 'Spatial Stories', in Andrew Ballantyne (ed.), *What is Architecture?* (Routledge, 2002), pp. 72–87.

46. Balkin Bach, *Public Art in Philadelphia*, p. 247.

47. Anna Fariello, 'Albert Paley: Drawing as Visual Roadmap,' *Metalsmith* (Spring 2005), 42–49. Accessed online.

48. Edward Lucie-Smith, *The Art of Albert Paley. Iron. Bronze. Steel* (Harry N. Abrams, 1996), p. 128.

49. Fariello, 'Albert Paley: Drawing as Visual Roadmap', pp. 42–49. Accessed online.

CRAFTS IN THE ENVIRONMENT: BIRMINGHAM AND GRIZEDALE FOREST CASE STUDIES

1. http://www.artscouncil.org.uk/aboutus/investment.php.

2. Malcolm Miles, *Art Space and the City. Public Art and Urban Futures* (Routledge, 1997), p. 110.

3. Sara Selwood, The Benefits of Public Art, The Polemics of Permanent Art in Public Spaces (Policy Studies Institute, 1995), p. 128.

4. Tim Hall, 'Public Art, Civic Identity and the New Birmingham', in Liam Kennedy (ed.), *Remaking Birmingham. The Visual Culture of Urban Regeneration* (Routledge, 2004), p. 68; see also, http://www.workshopoftheworld.co.uk/#.

5. This became even more obvious when the council started to advertise its new plans. See Graham Vickers, 'Streetwise Move for Brummie Metropolis', *Design Week*, 30 October 1987, p. 8; Roy Smith, 'A City of Art', B. Sculpture [sic] 22 April 1986 in *Newspaper Cuttings, Public Art 1950–1990* in Birmingham Central Library, p. 141.

6. To achieve the building projects, the council gained a grant from European Regional Development Funding. Selwood, *The Benefits of Public Art*, p. 130. See also for details about the Percent for Art scheme: Malcolm Miles, *Art Space and the City. Public Art and Urban Futures* (Routledge, 1997), p. 110.

7. Tim Hall, 'Public Art, Civic Identity and the New Birmingham', in Kennedy (ed.), *Remaking Birmingham*. p. 64.

8. Quote by Michael Diamond, director of Birmingham Museum and Art Gallery in Roy Smith, 'A City of Art', B. Sculpture [sic], 22 April 1986, in *Newspaper Cuttings, Public Art, 1950–1990*, Birmingham Central Library, p. 141. See also Selwood *The Benefits of Public Art*, pp.134–136.

9. *Birmingham Central Area District Plan no 3*, 1982.Prepared by Birmingham District Council and West Midlands Passenger Transport Executive. Section 8.1.

10. Jane Heath (ed.), *The Furnished Landscape. Applied Art in Public Places* (Bellew Publishing, 1992), pp. 7–8.

11. Claude Lévi-Strauss, *Tristes Tropiques*, trans. John Russell (Atheneum, 1968), p. 127.

12. Mikel Dufrenne, 'The World of the Aesthetic Object' in Clive Cazeaux, *The Continental Aesthetics Reader* (Routledge, 2000).

13. Ibid., pp. 141–145.

14. Michel de Certeau, *The Practice of Everyday Life*, trans. Steven F. Rendall (University of California Press, 1984).

15. Ibid., p. 97. One of the influential writers about the 'soft' city of personal experience was J. Raban, *Soft City* (Hamish Hamilton, 1974). Walter Benjamin also discussed the intricacies of personal and collective myths and memories in his writings; for instance, Walter Benjamin, 'One Way Street' in *One Way Street and Other Writings*, trans. Edmund Jephcott and Kingsley Shorter (Verso, 2000), pp. 45–106 and 'A Berlin Chronicle', in ibid., pp. 293–348.

16. De Certeau, 'Spatial Stories', in Andrew Ballantyne (ed.), *What is Architecture?* (Routledge, 2002), pp. 72–87.

17. De Certeau, 'Spatial Stories', pp. 72–73, 80–85.

18. Terry Grimley, 'City Drives Home the Cause of its Public Art', *Birmingham Post* (21.2.1990), Birmingham Newspaper Cuttings 1950–1990 housed in Birmingham Central Library.

19. See *Birmingham Central Area District Plan*, prepared by Birmingham District Council with West Midlands County Council and West Midlands Transport Executive, No. 3, 1982, housed in Birmingham Central Library.

20. George T. Noszlopy, with Jeremy Beach (ed.), *Public Sculpture of Birmingham, including Sutton Coldfield* (Liverpool University Press, 1998), p. 21. Terry Grimley, 'City Drives Home the Cause of Public Art', *Post* (21 February 1990), Birmingham Newspaper Cuttings 1950 to 1990, Birmingham Central Library, p. 181. See also Kim Williams, 'Environmental Patterns: Paving designs by Tess Jaray', on http://www.nexusjournal.com/Jaray.html.

21. See the many newspaper clippings housed in the folders on public art in Birmingham Central Library.

22. Kim Williams, 'Environmental Patterns: Paving Designs by Tess Jaray', *Nexus Network Journal*, Vol. 2 (2000), pp. 87–92, http://www.nexusjournal.com/Jaray.htmln.p.

23. Ibid.

24. Tess Jaray, 'Brick Bonding and Decorative Patterning', unpublished, quoted in ibid.

25. Alexander Beleschenko in *Glass, Light and Space* (Crafts Council, 1997), pp. 18–19.

26. http://www.freeform.org.uk/bullring.htm.

27. http://www.martindonlin.com/projects/birmingham.htm.

28. http://www.freeform.org.uk/bullring.htm.

29. http://www.ramshaw-watkins.com/wr/ah.htm.

30. http://public-art.shu.ac.uk/sheffield/mtlhvn1.html.

31. Telephone conversation with Mr Clarkson at Grizedale Forest Park, 23 January 2006. Figures based on those who pay at the car park, but excluding those using outlying car parks.

32. Jay Appleton, 'A Sort of National Property. The Growth of the National Parks Movement in Britain', in *The Lake District: A Sort of National Property* (Victoria and Albert Museum, 1986), p. 116.

33. Quoted in ibid., p. 116.

34. David Matless, *Landscape and Englishness* (Reaktion Books, 1998), p. 71.

35. Bill Grant, 'Introduction', in Bill Grant and Paul Harris (eds), *The Grizedale Experience. Sculpture, Arts and Theatre in a Lakeland Forest* (Cannongate Press, 1991), p. 9.

36. R. Woof, 'The Matter of Fact Paradise', in *The Lake District: A Sort of National Property*, p. 13. William Gilpin, *Observations Relative Chiefly to Picturesque Beauty, Made in the Year 1772, on Several Parts of England; particularly the Mountains, and Lakes of Cumberland, and Westmoreland* (printed for R. Blamire, 1786 [1776]). William Wordsworth, *Guide to the Lakes* (1810) reprint (Oxford University Press, 1977). Thomas West, *Guide to the Lakes* (1778). See also Wendy Joy Derby, *Landscape and Identity. Geographies of Nation and Class in England* (Berg, 2000), p. 56.

37. Wordsworth, *Guide to the Lakes*, p. 74.

38. See Chapter 2.

39. All three argued in many essays for responsibility of making and for making to be part of life itself; see for instance, W. Morris, 'The Art of the People', in G.D.H. Cole (ed.), *William Morris. Prose, Verse, Lectures and Essays* (Nonesuch Press, 1974), pp. 517–537. W.R. Lethaby, *Home and Country Arts* (Home and Country (1923) 1930), pp. 122–125. Eric Gill, 'Art in England Now... As it seems to me', in Eric Gill, *It All Goes Together. Selected Essays by Eric Gill* (Books for Libraries Press, 1971[1944]), pp. 88–95.

40. W.R. Lethaby, *Philip Webb and his Work* (Rowen Oak Press, 1974 [1935]), pp. 127–128.

41. Julian Andrews, *The Sculpture of David Nash* (Lund Humphries/Henry Moore Institute, 1996), p. 168.

42. David Kemp, 'Sculpture', in Bill Grant and Paul Harris (eds), *Natural Order. Visual Arts and Crafts in Grizedale Forest Park* (Grizedale Society, 1996), p. 34.

43. John Fowles and Andy Goldsworthy, 'Three Conversations with Andy Goldsworthy', in Terry Friedman and Andy Goldsworthy (eds), *Hand to Earth. Andy Goldsworthy Sculpture 1976–1990* (Henry Moore Centre, 1990), p. 161.

44. Alison Britton, 'Jim Partridge', in Alison Britton and Katherine Swift, *Jim Partridge* (Manchester City Galleries/Lund Humphries, 2003), p. 28.

45. http://www.forestry.gov.uk/website/ourwoods.nsf/LUWebDocsByKey/EnglandCumbriaNo ForestGrizedaleForestParkGrizedaleVisitorCentreRiddingWoodWalks.

46. Britton 'Jim Partridge', p. 33.

47. Email from Jim Partridge to author.

48. Email from Jim Partridge to author.

49. Britton, 'Jim Partridge', p. 23.

50. http://www.nigelross-sculpture.com/profile.html.

51. Christopher Tilley, *A Phenomenology of Landscape. Places, Paths and Monuments* (Berg, 1994), p. 16.

52. David Crouch (ed.), *Leisure/Tourism Geographies: Practices and Geographical Knowledge* (Routledge, 1999), pp. 2–3.

53. Ibid.

54. Neil Ravenscroft, 'Hyper-reality in the Official (Re)construction of Leisure Sites. The Case for Rambling', in David Crouch (ed.), *Leisure/Tourism Geographies. Practices and Geographical Knowledge* (Routledge, 1999), p. 74.

55. Tim Edensor, 'Walking in the British Countryside: Reflexivity, Embodied Practices and Ways to Escape', *Body and Society* (Vol. 6 (3–4), 2000), pp. 84–88.

56. HMSO, *Walking in Great Britain: Transport Statistics Report* (HMSO, 1998), quoted in Edensor, 'Walking in the British Countryside', p. 81. Her Majesty's Stationary Office (HMSO) was a body that had the responsibility for publishing legislation.

AFTERWORD

1. Paul Greenhalgh, 'Complexity', in Paul Greenhalgh (ed.), *The Persistence of Craft, the Applied Arts Today* (A&C Black/Rutgers University Press, 2002), pp. 195–196.

SELECT BIBLIOGRAPHY

Adamson, G. (2001), 'Circular Logic: Wood Turning 1976 to the present', *Wood Turning in North America Since 1930, exhibition catalogue*, Philadelphia: Wood Turning Centre/New Haven: Yale University Art Gallery.

Albers, A. (1961), 'More Serving, Less Expressing', *Craft Horizons* July/August: 52–53.

Andrews, J. (1996), *The Sculpture of David Nash*, London: Lund Humphries and Henry Moore Institute.

Anon. (1966), 'Craftsmen USA '66 – Northeast Region', *Craft Horizons*, June: 75–77, 109.

Appleton, J. (1986), 'A Sort of National Property: The Growth of the National Parks Movement in Britain', in *The Lake District: A Sort of National Property*, London: Victoria and Albert Museum.

Atfield, K. (2000), *Wild Things. The Material Culture of Everyday Life*, Oxford: Berg.

Atkins, J.M. (2001), 'Tradition and Transformation. Women Quilt Designers', in P. Kirkham (ed.), *Women Designers in the USA 1900–2000. Diversity and Difference*, New Haven/London: Yale University Press.

Bachelard, G. (1969/1994), *The Poetics of Space*, M. Jolas (trans.), Boston: Beacon Press.

Balkin Bach, P. (1992), *Public Art in Philadelphia*, Philadelphia: Temple University Press.

Balkin Bach, P. (ed.) (2001), *New.Land.Marks: Public Art, Community and the Meaning of Place*, Washington: Grayson.

Baudelaire, C. (1988), *Selected Writings on Art and Artists*, P.E. Charvet (trans.), Cambridge: Cambridge University Press.

Baudrillard, J. (1988) 'The System of Objects', in M. Poster, (ed.), *Jean Baudrillard. Selected Writings*, Stanford: Stanford University Press.

Beavan, J. (1992), *Illuminations*, H. Zohn (trans.), London: Fontana.

Beavan, J. (2003), 'In Transition', *Ceramic Review* January/February: 36–39.

Benjamin, W. (2000), *One Way Street and Other Writings*, E. Jephcott and K. Shorter (trans.), London: Verso.

Bergson, H. (1911), *Matter and Memory*, Nancy Margaret Paul and W. Scott Palmer (trans.), London: Swan Snnerschein/New York: Macmillan.

Binns, P. (1997), 'Vision and Process in Textile Art. A Personal Response to a Particular Landscape Expressed through Textiles', unpublished PhD, University of Teeside.

Birks, T. (1994), *Lucie Rie*, Yeovil: Marston House.

Bond, D'E. (1973), 'Michael Rowe', *Crafts* March: 22–25.

Boot, M., Buck, L., Fuchs, R. and Wilson, A. (2002), *Grayson Perry. Guerrilla Tactics*, Rotterdam: NAi Uitgevers.

Bosley, E.R. (2003), 'Two Sides of the River: Morris and American Arts and Crafts' in D. Waggoner (ed.), *William Morris and the Art of Design*, London: Thames and Hudson.

Boston, R. (1986), 'David Drew, Basketmaker', in *David Drew: Baskets*, London: Crafts Council.

Braham, Jeanne (2004), 'Mark Shapiro', *Made by Hand: Art and Craft in the Heartland of New England*, Beverly: Commonwealth Editions.

Branzi, A. (1989), 'We are the Primitives', in V. Margolin (ed.), *Design Discourse: History, Theory, Criticism*, London: University of Chicago Press.

Brears, P. (1971), *The English Country Pottery: Its History and Techniques*, Newton Abbott: David and Charles.

Brennan, S.P. (1990), 'John Garrett', *Explorations:. The Aesthetic of Excess*, New York: American Craft Museum.

Brennand-Wood, M. (1982), 'Reply to Peter Fuller', *Crafts*, November/December: 44–45.

Bridge, G., and Watson, S. (2003), *A Companion to the City*, Oxford: Blackwell.

Britton, A. (1990) *Ken Eastman*, London: Contemporary Applied Arts.

Britton, A. (1991) 'The Manipulation of Skill on the Outer Limits of Function', in *Beyond the Dovetail: Craft, Skill and Imagination*, London: Crafts Council.

Britton, A. (1993), *Gordon Baldwin*, London: Contemporary Applied Arts.

Britton, A. and Swift, K. (2003), *Jim Partridge*, Manchester: Manchester City Galleries/Lund Humphries.

Brown, G.R. (1996), *Intimate Immensity: Recent Works by Patti Warashina*, Lubbock: FOVA Galleries.

Brown, G.R. (1999), 'Jan Yager, Urban Stigmata', *Ornament USA* 23(2, Winter): 38–41.

Brown, S. and Kumar Mitchell, M. (eds) (2004), *The Beauty of Craft. A Resurgence Anthology*, Totnes: Chelsea Green Publishing.

Bryson, N. (1990), *Looking at the Overlooked. Four Essays on Still Life Painting*, London: Reaktion Books.

Buechner, T.S. (1989), 'Forward', in S.K. Frantz, *Contemporary Glass*, New York: Harry N. Abrams.

Burke, E. (1999), 'A Philosophical Inquiry into the Origins of Our Ideas of the Sublime and Beautiful', in I. Kramnick (ed.), *The Portable Edmund Burke*, Harmondsworth: Penguin.

Cage, J. (1968), *Silence*, London: Calder and Boyars.

Campbell, D. (1961), 'Fabrics International', *Craft Horizons*, special issue, September/October.

Canavier, E. (1977), 'Introduction', *American Crafts at the White House*, Los Angeles: Los Angeles Craft and Folk Museum.

Carruthers, A. (1992/4), *Edward Barnsley and his Workshop: Arts and Crafts in the Twentieth Century*, Oxford: White Cockade Publishing.

Carruthers, A. and Mary Greensted (1999), *Simplicity and Splendour. Arts and Crafts Living: Objects from the Cheltenham Collections*, Cheltenham: Cheltenham Art Gallery and Museums/London: Lund Humphries.

Cary, L., Graham, L. and Stone, J. (2001), *New.Land.Marks. Public Art, Community and the Meaning of Place*, Philadelphia: Fairmont Park Association.

Causey, A. (1990), 'Environmental Sculptures', in T. Friedman and A. Goldsworthy (eds), *Hand to Earth. Andy Goldsworthy Sculpture, 1976–1990*, Leeds: Henry Moore Centre.

Clark, G. (1979), *A Century of Ceramics in the United States*, New York: E.P. Dutton/Everson Museum of Art.

Clark, G. (2001) *The Artful Teapot*, New York: Watson-Guptill Publications.

Clark, G. (2001) 'Forward: The Bray Incubator', in P. Held (ed.), *A Ceramic Continuum: Fifty years of the Archie Bray Influence*, Seattle/London: University of Washington Press.

Clayton, A. (2002), 'Jill Nordfors Clark: Lace and Gut', *Fiberarts* November/December: 21.

Cloke, P. (2003), *Country Visions*, Harlow: Pearson Education.

Cocks, A.S. (1980), *The Victoria and Albert Museum. The Making of the Collection*, Leicester: Windward.

Cole, G.D.H. (ed.) (1974), *William Morris. Prose, Verse, Lectures and Essays*, New York: Nonsuch Press.

Coleman, M. (1976), 'On being a Potter. Interview with Mick Casson', *Crafts* January/February: 36–40.

Comino, M. (1980), *Gimson and the Barnsleys. 'Wonderful Furniture of a Commonplace Kind'*, London: Evans Brothers.

Cooke Jr, E.S. (2001), 'From Manual Training to Freewheeling Craft: The Transformation of Wood Turning 1900–1976', in *Wood Turning in North America since 1930* catalogue, Philadelphia: Wood Turning Center/New Haven: Yale University Art Gallery.

Cooper, E. and Taylor, L. (1999), *(Un)limited. Repetition and Change in International Craft*, London: Crafts Council.

Coplans, John (1966), *Abstract Expressionist Ceramics*, San Francisco: San Francisco Museum of Art/University of California Art Gallery.

Corwin, N. (1991), 'Content in Crafts: Materials in the Service of Larger Ideas', in symposium papers, *Craft in the 90s: A Return to Crafts*, Haystack Mountain School of Crafts.

Corwin, N. (1992) *The New Narrative. Contemporary Fiber Arts*, Raleigh: North Carolina State University.

Cosgrove, D. (ed.) (1999), *Mappings*, London: Reaktion Books.

Cousens, C. (2002), *Cynthia Cousens: Shift*, London: International Design.

Craft Horizons (1976) 'The Decade: Change and Continuity. A Round Table Discussion on April 4th about the Future and Past', *Craft Horizons* June 38–43.

Crafts Advisory Committee (1976), *Craftsmen of Quality*, London: Crafts Advisory Committee.

Crafts Council (1997) *Glass, Light and Space: New Proposals for the Use of Glass in Architecture*, London: Crafts Council.

Crafts Council (2004), *All about the Crafts Council*, London: Crafts Council.

Craftspace Touring (1996), *Recycling. Forms for the Next Century – Austerity for Posterity*, exhibition catalogue, Birmingham: Craftspace Touring.

Crawford, Alan (1985), *C. R. Ashbee, Architect, Designer and Romantic Socialist*, New Haven/London: Yale University Press.

Crommelin, L. and Meihuizen, J. (1998), *Ceramics in the Stedelijk Museum Amsterdam*, Amsterdam: Stedelijk Museum.

Crouch, D. (ed.) (1999), *Leisure/Tourism Geographies: Practices and Geographical Knowledge*, London/New York: Routledge.

Cusick, Dawn (ed.) (1995) *Quilt National: Contemporary Designs in Fabric*, Ashville NC: Lark Books.

Daley, W. (1991), 'Thoughts on Craft and Learning', in *Craft and Learning Symposium*, Haystack Mountain School of Crafts.

Dames, J., (ed.) (2004), *Hands Across the Border*, Ruthin: Ruthin Craft Centre.

Danto, A.C. (1997), 'Illusion and Comedy: the Art of John Cederquist', in *The Art of John Cederquist. Reality of Illusion* catalogue, Oakland: Museum of California.

Danto, A.C. (1999), 'Between the Utensil and Art: The Ordeal of American Ceramics', in Y. Joris (ed.), *Choice from America. Modern American Ceramics*, Hertogen Bosch: Het Kuithuis.

De Certeau, M. (1984), *The Practice of Everyday Life*, S.F. Rendall (trans.), Berkeley, Los Angeles/London: University of California Press.

De Waal, E. (2001), 'Comment. To Say the Least', *Crafts* March/April: 44–47.

Derby, W.J. (2000), *Landscape and Identity. Geographies of Nation and Class in England*, Oxford/New York: Berg.

Dewhurst, C.K., MacDowell, B. and MacDowell, M. (1979), *Artists in Aprons*, New York: E.P. Dutton/Museum of American Folk Art.

Diamonstein, B. (1995 [1983]), *Handmade in America. Conversations with Fourteen Craftmasters*, New York: Harry H. Abrams.

Dissanayake, E. (2001), 'Why Public Art is Necessary', in L. Cary, L. Graham and J. Stone (eds), *New.Land.Marks: Public Art, Community and the Meaning of Place*, Philadelphia: Fairmont Park Association.

Dormer, P. (1984)), 'Dyed in the Wool', *Crafts*, July/August: 12–13.

Dormer, P. (1991) 'Beyond the Dovetail', in Crafts Council, *Beyond the Dovetail. Craft, Skill and Imagination*, London: Crafts Council.

Dormer, P. (1994) *The Art of the Maker. Skill and its Meaning in Art, Craft and Design*, London: Thames and Hudson.

Dormer, P. (1994) *The New Ceramics. Trends and Traditions*, revised edition, London: Thames and Hudson.

Dormer, P. (ed.) (1997), *The Culture of Craft. Status and Future*, Manchester: Manchester University Press.

Dufrenne, M. (2000), 'The World of the Aesthetic Object' in C. Cazeaux, *The Continental Aesthetics Reader*, London and New York: Routledge.

Dutton, L. (1976), 'Michael Cardew at 75', *Ceramic Review* July/August: 9–10.

Edensor, T. (2000), 'Walking in the British Countryside: Reflexivity, Embodied Practices and Ways to Escape', *Body and Society* 6(3–4): 81–106.

Edgelar, J. (ed.) (2006), *Ray Finch Craftsman Potter of the Modern Age*, Winchcombe: Cotswold Living Publications.

Ellis, J. (2001), *Get Real. Romanticism and New Landscapes in Art*, Wolverhampton: University of Wolverhampton.

Enwezor, O. (1999), 'Tricking the Mind: The Work of Yinka Shonibare', in *Yinka Shonibare. Dressing Down*, Birmingham: Ikon Gallery.

FAF–PFPAFP (1982), *Form and Function: Proposals for Public Art for Philadelphia*, Philadelphia: Pennsylvania Academy of Fine Arts/Fairmount Park Art Association.

Fairmount Park Art Association (1986), *Sculpture/Fairmount Park. A Celebration of Art and Nature*, exhibition catalogue, Philadelphia: Fairmount Park Art Association.

Fairmount Park Commission (1999), *Fairmount Park System. Natural Lands Restoration Master Plan*, Vol. 1.

Fariello, A. (2005), '*Albert Paley*: Drawing as Visual Roadmap,' *Metalsmith* Spring: 42–49.

Fayet, R. and Hufnagl, F. (eds) (2003), *Bernard Schobinger. Jewels Now*, Stuttgart: Arnoldsche Art Publishers.

Fielding, A. (2001), 'Lucy Casson' in *Lucy Casson*, Ruthin: Ruthin Craft Centre.

Fielding, A. (2004)'Making Connection', in *Hands Across the Border*, Denbighshire: Ruthin Craft Centre,.

Fielding, A. (2005) 'A Culture of Collection: Silver and Metalwork in the Public Domain', *Jerwood Applied Arts Prize, 2005: Metal*, London: Crafts Council.

Fike, B. (1998), 'The Art Historical Context of Contemporary Glass' in B. Fite, *A Passion for Glass. The Ariva and Jack A Robinson Studio Glass Collection*, Michigan: Detroit Institute of Arts.

Fisch, A. (1980/1981), 'Detail', *American Craft* December/January: 20–21.

Foote, N. (1980), 'Sightings in Siting', in L. Alloway (ed.), *Urban Encounters. Art. Architecture. Audience*, Philadelphia: Institute of Contemporary Arts/University of Pennsylvania.

Foster, H. (1996), *The Return of the Real. The Avant-Garde at the End of the Century*, Cambridge, MA/London: MIT Press.

Fowles, J. and Goldsworthy, A. (1990), 'Three Conversations with Andy Goldsworthy', in T. Friedman and A. Goldsworthy (eds), *Hand to Earth. Andy Goldsworthy Sculpture 1976–1990*, Leeds: Henry Moore Centre.

Frayling, C. (2003) 'Shapes of things to come. United Kingdom', *Crafts* March/April: 28–29, special anniversary issue.

Frayling, C. and Sowden, H. (1982), 'The Myth of the Happy Artisan', *Crafts*, January/February: 16–17.

Frayling, C. and Sowden, H. (1982),'Crafts, With or Without Arts', *Crafts* March/April: 24–25.

Frayling, C. and Sowden, H. (1982), 'Skill: A Word to Start an Argument', *Crafts* May/June: 19–21.

Frayling, C. and Sowden, H. (1982), 'Crafts in the Market Place' *Crafts* July/August: 14–17.

Frayling, C. and Sowden, H. (1982), 'Nostalgia isn't what it used to be', *Crafts* November/December: 12–13.

Friedman, M. (1994), *Visions of America. Landscape as Metaphor in the Late Twentieth Century*, Denver: Denver Art Museum/Columbus Museum of Art.

Fry, P.S. (1973), 'Back to Thatch', *Crafts* March: 18–20.

Fuller, P. (1982), 'Review of Fabric and Form', A British Council Touring Exhibition, *Crafts* November/December: 43–44.

Gablik, S. (1991), *The Re-enchantment of Art*, New York/London: Thames and Hudson.

Game, A. and Goring, E. (1998), *Jewellery Moves. Ornament for the 21st century*, Edinburgh: NMS Publishing.

Garbler, N. (1998), *Life: the Movie. How Entertainment Conquered Reality*, New York: Vintage Books.

Gill, E. (1944/1977), *Selected Essays. It All Goes Together*, New York: Books for Libraries Press.

Gilpin, W. (1786 [1776]), *Observations relative chiefly to Picturesque Beauty, Made in the Year 1772, on Several Parts of England; particularly the Mountains, and Lakes of Cumberland, and Westmoreland*, London: R. Blamire.

Gilpin, W. (1792) *Three Essays: On Picturesque Beauty, On Picturesque Travel: and On Sketching Landscape*, London: Blamire.

Grant, B. and Harris, P. (eds) (1991), *The Grizedale Experience. Sculpture, Arts and Theatre in a Lakeland Forest*, Edinburgh: Canongate Press.

Greenbaum, T. and Kirkham, P. (2000), 'Women Jewelry Designers', in P. Kirkham (ed.), *Women Designers in the USA, 1900–2000. Diversity and Difference*, New Haven/London: Yale University Press.

Greenberg, C. (1986), 'The Avant-garde and Kitsche', in J. O'Brian (ed.), *Clement Greenberg. The Collected Essays and Criticism. Vol 1. Perceptions and Judgements, 1939–1944*, Chicago/London: University of Chicago Press.

Greenhalgh, P. (ed.) (2002), *The Persistence of Craft*, London: A&C Black/New Brunswick: Rutgers University Press.

Guignon, C. (2004), *On Being Authentic*, London and New York: Routledge.

H.H. (1961) 'Fourth National Conference of American Craftsmen', *Craft Horizons* November/December, special issue.

Haggar, R.G. (1950), *English Country Pottery*, London: Phoenix House.

Hall, J. (1977), *Tradition and Change. The New American Craftsman*, New York: E.P. Dutton.

Hall, T. (2004), 'Public Art, Civic Identity and the New Birmingham' in L. Kennedy (ed.), *Remaking Birmingham. The Visual Culture of Urban Regeneration*, Abingdon: Routledge.

Halper, V. and Rossbach, E. (1991), *John McQueen. The Language of Containment*, Washington: University of Washington Press and Smithsonian Institute.

Halstead, W. (1968), 'Claire Zeisler and the Sculptural Knot', *Craft Horizons* September/October: 10.

Harris, P. and Lyon, D. (2004), 'Mystery and Memory. The Jewellery of Sandra Enterline', *Metalsmith* Spring: 30–35.

Harrod, T. (1999), *The Crafts in Britain in the Twentieth Century*, New Haven/London: Yale University Press.

Hazlitt, W. (1930), 'On going on a Journey', in G. Keynes (ed.), *Selected Essays of William Hazlitt, 1778:1830*, London: Nonsuch Press.

Hazlitt, W. (1930) 'On the Love of the Country', in G. Keynes (ed.), *Selected Essays of William Hazlitt, 1778:1830*, London: Nonsuch Press.

Heath, J. (ed.) (1992), *The Furnished Landscape. Applied Art in Public Places*, London: Bellew Publishing.

Herman, L.E. (2004), *Looking Forward. Glancing Back. Northwest Designer Craftsmen at 50*, Washington: Whatcom Museum of History of Art.

Higby, W. (1981), *Art in Craft Media. The Haystack Tradition*, Brunswick Maine: Bowdoin College Museum of Art.

Higby, W. (1991), 'Expectation: Art, Material and the Photograph' in Haystack Mountain School of Crafts, *Craft in the 1990s: A Return to Materials* symposium papers.

High, P.B. (1986), *An Outline of American Literature*, Harlow: Longman.

Highmore, B. (2002), *The Everyday Life Reader*, London: Routledge.

Hobsbawm, E. and Ranger, T. (eds) (1983), *The Invention of Tradition*, Cambridge: Cambridge University Press.

Holstein, J. (1972), 'American Pieced Quilts', *American Pieced Quilts* catalogue, Lausanne: Editions des Massons SA.

Hoskins, W.C. (1991), *The Making of the English Landscape*, London: Penguin.

Houston, J. (1973), 'Recent British Jewellery', *Crafts* July/August: 30–32.

Houston, J. (1990) *Richard Slee. Ceramics in Studio*, London: Bellew Publishing.

Houston, J. (1991) *The Abstract Vessel. Ceramics in Studio*, London: Bellew Publishing.

Howkins, A. (2003), *The Death of Rural England. A Social History of the Countryside since 1900*, London/New York: Routledge.

Hughes, R. (1997), *American Visions. The Epic History of Art in America*, London: Harville Press.

Hussey, C. (1967), *The Picturesque. Studies in a Point of View*, London: Frank Cass.

James, M. (1985), 'Beyond Tradition. The Art of the Studio Quilt', *American Craft* February/March: 16–22.

Jameson, F. (1990), *Signatures of the Visible*, New York: Routledge.

Jaray, T. (2000), 'Brick Bonding and Decorative Patterning', unpublished, quoted in K. Williams, 'Environmental Patterns: Paving Designs by Tess Jaray', *Nexus Network Journal 2*.

Jarmusch, A. (1981), 'From Mesas through Canyons to the Sea and Back', *American Craft* April/May: 10–13.

Johnson, J. (ed.) (2002), *Exploring Contemporary Craft. History Theory and Critical Writing*, Toronto: Coach House Books.

Johnson, P. (ed.) (1998), *Ideas in the Making: Practice in Theory*, London: Crafts Council.

Johnson, P. (2003) *Polly Binns Monograph. Surfacing*, Bury St Edmunds: Bury St Edmunds Art Gallery.

Jones, M.A. (1995), *The Limits of Liberty. American History 1607–1992*, Oxford: Oxford University Press.

Kangas, M. and Herman, L. (1993), *Tales and Traditions. Storytelling in Twentieth Century American Crafts*, St Louis: Craft Alliance.

Kaplan, W. (1987), *The Art that is Life. The Arts and Crafts Movement in America 1875–1920*, Boston: Little, Brown.

Kaplan, W. (2004) 'America: The Quest for Democratic Design' in W. Kaplan, *The Arts and Crafts Movement in Europe and America: Design for the Modern World*, London: Thames and Hudson.

Kardon, J. (1980), 'Street Wise/Street Foolish', in *Urban Encounters. Art. Architecture. Audience*, Philadelphia: Institute of Contemporary Arts and University of Pennsylvania.

Kardon, J. (1990) 'The Aesthetic of Excess', *Explorations. The Aesthetic of Excess*, New York: American Craft Museum.

Kardon, J. (ed.) (1994), *Revivals! Diverse Traditions, The History of Twentieth Century American Crafts, 1920–1945*, New York: Harry N. Abrams.

Kardon, J. (ed.) (1995), *Craft in the Machine Age, 1920–1945. The History of Twentieth Century American Craft*, New York: Harry N. Abrams.

Klein, D. (2001), *Artists in Glass. Late Twentieth Century Masters in Glass*, London: Mitchell Beazley.

Kline, V. (1973), 'Craft Centre Fact Sheet: A Sampling' *Craft Horizons* April: 43–59.

Knott, Cherry Ann (1994), *Crafts in the 1990s. An Independent Socio-economic study of Craftspeople in England, Scotland and Wales*, London: Crafts Council.

Koplos, J. (2003), *Gyöngy Laky: Connections*, Winchester: Telos Art Publishing.

Kostelanetz, R. (ed.) (1967), *The New American Arts*, New York: Collier Books.

Krauss, R. (1993), *The Originality of the Avant-Garde and other Modernist Myths*, Boston: MIT Press.

Kuspit, D. (1999), 'High Kitsch: Poking fun at the Vessel', *American Ceramics* 13(1).

Kuyken-Schneider, D.U. (1989), 'Introduction', in *Gordon Baldwin, Mysterious Volumes*, Rotterdam: Museum Boymans van Beuningen.

Larsen, J.L. (1961), 'The Future of the Textile', *Craft Horizons* September/October: 7.

Larsen, J.L. (1973) 'The Colossal Sixth Tapestry Biennial', *Craft Horizons* October: 20–29.

Larsen, J.L. (1973), 'The American Crafts Council Evolves', *Craft Horizons* December: 8.

Larsen, J.L. (1998) *A Weaver's Memoir*, New York: Harry N. Abrams.

Leach, B. (1965), *A Potter's Book*, Hollywood-by-the-sea: Transatlantic Arts.

Lee, M. (2007), *Gyöngy Laky. Intersections*, San Francisco: Braunstein/Quay Gallery.

Lethaby, W.R., Powell, A.H. and Griggs, F.L. (1924), *Ernest Gimson: His Life and Work*, Stratford-upon-Avon: Shakespeare Head Press.

Lethaby, W.R. (1928), *About Beauty*, Birmingham: Birmingham School of Printing.

Lethaby, W.R. (1930 [1913]) 'Art and Workmanship', reprinted from *The Imprint* by Birmingham School of Printing.

Lethaby, W.R. (1930 [1923]) *Home and Country Arts*, London: Home and Country.

Lethaby, W.R. (1974 [1935]) *Philip Webb and his Work*, London: Rowen Oak Press.

Levin, E. (1988), *The History of American Ceramics, From Pipkins and Bean Pots to Contemporary Forms, 1607 to the Present*, New York: Harry N. Abrams.

Lewin, S.G. (1994), *American Art Jewelry Today*, New York: Harry N. Abrams.

Lewis, P.F. (1994 [1990]), 'The Northeast and the Making of American Geographical Habits', in M.P. Conzen (ed.), *The Making of the American Landscape*, New York/London: Routledge.

Lipman, J. (1948), *American Folk Art in Wood, Metal and Stone*, Meriden Connecticut: Pantheon.

Lloyd, D.W. (1984), *The Making of English Towns. 2000 Years of Evolution*, London: Victor Gollancz.

Loos, A. (1998), *Ornament and Crime: Selected Essays*, Michael Mitchell (trans.), Riverside, CA: Ariadne Press.

Lucie-Smith, E. (1975), *World of the Makers. Today's Master Craftsmen and Craftswomen*, London: Paddington Press.

Lucie-Smith, E. (1977) 'A New Vocabulary', *Crafts* January/February: 29–31.

Lucie-Smith, E. (1996) *The Art of Albert Paley. Iron. Bronze. Steel*, New York: Harry N. Abrams.

Lynch, K. (1972), 'The Openness of Open Space', in G. Kepes (ed.), *Arts of the Environment*, New York: George Braziller.

Lynton, N. (1990), 'David Nash', in David Nash, *David Nash, Sculpture, 1971–1990*, London: Serpentine Gallery.

MacCarthy, F. (1981), *The Simple Life. C.R. Ashbee in the Cotswolds*, London: Lund Humphries.

Malpas, W. (1998), *Land Art, Earthworks, Installations, Environments, Sculptures*, Kidderminster: Crescent Moon Publishing.

Manhart, M. and Manhart, T. (1987), 'The Widening Arcs: A Personal History of a Revolution in the Arts', in M. Manhart and T. Manhart (eds), *The Eloquent Object. The Evolution of American Art in Craft Media since 1945*, Tulsa: Philbrook Museum of Art.

Margetts, M. (1988), 'Haute Couture Objects', in *London, Amsterdam. New Art Objects from Britain and Holland*, Amsterdam: Galerie Ra.

Margetts, M. (2003) 'A Natural Journey', in *Cynthia Cousens: Shift – Towards New Jewellery*, Brighton: Royal Pavillion, Libraries and Museums.

Margetts, M. (2003) 'Strangely Familiar', in R. Hill and M. Margetts, *Michael Rowe*, catalogue, Birmingham: Birmingham Museums and Art Gallery/Aldershot: Lund Humphries.

Marx, L. (1991), 'The American Ideology of Space', in W.H. Adams and S. Wrede (eds), *Denatured Visions: Landscape and Culture in the Twentieth Century*, New York: Harry N. Abrams.

Massey, D., Allen, J. and Sarre, P. (eds) (1999), *Human Geography Today*, Cambridge: Polity Press.

Master, J., Miller, C., Riordan, M., Slade, R., Taragin, D. and Mayer-Thurman, C. (1983), *Design in America. The Cranbrook Vision, 1925–1950*, New York: Harry N. Abrams.

Matless, D. (1998), *Landscape and Englishness*, London: Reaktion Books.

Mayer, B. (1988), Contemporary American Craft Art. A Collector's Guide, Layton: Gibbs M. Smith.

McFadden, D., Friedman, M., Stack L. and Larsen, J. (2004), *Jack Lenor Larsen. Creator and Collector*, London/New York: Merrell.

Melkisethian, A. (2004), 'Ed Levine. Embodying Thoreau: Dwelling, Sitting, Watching', *Sculpture* June: 26–27.

Merleau-Ponty, M. (1964), *The Primacy of Perception*, Evanston: Northwestern University Press.

Merleau-Ponty, M. (2002), *The Phenomenology of Perception*, Colin Smith (trans.), London: Routledge.

Metcalf, B. (2000), 'The Problem of the Fountain' *Metalsmith* Summer: 28–35.

Miles, M. (1997), *Art, Space and the City. Public Art and Urban Futures*, London/New York: Routledge.

Mirzoeff, N. (ed.) (1998), *Visual Culture Reader*, London/New York: Routledge.

Moignard, E. (2005), 'Narrative and Memory' in J. Cunningham, *Maker, Wearer, Viewer*, Edinburgh: Scottish Arts Council.

Mornement, C. (ed.) (1993), *Craft Galleries. A Directory of English Galleries and their Craftspeople*, Taunton: Tony Williams Publishers.

Mornement, C. (ed.) (2002), *Craft Galleries Guide. A Selection of British Galleries and their Craftspeople*, Yeovil: BCF Books.

Morton, H.V. (2000 [1927]), *In Search of England*, London: Methuen.

Mossop, E. (2001), 'Public Space: Civilizing the City', in E. Mossop and P. Walton (eds), *City Spaces. Art and Design*, Sidney: Fine Art Publishing.

Naylor, G. (1990), 'Swedish Grace … Or the Acceptable Face of Modernism?', in P. Greenhalgh (ed.), *Modernism in Design*, London: Reaktion Books.

Nora, P. (1986), 'Between Memory and History. Les Lieux de Mémoire,' *Representations* Spring: 7–25.

Nesbitt, P. (1996), 'Sheepfolds: Interviews with Andy Goldsworthy', in *Andy Goldsworthy Sheepfolds*, London: Michael Hue Williams Fine Art.

Newby, R. and Jiusto, C. (2001), 'A Beautiful Spirit': Origins of the Archy Bray Foundation for the Ceramic Arts', in P. Held (ed.), *A Ceramic Continuum. Fifty years of the Archie Bray Influence*, Seattle/London: University of Washington Press.

Nordfors Clark, J. (2003), 'Seductive Surfaces: Fishskin and Gut', *Surface Design Journal* Fall: 32–39.

Nordness, L. (1970), *Objects: USA*, London: Thames and Hudson.

Noszlopy, G.T. and Beach, J. (eds) (1998), *Public Sculpture of Birmingham, including Sutton Coldfield*, Liverpool: Liverpool University Press.

Novak, B. (1995), *Nature and Culture. American Landscape and Painting, 1825–1875*, rev. edn, New York/Oxford: Oxford University Press.

Olding, S. (ed.) (2007), *Urban Field*, Farnham: Crafts Study Centre.

O'Mara, A.M. (1982), *Urban Metaphor in American Art and Literature, 1910–1930*, PhD thesis: Northwestern University.

Opie, J.H. (2004), *Contemporary International Glass. 60 Artists in the V&A*, London: V&A Publications.

Paetzold, H. (2000), 'The Philosophical Notion of the City', in M. Miles, T. Hall, and I. Borden, *The City Cultures Reader*, London/New York: Routledge.

Pagliaro, J. (ed.) (2003), *Shards. Garth Clark on Ceramic Art*, New York: Ceramics Arts Foundation/Distributed Art Publications.

Perry, G. (2006), *The Charms of Lincolnshire*, Lincoln: The Collection.

Phillpot, C. and Hendricks, J. (1988), *Fluxus. Selections from the Gilbert and Lila Silverman Collection*, New York: MOMA.

Pohl, F.K. (2002), *Framing America. A Social History of American Art*, London: Thames and Hudson.

Porritt, J. and Winner, D. (1988), *The Coming of the Greens*, London: Fontana Paperbacks.

Porte, J. (1999), 'Introduction: Representing America – the Emerson Legacy', in J. Porte and S. Morris, *The Cambridge Companion to Ralf Waldo Emerson*, Cambridge: Cambridge University Press.

Postrel, V. (2003), *The Substance of Style. How the Rise of Aesthetic Value is Remaking Commerce, Culture, and Consciousness*, New York: Perennial.

Princenthal, N. (1997), 'John Cederquist. Theatre in the Round', in *The Art of John Cederquist. Reality of Illusion* catalogue, Oakland: Museum of California.

Pye, D. (1968), *The Nature and Art of Workmanship*, Cambridge: Cambridge University Press.

Raban, J. (1974), *Soft City*, London: Hamish Hamilton.

Ramshaw, W. (1998), *Jewel Drawings and Projects*, Barcelona: Renart Edicions.

Ramshaw, W. and Watkins, D. (2000), *The Paper Jewelry Collection. Pop Out Artwear*, London: Thames and Hudson.

Ramshaw, W. and Watkins, D. (2004) *The Big Works of Wendy Ramshaw*, Barcelona: Sd.edicions-Hipotesi.

Ravenscroft, N. (1999), 'Hyper-reality in the Official (Re)construction of Leisure Sites. The Case for Rambling', in D. Crouch (ed.), *Leisure/Tourism Geographies. Practices and Geographical Knowledge*, London/New York: Routledge.

Rawson, P. (1971), *Ceramics*, London: Oxford University Press.

Revere McFadden, D. (2003), 'Shape of Things to Come. United States', *Crafts* March/April: 30–31.

Rhoads, W.B. (1994), 'Colonial Revival in American Craft. Nationalism and the Opposition to Multicultural and Regional Traditions', in J. Kardon (ed.), *Revivals! Diverse Traditions. The History of 20th Century American Craft, 1920–1945*, New York: American Craft Museum.

Rhodes, D. (1978), 'A Potter's Philosophy', *Crafts* November/December: 21.

Rice, N. (1982), 'Landscapes recalled', *American Craft* February/March: 11–13.

Richardson Jr, R. (1995), 'Thoreau's Concord', in Joel Myerson, *The Cambridge Companion to Henry David Thoreau*, Cambridge: Cambridge University Press.

Richardson Jr, R.D. (1999), 'Emerson and Nature', in J. Porte and S. Morris, *The Cambridge Companion to Ralf Waldo Emerson*, Cambridge: Cambridge University Press.

Richman, M. (1974), 'Hudson Bay Wolves', *Sculpture of a City*, New York: Walker Publishing.

Rieman, T.D. (1995), 'Shaker Design, Superfluities Doomed', in T. Rieman, *Shaker. The Art of Craftsmanship*, Alexandria: Art Services International.

Risatti, H. (1998), 'Metaphysical Implications of Function, Material, and Technique in Craft', in *Skilled Work. American Craft in the Renwick Gallery*, Washington/London: Smithsonian Institute Press.

Robbins, E. (2000), 'Thinking Space/Seeing Space: Thamesmead Revisited', in Miles, M., Hall, T. and Borden, I. (eds), *The City Cultures Reader*, London/New York: Routledge.

Robertson, C. (1987), 'House and Home in the Arts and Crafts Era: Reforms for Simpler Living', in W. Kaplan, *The Art that is Life. The Arts and Crafts Movement in America 1875–1920*, Boston: Little, Brown.

Robinson, D.M. (1999), 'Transcendentalism and its times' in J. Porte and S. Morris, *The Cambridge Companion to Ralf Waldo Emerson*, Cambridge: Cambridge University Press.

Safford., C.L. and Bishop, R. (1972), *America's Quilts and Coverlets*, New York: E.P. Dutton.

Sandino, L. (2007), 'Field Notes', in S. Olding (ed.), *Urban Field*, Farnham: Crafts Study Centre.

Santayana, G. (1955 [1896]), *The Sense of Beauty. Being the Outline of Aesthetic Theory*, New York: Dover.

Sarsby, J. (1997), 'Alfred Powell: Idealism and Realism in the Cotswolds', *Journal of Design History*, Special Issue: *Craft, Culture and Identity* 10(4): 375–397.

Sarsby, J. (1999) 'Pots of Life: Winchcombe Pottery 1926–1998. Cheltenham Art Gallery and Museum', *Crafts* March/April: 61–62.

Schoester, M. (2004), 'Bucking the Trend' in *Michael Brennand-Wood. Field of Centres*, Worksop: Harley Gallery/ Ruthin: The Gallery, Ruthin Craft Centre.

Schwartz, F.J. (1996), *The Werkbund. Design, Theory and Mass Culture before the First World War*, New Haven/London: Yale University Press.

Schwartz, S. (1990), 'Joyce Scott', in *Explorations. The Aesthetic of Excess*, New York: American Craft Museum.

Sealts Jr, M.M. and Ferguson, A.R. (1969), *Emerson's Nature. Origin, Growth, Meaning*, Carbondale/Edwardsville: Southern Illinois University Press.

Sears, J.F. (1989), *Sacred Places. American Tourist Attractions in the Nineteenth Century*, Amherst: University of Massachusetts Press.

Sellers, C.C. (1974), 'William Rush at Fairmount', Fairmount Park Association, *Sculpture of a City*, New York: Walker Publishing.

Selwood, S. (1995), *The Benefits of Public Art, The Polemics of Permanent Art in Public Spaces*, London: Policy Studies Institute.

Seymour, J. (2004), *Wonder of Work*, in S. Brown and M.K. Mitchell, *The Beauty of Craft. A Resurgence Anthology*, Totnes: Chelsea Green Publishing.

Shields, R. (1991), *Places on the Margin*, London: Routledge.

Slivka, R. (1961), 'The New Ceramic Presence', *Craft Horizons* (July/August): 31–37.

Slivka, R. (1970) 'Affirmation. The American Craftsman 1971', *Craft Horizons* December: 11.

Smith, P.J. (1986), *Craft Today. Poetry of the Physical*, New York: American Crafts Council.

Smith, P.J. (2001) *Objects for Use: Handmade by Design*, New York: Harry N. Abrams/ American Craft Museum.

Sozanski, E.J. (1992), 'Sculptor Martin Puryear Carves out his Spot at the Top', *Philadelphia Inquirer*, 8 November, H01.

Sparke, P. (2004), *An Introduction to Design and Culture*, London/New York: Routledge.

Spooner, B. (1997), 'Weavers and Dealers: The Authenticity of an Oriental Carpet', in A. Appadurai, *The Social Life of Things. Commodities in Cultural Perspective*, Cambridge: Cambridge University Press.

Staal, G. (1988), *London, Amsterdam. New Art Objects from Britain and Holland*, Amsterdam: Galerie Ra.

Taylor, J.C. (1976), *America as Art*, Washington: Smithsonian Institute Press.

Taylor, L. (1998), 'Forward', *No Picnic*, London: Crafts Council.

Thalacker, D. (1980), *The Place of Art in the World of Architecture*, New York/London: Chelsea House Publishers.

Theophilus, L. (2004), *Sally Freshwater. Defining Spaces*, Sleaford: Hub, Centre for Craft, Design and Making.

Tilley, C. (1994), *The Phenomenology of Landscape. Places, Paths and Monuments*, Oxford: Berg.

Tozer, J. (1999), 'Repeat after Me', in E. Cooper and L. Taylor, *(Un)limited. Repetition and Change in International Craft*, London: Crafts Council.

Trapp, K.R. (1998), 'Dedicated to Art: Twenty-five Years at the Renwick Gallery', *Skilled Work. American Craft in the Renwick Gallery*, Washington/London: Smithsonian Institution Press.

Tresidder, R. (1999), 'Tourism and Sacred Landscapes', in D. Crouch (ed.), *Leisure/Tourism Geographies: Practices and Geographical Knowledge*, London/New York: Routledge.

Trilling, J. (2001), *The Language of Ornament*, London: Thames and Hudson.

Turner, R. (1996), *Jewellery in Europe and America. New Times, New Thinking*, London: Thames and Hudson.

Urry, J. (2003), 'City Life and the Senses', in G. Bridge and S. Watson (eds), *A Companion to the City*, Oxford: Blackwell.

Valentine, G. (1999), 'Imagined Geographies: Geographical Knowledge of Self and Other in Everyday Life', in D. Massey, J. Allen and P. Sarre (eds), *Human Geography Today*, Cambridge: Polity Press.

Van Leeuwen, T.A.P. (1988), *The Skyward Trend of Thought. The Metaphysics of the American Skyscraper*, Cambridge MA: MIT Press.

Vance, Jr. J. E (1994 [1990]), 'Democratic Utopia and the American Landscape', in M.P. Conzen (ed.), *The Making of the American Landscape*, New York/London: Routledge.

Veiteberg, Jorunn (2005), *Crafts in Transition*, Douglas Ferguson (trans.), Bergen: Bergen National Academy of the Arts.

Vickers, G. (1987), 'Street wise move for Brummie Metropolis' *Design Week*, 30 October, p. 8.

Von Gwinner, S. (1988), *The History of the Patchwork Quilt. Origins, Traditions and Symbols of a Textile Art*, West Chester: Schiffer Publishing.

Watkins, D. (1999), *Design Sourcebook. Jewellery*, London: New Holland Publishers.

Weigley, R.F. (1982), *Philadelphia. A 300-Year History*, New York/London: W.W. Norton.

Wheeler, R. (1998), *Winchcombe Pottery. The Cardew-Finch Tradition*, Oxford: White Cockade Publishing, and Cheltenham Museum and Art Gallery.

Williams, K. (2000), 'Environmental Patterns: Paving Designs by Tess Jaray', *Nexus Network Journal 2*.

Wilson, I. (2001), 'Pushing It', *Crafts* March/April: 24–27.

Woof, R. (1984), 'The Matter of Fact Paradise', *The Lake District: A Sort of National Property*, London: Countryside Commission/V&A .

Wordsworth, W. (1977 [1810]), *Guide to the Lakes*, Oxford: Oxford University Press.

Yorke, M. (1987), *The Spirit of Place. Nine Neo Romantic Artists and their Times*, London: Constable.

WEBSITES

www.aber.ac.uk/ceramics/gendered/biographies/madolinekeeler.htm

www.alan-lomax.com/home_loc.html

http://www.andrewleicester.com/built.html

http://archivesofamericanart.si.edu/oralhist/woell01.htm. Donna Gold interviews J.Fred Woell, accessed 16 October 2004.

http://www.basketassoc.org/index.php

http://www.basketassoc.org/pages/basketmaking.php

http://www.burchardstudio.com/C.Burchard.pdf

www.cartage.org.lb/en/themes/Biographies/MainBiographies/M/Musler/Musler.htm

http://www.christinayocca.com/pb/wp_0334afd9/wp_0334afd9.html? 0.07700795711267266

www.cia.gov/cia/publications/factbook/print/us.html

www.cmog.org/collection/main.php?module=objects

http://coursesa.matrix.msu.edu/~hst306/documents/great.html, accessed August 2007.

www.craftscouncil.org.uk/about/socio_econ_survey.pdf.

www.craftscouncil.org.uk/about/socio_econ_survey.pdf. 5, accessed May 2006.

www.craftscouncil.org.uk/about/socio_econ_survey.pdf. 6, accessed May 2006.

www.craftscouncil.org.uk/about/socio_econ_survey.pdf. Making it in the 21st century. A Socio-economic survey of crafts in England and Wales in 2002–2003.

www.craftscouncil.org.uk/boyswhosew/hew.html.

www.craftscouncil.org.uk/collect/about.html

www.craftsonline.org.uk/about_origin

http://eliawoods.com/elia.htm

http://encarta.msn.com/encyclopedia_761572205/England.html

http://www.englishwillowbaskets.co.uk

http://www.fiberarts.com/article_archive/process/Johnmcqueen.asp

http://www.forestry.gov.uk/website/ourwoods.nsf/LUWebDocsByKey/EnglandCumbriaNo
　ForestGrizedaleForestParkGrizedaleVisitorCentreRiddingWoodWalks

http://fpaa.org/about_nlm.html

http://www.fpaa.org/child/dpaip_pavilion.html

http://fpaa.org/child/dpaip_thoreau.html

http://www.fpaa.org/other_prog.html#forpro

http://fpaa.org/whatsnew_tho.html

http://www.georgiecline.com/Pages/Gallery1.html

http://www.greenswardparks.org/books/menwhomade.html

http://www.hartsilversmiths.co.uk/the_company/heritage/heritage.html

http://www.jennycrisp.co.uk/Site/about%20jenny.html

http://www.joewoodstudio.com/stat-pg.html

http://www.johnleachpottery.co.uk/about.asp

http://www.lawrencenealchairs.co.uk/index,htm

http://www.leighcgriffith.com/

http://www.mayamachinpottery.com

http://www.msu.edu/user/shermanh/galeb/resume.htm

http://www.nationalgallery.org.uk/about/press/2007/scratch_surface.htm

http://www.naturalturnedwoodbowls.com

http://www.neighborhoodsnowphila.org/challenge.pdf

http://news.bbc.co.uk/nol/shared/bsp/hijlive_eve, accessed 14 July 2004. Grayson Perry
　interview on BBC news.

http://www.nps.gov

www.nps.gov/appa

http://www.pbs.org/art21/artists/puryear/index.html

http://www.phl.org/art/knauss.html

www.sofaexpo.com/

www.statistics.gov.uk/articles/population_trends/popreview_pt112.pdf

http://stonepoolpottery.com.index.htm

http://www.taunton.com/thetauntonpress/about_us.asp

http://www.taunton.com/thetauntonpress/our_culture.asp

http://www.uchs.net/Newsletter/newsletter12–98.html

http://vads.ahds.ac.uk/learning/designing britain/html/tnj_body2.html. 15, accessed October
　2006.

EMAIL DISCUSSIONS

Gyöngy Laky, Jennifer Trask, Boris Bally, Jim Partridge

INTERVIEWS AND TELEPHONE DISCUSSIONS IN ORDER THAT THEY APPEAR IN THE BOOK

Chapter 2. David Wilson, David Hart, Jeff Humpage, William Hall, Jenny Crisp.

Chapter 3. Jonathan Winfisky, Jean Weller, Kenny Lafond, Tom Kuklinski, Jim Picardi, Peggy Hart, Becky Ashenden, Mark Shapiro, Andrew Quient.

Chapter 4. Jenny Beavan, David Binns.

Chapter 5. Anne Brauer, Deb Todd Wheeler.

Chapter 6. Jan Yager.

Chapter 7. David Binns, Sally Freshwater.

Chapter 9. Mr Clarkson.

INDEX